RICK SAMMON'S

Exploring the Light

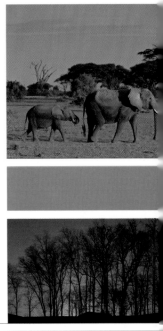

ALSO BY RICK SAMMON

Rick Sammon's Complete Guide to Digital Photography 2.0

Rick Sammon's Digital Imaging Workshops

Rick Sammon's Travel and Nature Photography

Flying Flowers

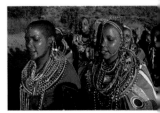

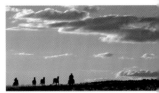

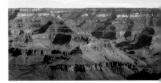

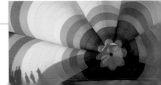

RICK SAMMON'S

Exploring the Light

Making the Very Best In-Camera Exposures

 W. W. NORTON & COMPANY NEW YORK • LONDON

For information about permission to reproduce selections from this book, write to
Permissions, W. W. Norton & Company, Inc., 500 Fifth Avenue, New York, NY 10110

For information about special discounts for bulk purchases, please contact
W.W. Norton Special Sales at specialsales@wwnorton.com or 800-233-4830

Manufacturing by Quebecor World, Versailles
Book redesign by Carole Desnoes
Production manager: Devon Zahn

Library of Congress Cataloging-in-Publication Data
Sammon, Rick
[Exploring the Light]
Rick Sammon's exploring the light : getting the very best in-camera exposures. — 1st. ed.
p. cm.
Includes index
ISBN 978-0-393-33123-3 (pbk.)
1. Photography—Exposure. 2. Photography—Lighting. I. Title. II. Title: Exploring the Light.
TR591.S32 2008
778.7—dc22
2007035461

W. W. Norton & Company, Inc., 500 Fifth Avenue, New York, NY 10110
www.wwnorton.com

W. W. Norton & Company Ltd., Castle House, 75/76 Wells Street, London W1T 3QT

1 2 3 4 5 6 7 8 9 0

Dedicated to the researchers at the Macular Degeneration
Foundation (www.eyesight.org)

For striving to find a cure for the leading cause of
blindness in adults.

A portion of the proceeds from the sale of this book
will be donated to this worthwhile foundation.

Normal Vision

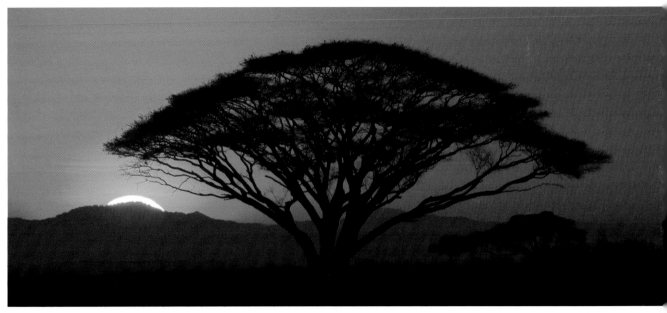

Macular Degeneration Vision

Contents

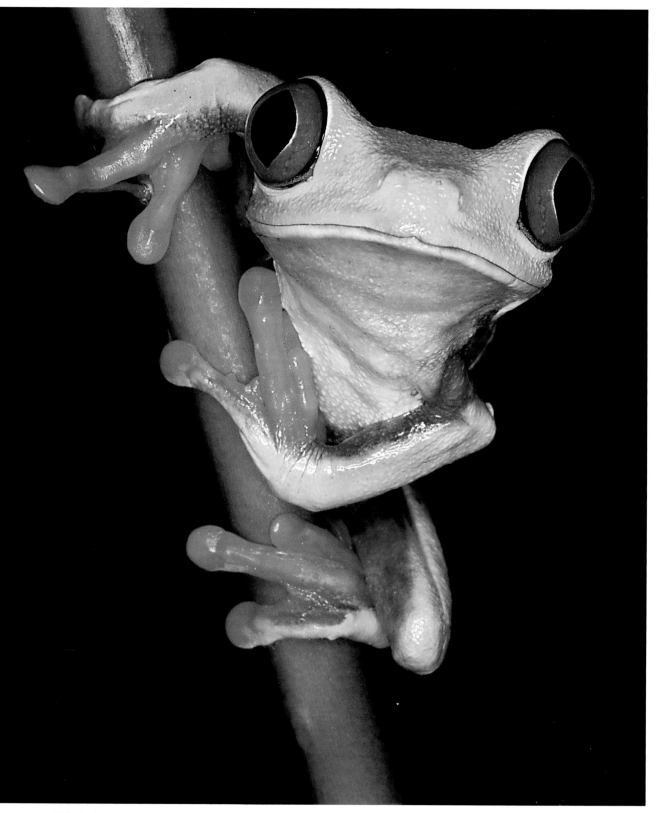

TECH INFO: Canon EOS 5D, Canon 100mm macro lens, Canon Ring Lite MR-14EX, ISO 100, 1/60th sec. @ f/22

Seeing vs. Looking

My goal in writing this book is simple. After reading all the pages,
I hope you identify with this adage:

I have eyes to see now what I have never seen before.

If you do, I will have reached that goal—and you will begin to see your
world with new eyes, rather than simply *looking* at it.

Subsequently, you will picture your world differently, uniquely, and more
creatively, recording the images you see in your mind's eye with your
camera.

Like this little red-eye tree frog, you'll always be aware of what's around
you—eyes wide open so you don't miss a thing.

Exploring the Light

Prologue

The Well-Balanced Photographer

My guess is that you are reading this book because you want to make the best possible in-camera pictures. From a technical standpoint, half of that process is getting a good exposure, the main focus of this book. The other half is good composition—deciding what to include and what not to include, how to arrange different elements in a scene. Before we launch into a discussion of exposure, let's briefly discuss the role of composition in creating well-balanced photography.

To illustrate different composition techniques, I'll use some pictures that I took on a four-day exploration of Yosemite National Park and relatively nearby areas: Mono Lake, Bodie State Historic Park, Ancient Bristlecone Pine Forest, and the Alabama Hills Recreation Area, all of which are in southern California.

The color pictures were taken with my Canon EOS 5D camera and a Canon 24–105mm IS lens, usually set at a wide-angle setting and small f-stop for good depth of field. The infrared pictures were taken with a Canon SD 800 compact camera that I had converted to an infrared-only (IR) camera by the company Life Pixel (www.lifepixel.com). For the IR pictures, I used the wide-angle setting, for the most part, again for good depth of field.

I offer this technical information on exposure, because for the rest of this prologue, I'll only talk about composition. You'll find information about exposure, shutter speed, and f-stop for many different flash and natural lighting situations—indoors and out—later in this book, in most of the lessons.

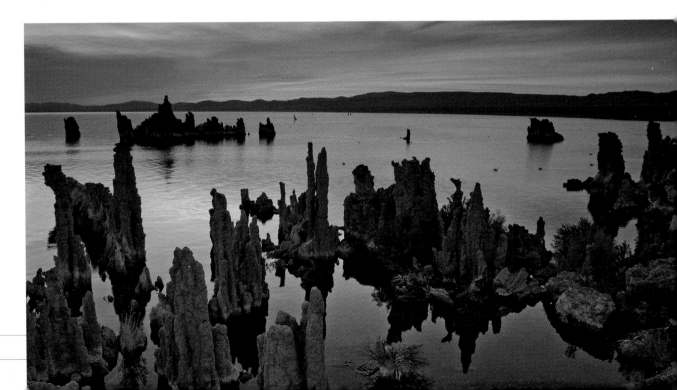

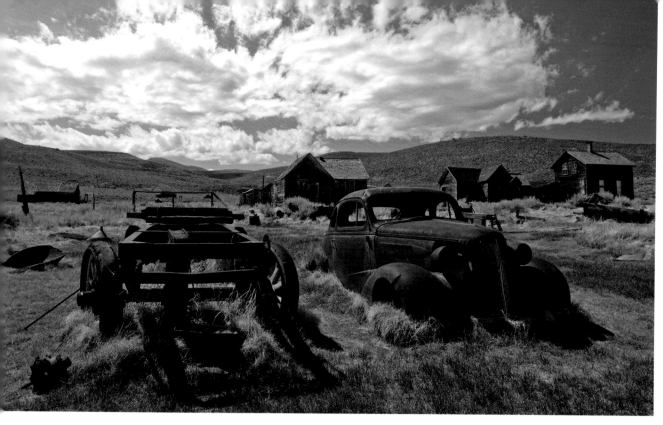

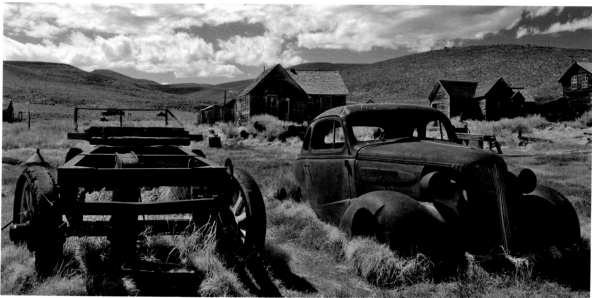

Fill the Frame

I photographed this scene at Bodie State Historical Park. As you can probably tell, both images are from the same file. The image on the bottom is simply cropped tighter than the image on the top. By filling the frames with interesting subjects, in this case the vehicles and clouds, we can reduce dead space and increase the photograph's impact. I include both photos as examples of how to fill a frame differently using the same image.

The opening picture in this prologue, taken at sunrise at South Tufa, Mono Lake, also illustrates the technique of filling the frame.

Get Closer

Many novice photographers don't move in or zoom in close enough to the main subject. Compare these two pictures. By simply moving a few feet closer to the foreground truck, the picture at bottom becomes more dramatic and has a greater sense of depth.

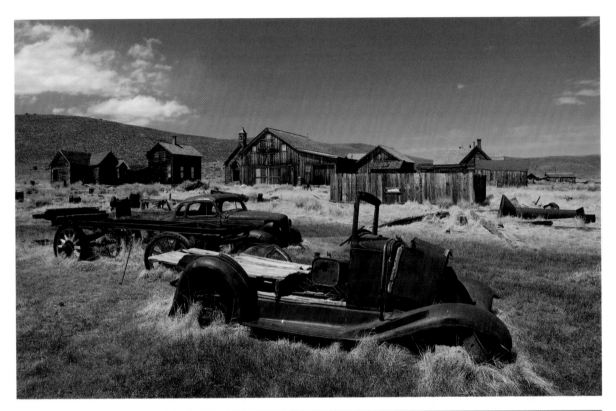

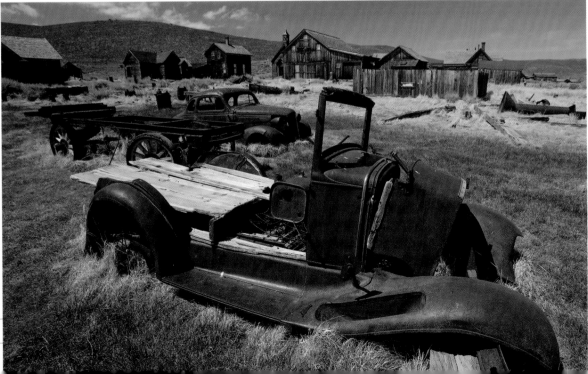

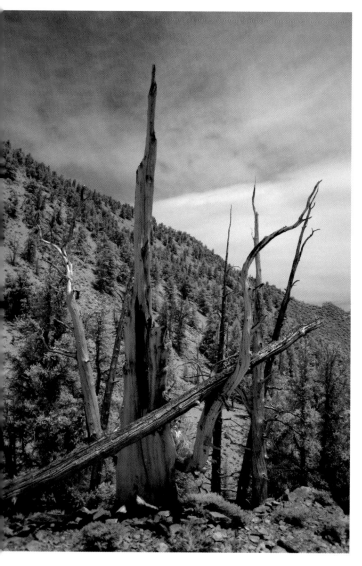

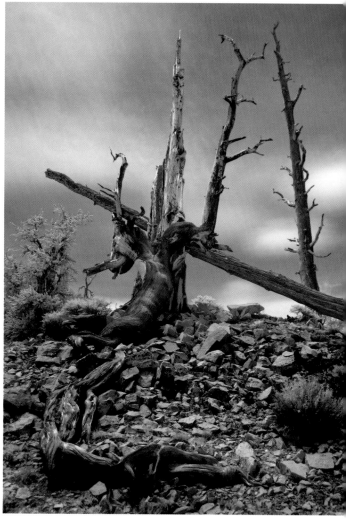

Go for a Walk

This picture, taken in Ancient Bristlecone Pine Forest, might be the most boring picture in the book! I include it in order to illustrate an important yet simple technique for finding the best composition to capture a scene: When you see a potential subject, take your time, walk around it, and envision different photographs.

Here we see the same tree, photographed from the opposite side, from a lower angle, and with some of the foreground included in the scene. It hardly looks like the same tree.

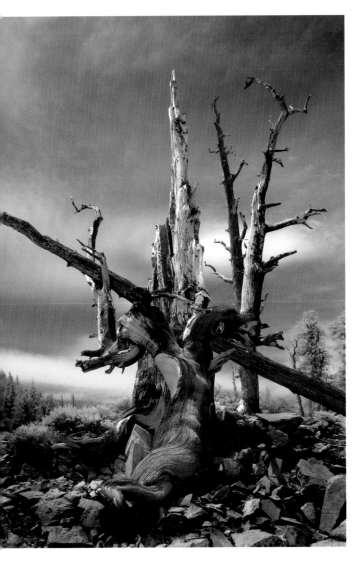

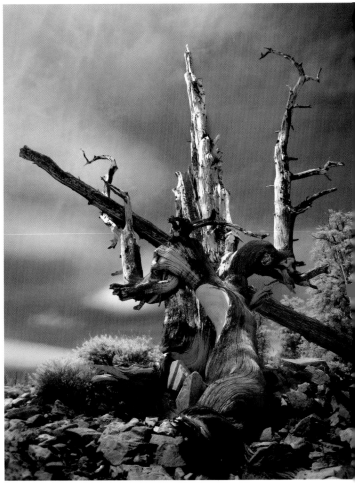

Look what happened when I got closer to the subject. I am not saying that this photograph's composition is better than the previous one. It's just different.

Getting even closer and lower produces yet another view of a subject that looked boring from the opposite side. Also, the light happened to poke through the clouds a bit more brightly during the time it took me to reach this perspective.

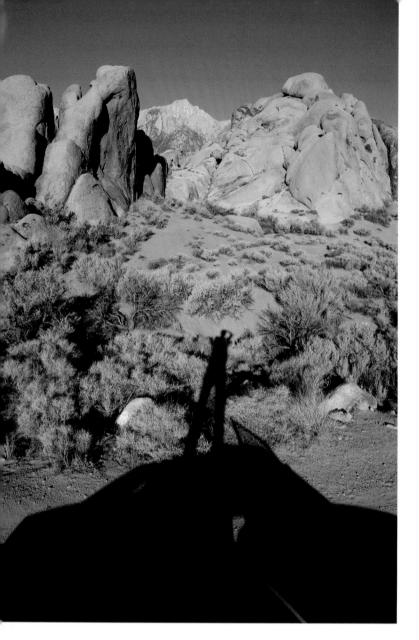

Look for Unusual Viewpoints

Famed landscape photographer Ansel Adams, who photographed in many of the areas pictured here, had a special photography platform built on top of his station wagon. From that vantage point, he found he could eliminate distracting foreground elements.

While photographing in the Alabama Hills Recreation Area, I stood on the roof of my rental car (after taking off my shoes), for a different viewpoint—thinking about what Ansel Adams might do in the same situation.

When composing a picture, don't settle for shooting at eye level. Shooting from a higher or lower position can produce images with more interesting composition. The horizontal image above was taken from my car-top vantage point at the same location.

Think Horizontal, Vertical, or Square

The most basic composition choice is whether to photograph a subject with the camera held horizontally or vertically. We also have cropping choices in Photoshop, including cropping to the square format pictured below. Try not to get locked into the 8 x 10 or 5 x 7 formats. Crop creatively and your photographs will have more impact.

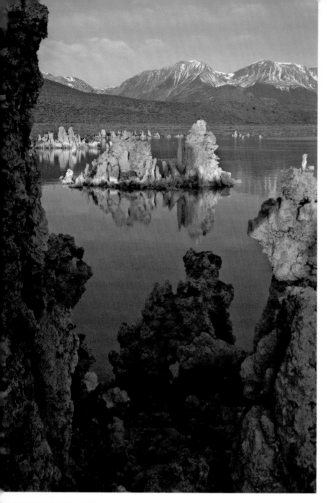

Foreground Elements Add a Sense of Depth

Previously, I mentioned the benefit of eliminating foreground elements; they can sometimes be a distraction. If, however, we have an interesting foreground element, and compose the scene carefully, the foreground can add a sense of depth. Foreground elements give the viewer a reference point from which to contemplate the wider scene.

At South Tufa, I framed some of the brightly illuminated formations with shaded tufas (calcium carbonate deposits) on the left, right, and bottom of the frame.

Including the Foreground Is Up to You

These are the same tufas as pictured above. Here I zoomed in on the subject and chose not to use a foreground element. I like this image, too, even though there is no foreground to add a sense of depth to the scene. Photography is very subjective, and the different elements of photography, including composition, are subjective too. So choose the composition technique that you like the best. Don't follow any so-called rule just because someone else said so!

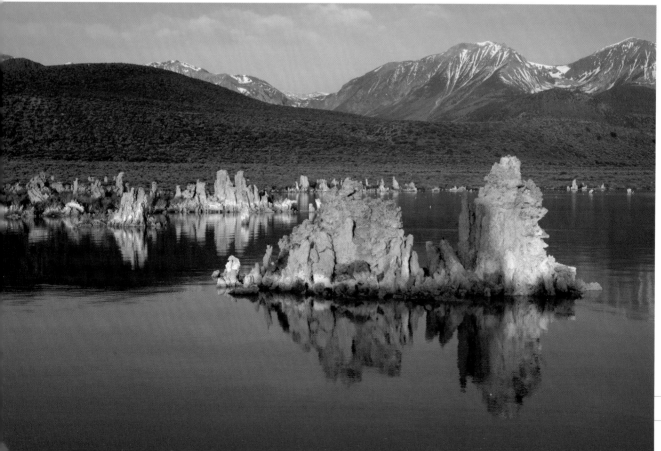

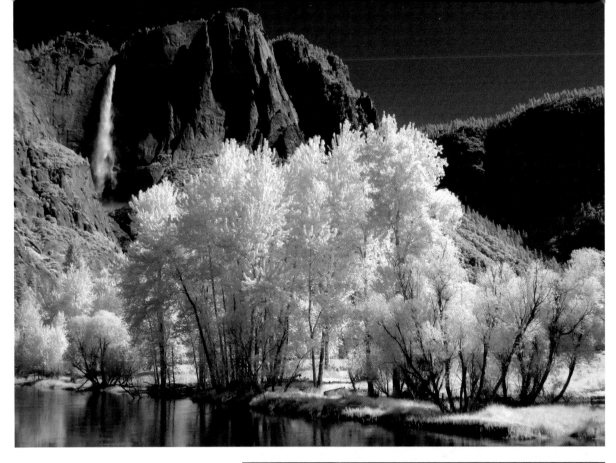

See It All

Sometimes we are overwhelmed by beauty. When I saw this scene in Yosemite, my first impulse was to capture the image horizontally with my IR camera. Then, after taking my time and looking at all the elements in the scene, I realized that the reflections of the trees in the calm water added beauty to the setting. In the horizontal image, those reflections were cut out.

In both shots the waterfall in the background is off center. When composing a picture, keep this in mind: Dead Center is Deadly. By positioning an element off center, you draw the viewer into the scene as he or she visually searches the picture for other interesting subjects.

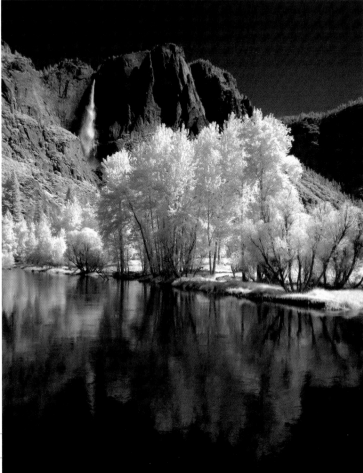

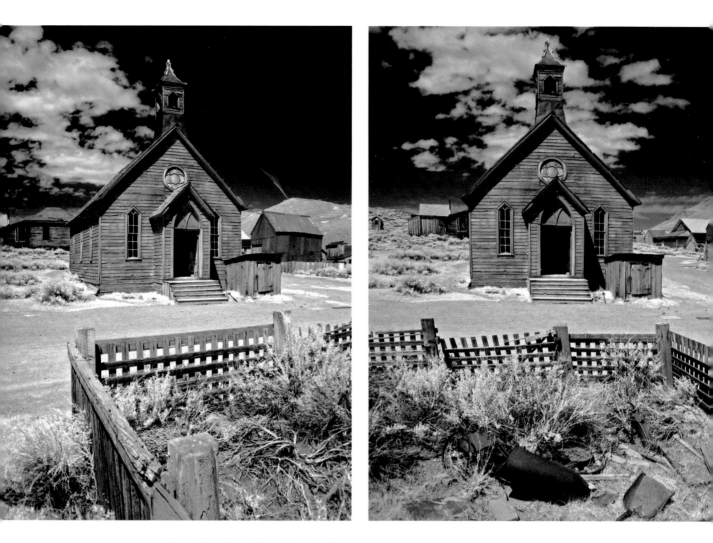

Consider Your Shooting Angle

Photographing a subject at an angle usually results in a more interesting shot with a greater sense of depth. Compare these two pictures taken at Bodie. Personally, I like the straight-on view better than the side view. However, because I was having such a great time in the ghost town, I did not know which view I'd like better. My advice: shoot a scene both ways and decide later which is better.

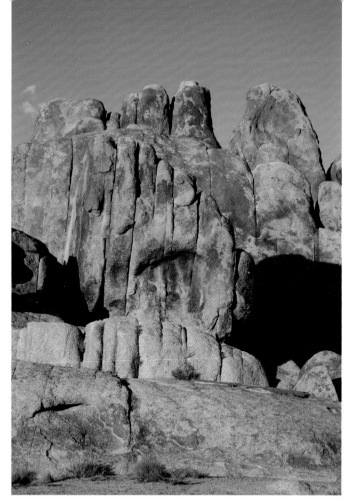

Be Aware of the Background

The background can make or break a picture.

I used to tell my workshop students that the background is almost as important as the main subject. Now, I stress that both are equally important.

Check out these two pictures of the same subject. In the first one, the rock formation that looks like a foot is lost in the background. By moving a few feet to the side, and therefore choosing a different background, we can easily see the "toes."

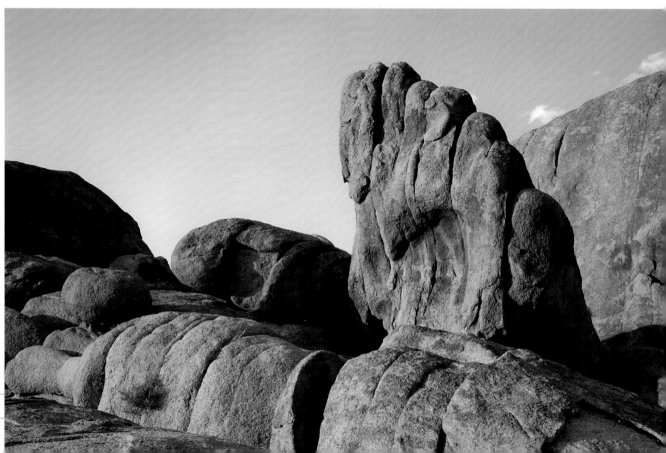

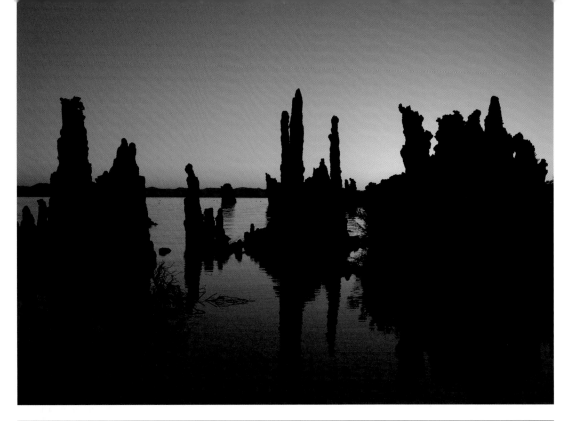

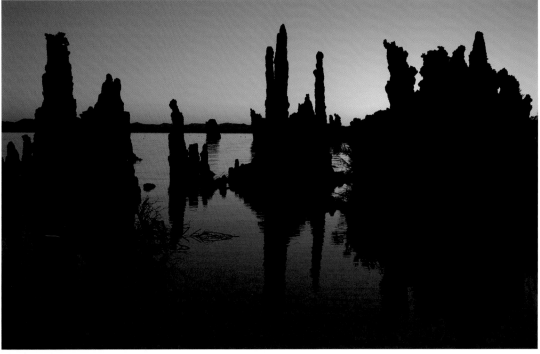

Watch the Horizon Line

In landscape photography, placing the horizon line dead center in the frame is sometimes not the best idea—it cuts the scene in half. Compare these two images. They are from the same photo, an image with some dead space at the top of the frame. The image with the horizon line nearer the top of the frame shows the effect of creative cropping in Photoshop.

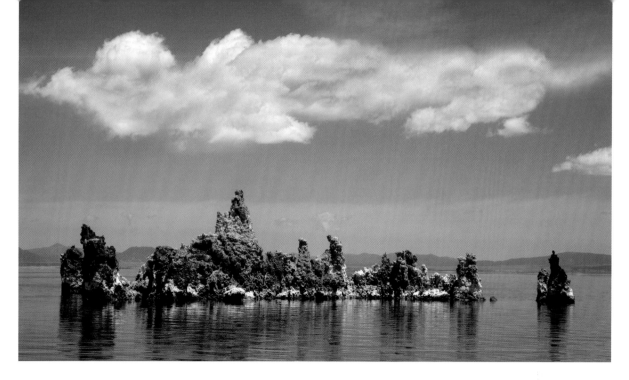

High or Low Horizon Line Placement

Here you see the effect of placing the horizon line at the bottom of the frame, a good idea when you have an interesting sky. Compare this with the opening image for this prologue. Notice the effect of placing the horizon line near the top of the frame, which helps highlight an interesting foreground.

Think about Your End Use

In considering the placement of the horizon line, think about the possible end results. Here you see one result of loose cropping and a centered horizon line. Remember this about centered horizon lines: all rules are meant to be broken!

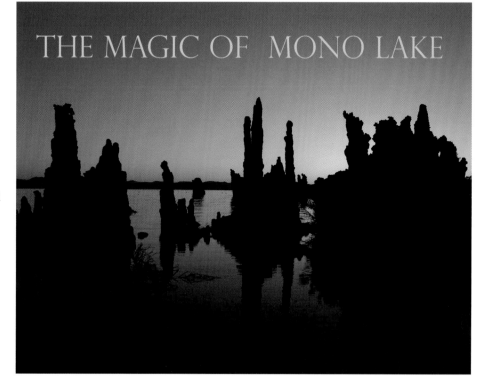

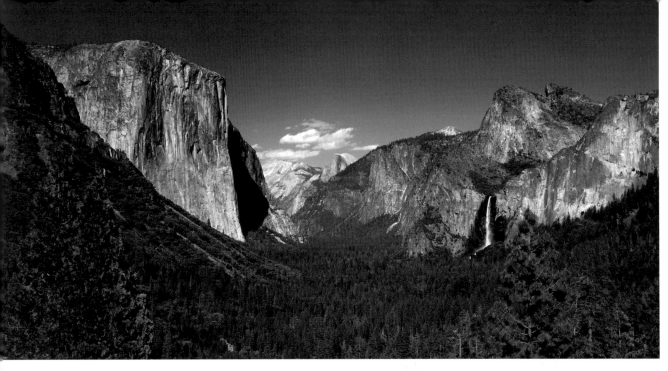

Get Inspired and Have Fun

In thinking about how to get the best possible picture, here are two more things to consider.

One, get inspired by going to a photogenic location, such as Yosemite, as I did for this horizontal image of El Capitan, Half Dome, and Bridal Veil Falls.

Two, don't get so caught up with the technical aspects of photography that you forget to have fun. Me? I am usually looking for fun. That was the case when I photographed this landscape and cloud formation in Yosemite. Do you see a familiar-looking animal form in the image?

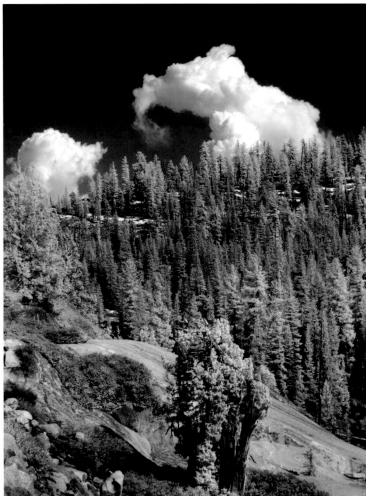

Introduction

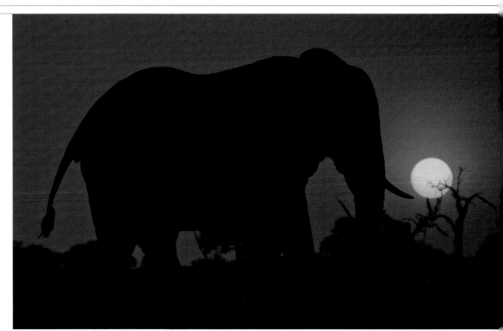

"It is with the heart that one sees rightly; what is essential is invisible to the eye."

—Antoine de Saint-Exupery,
The Little Prince

TECH INFO: Canon EOS 1D Mark II, Canon 100–400mm lens @ 400mm, ISO 400, 1/125th sec. @ f/11

TECH INFO: Canon EOS 1Ds Mark II, Canon 16–35mm lens @ 16mm, ISO 200, 1/250th sec. @ f/8

Check out these photographs: an elephant silhouetted against a brilliant setting sun, and a lone tree also silhouetted at sunset. They are two of my favorite digital exposures, made during a photo safari to Botswana in 2005.

Emotionally, the images capture the wonderful feeling of being alone with nature on the sweltering plains of Africa. I composed the pictures in my mind, then set the exposure and chose the appropriate lens to capture each scene.

My camera recorded the combination of shadow and highlight areas as I envisioned them, because I made the right exposure decisions, and then tweaked my images in Adobe Photoshop.

15

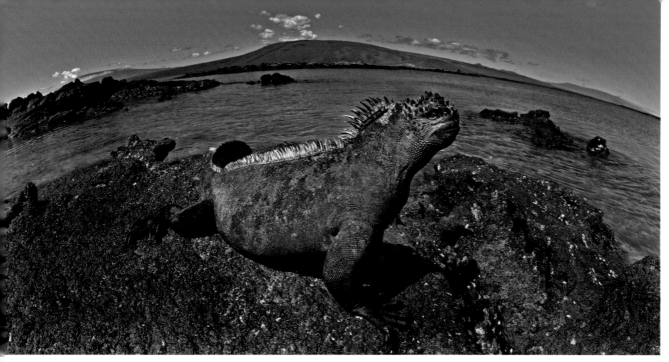

TECH INFO: Canon EOS 1Ds Mark II, Canon 15mm lens, ISO 200, 1/125th sec. @ f/11

Four basic considerations went into taking the photographs on the previous pages. The first three: exposure setting, lens selection, and composition. The fourth? One of the most important elements of any photograph: the idea behind the image that we want to capture with our cameras. I'll discuss each of these four elements on the following pages—with the goal of helping you take better pictures.

It's important to keep the idea of a good picture first and foremost in your mind. Sure, I'd like you to get as much technical information on exposure as possible from this book. But it's the idea *behind* a photograph that really makes it special. Here is an example that illustrates that point.

While on a trip to the Galapagos Islands, I had the idea of taking a unique photograph of a marine iguana, animals that are only found in the Galapagos. My idea was to use a fisheye lens to show an iguana in its habitat. Out of the dozens of pictures I took, this is my favorite.

Without this idea, I might have achieved perfect exposure and ended up with the same kind of picture that thousands of other photographers have taken: a telephoto view of only the animal. Keep in mind that it's important to put on your thinking cap when you are out there photographing.

TECH INFO: Canon EOS 1Ds Mark II, Canon 16–35mm lens @ 16mm, ISO 100, 1/125th sec. @ f/11

On the following pages you'll also get ideas for taking and making photographs, two processes that are quite different from each other. By reading the text and the tech info that accompany many of the photographs, you'll learn about seeing and controlling light, lens choice, shooting techniques, flashes and flash accessories, camera controls, and Photoshop. You may also get some ideas on where to travel for good photo opportunities, such as Arches National Park in Utah.

You might wonder why I am writing a book on exposure when many exposure problems can be fixed in Adobe Photoshop, Adobe Camera RAW, and Adobe Photoshop Lightroom—the image-editing programs I swear by.

The answer is simple: The more we know about getting the best possible exposure, the less time we have to spend in the digital darkroom rescuing our pictures, and therefore the more time we have to take pictures. What's more, with a solid understanding of what it takes to get a good exposure, we'll get a higher percentage of keepers and fewer outtakes.

Sure, Photoshop is a wonderful and powerful tool. I use it daily. But the real fun is *taking* pictures. My guess is that you feel the same way.

You will see some mention of Photoshop here and there in this book, and Lesson 14, "Adobe Photoshop CS3 Changes the Exposure Rules," and Lesson 15, "From Snapshot to Art Shot in Photoshop," are devoted entirely to Photoshop enhancements.

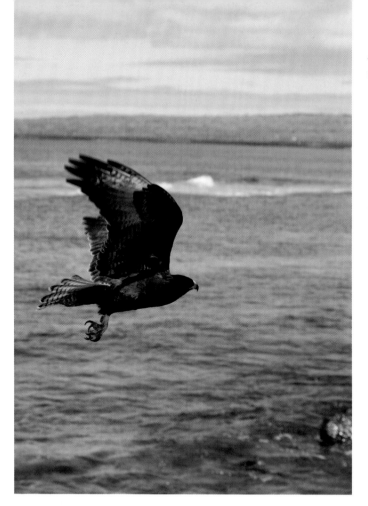

TECH INFO: Canon EOS 1D Mark II, Canon 100–400mm lens @ 400mm, ISO 400, 1/125th sec. @ f/11

Here are two examples of the power of Photoshop, and how the program can be used to enhance an image—even an image that is properly exposed.

Take a look at these before-and-after pictures. The enhancements on the Galapagos hawk picture include cropping, increasing the contrast, boosting the red and yellow tones, dodging the hawk's face, and selectively blurring the wings.

The enhancements for the Antarctica image on the opposite page include cropping, darkening, and increasing the blue tones.

I share these examples with you at the beginning of this book because Photoshop is an important part of a serious photographer's life, and it's important to keep in mind when looking through our viewfinders the result that can be achieved later in Photoshop.

That said, please don't skip ahead to those later lessons to see how you can enhance your pictures and fix your mistakes. The real meat of this book is served way before that dessert. It's important to digest that information before you get to the cake.

Speaking of the information in this book, I'd like to share an interesting experience with you. When I first had the idea for a

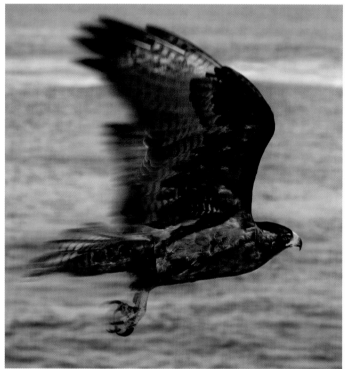

TECH INFO: Canon EOS 1D Mark II, Canon 70–200mm IS lens @ 200mm, ISO 100, 1/125th sec. @ f/8

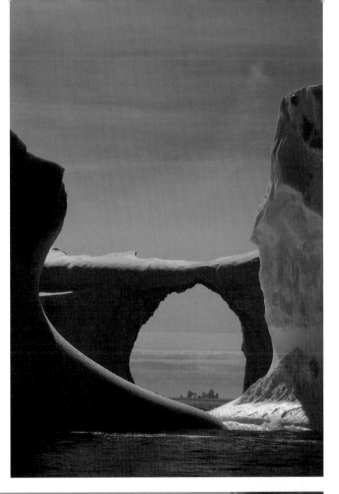

book on exposure, I asked myself if such a book was really necessary. After thinking further about the project, I came to an important realization: for serious photographers like you, with a good eye for composition and creative ideas, getting the best image is mainly about exposure. During a quarter-century of taking pictures around the world, teaching workshops, and writing books and magazine articles, I never really visualized the process in that way—breaking down exposure factors into their individual components, with the goal of getting the desired exposure. I've talked and written about getting a good exposure before, but I have never gone into an explanation as detailed as you'll find in this book.

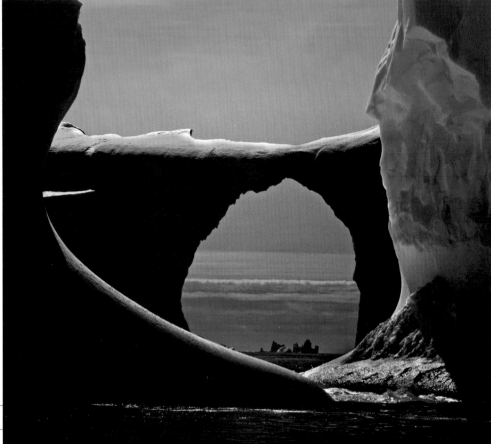

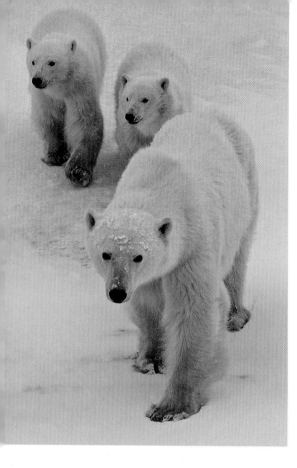

TECH INFO: Canon EOS 1Ds Mark II, Canon 400mm DO IS lens with 1.4X tele converter, ISO 200, 1/500th sec. @ f/8

Before you begin your exploration of exposure, I'd like to remind you that some of your favorite photographs will derive their value from your excitement as the photographer. I took this picture of a mother polar bear and her cubs in the subarctic, in Churchill, Canada, to be exact, in subfreezing conditions! It was –35° F when I snapped the shutter. Like the earlier photographs of Africa, the photo's quality is the result of an idea combined with good composition and, of course, a good exposure. While the picture is less dramatic, color-wise, than my elephant and tree at sunset, it still captures the magical feeling of the moment, bringing back memories of freezing fingers and toes.

The photograph of the iceberg, taken in Antarctica, also captures a magical feeling—one of being at the bottom of the world, hundreds of miles from civilization. It illustrates a technical point, too: You don't necessarily need dramatic color or strong highlight and shadow areas to come up with a pleasing picture.

I mention emotion and memories for a good reason. Yes, exposure is very important. But don't get so caught up in the technical aspects of picture taking that you forget why you took up this hobby in the first place. Have fun! I'll remind you of this throughout the book.

TECH INFO: Canon EOS 1Ds Mark II, Canon 17–40mm lens @ 17mm, ISO 400, 1/125th sec. @ f/8

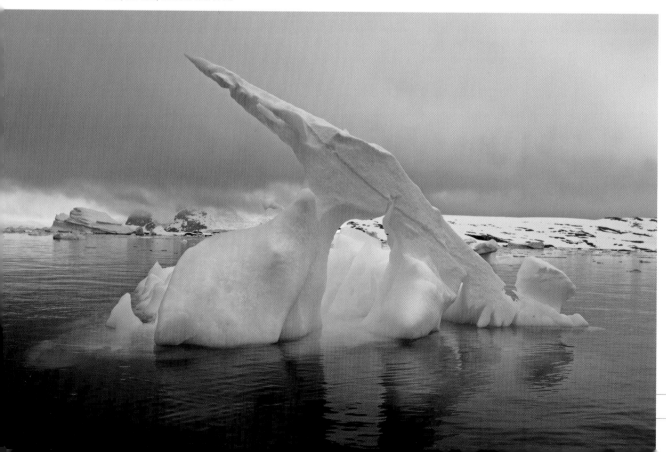

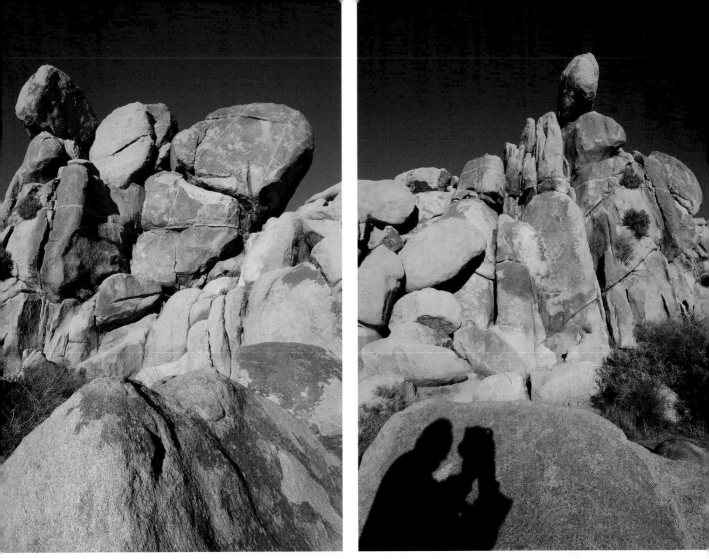

TECH INFO: Canon EOS 1Ds Mark II, Canon 17–40mm lens @ 17mm, ISO 100, 1/125th sec. @ f/11

Check out these two images taken in Joshua Tree National Park in California. One is a straight shot and one is a fun shot. That's my shadow in the foreground. The shadow, which shows me holding my camera, brings back the fun memory of being on location in the late afternoon. This is my favorite of the two, because it has more life.

Some of your most memorable shots will begin with good fortune. For instance, I spotted this rainbow in the rearview mirror of my car while I was driving down a road near Arches National Park in Utah.

TECH INFO: Canon EOS 1Ds Mark II, Canon 17–40mm lens @ 17mm, ISO 400, 1/125th sec. @ f/11

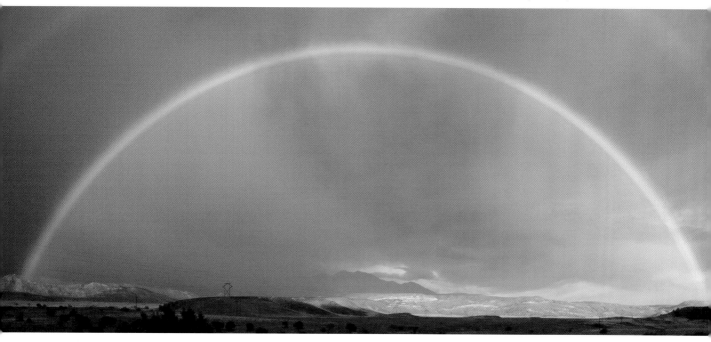

So keep your eyes out for lucky shots, have your gear ready, apply the techniques covered in the following pages, and keep this saying in mind: The harder you work, the luckier you become. I hope you enjoy the learning process. I certainly still do—every time I go out and shoot.

I wish you good luck with your photography—and your exposures.

—Rick Sammon
December 2007

Exposure by Definition

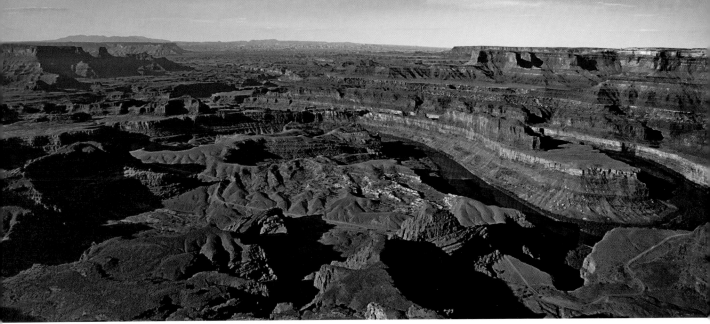

TECH INFO: Canon EOS 1Ds Mark II, Canon 16–35mm lens @ 16mm, ISO 100, 1/125th sec. @ f/11

Dead Horse Point State Park in Utah offers many photo/exposure opportunities, especially at sunrise and sunset, when long shadows can add a sense of depth to a two-dimensional picture.

Now, you may be asking, "Why did Rick use the term 'photo/exposure' rather than simply 'photo'?" Well, that's easy. The terms can be used interchangeably, because technically speaking, a photograph is the result of exposing the digital image sensor in your camera to light. It's that simple. Or is it?

Yes, an exposure is the process of light being recorded. No light, no photo/exposure. But how you record and control that light, how you process it in the digital darkroom, and then how you print the image, all have a lot to do with the final result. What's more, different cameras record light differently, topics we'll explore in Lesson 4, "Digital SRL Camera Basics." In addition, different RAW processing programs manipulate RAW data differently, with slightly different results.

RAW data, or RAW files, are unprocessed files—just as film negatives are unprocessed analog images. You get the best possible image from a RAW file, because it maintains all the original data that was captured in-camera. JPEG files, on the other hand, are already

processed when they come out of your camera. The contrast, color, and sharpness have been enhanced. The problem with JPEG files is that those enhancements can be undesirable, and can cause a loss of detail in a scene, especially those with high contrast and bright highlights.

In addition, you can rescue, up to one f-stop in overexposed areas in RAW files. With JPEG files, if an area is overexposed and washed out, the detail is lost forever.

Two Factors

Let's take a quick look at the two prime exposure factors that, when combined, determine the amount of light falling on the camera's image sensor: shutter speed and f-stop. If that was all there was to it, this book would be much thinner. I have plenty more in store!

Shutter Speed Basics

Let's begin with shutter speed. The shutter opens to allow light through the lens to the digital image sensor, and "shutter speed" refers to the amount of time that the shutter remains open (or that the image sensor remains active). If you are new to photography, think of it this way: If you are in a room and open and close a window shade, you are basically doing the same thing a shutter does—letting light expose an area. The longer you leave the shade up, the longer the room is illuminated. Knowing

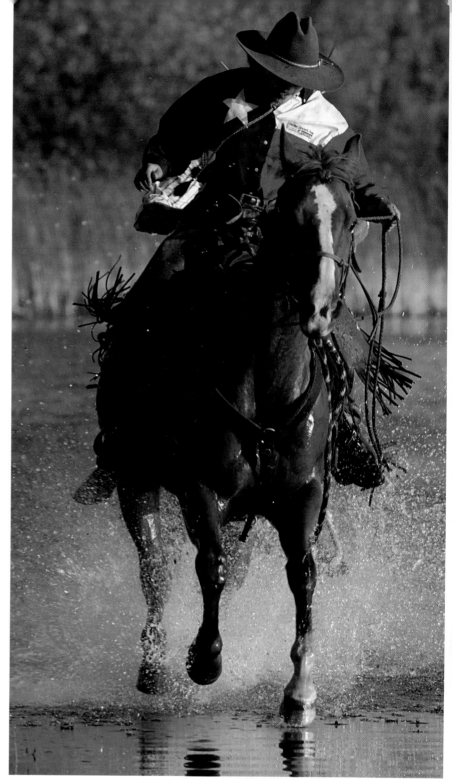

TECH INFO: Canon EOS 1D Mark II, Canon 100–400 IS lens @ 400mm, ISO 400, 1/500th sec. @ f/5.6

which speed to choose is the key to getting a desired effect. Sometimes it's an educated guess. Sometimes it's just plain luck. But most of the time it should be the result of knowing how different shutter speeds affect the recording of a subject's movement.

Fast shutter speeds freeze action, as the 1/500th second shutter speed did when I photographed a horse and rider at the Double JJ Ranch in Rothbury, Michigan, pictured on the previous page. The faster the shutter speed, the better chance you have of freezing the action. But there's more. Telephoto lenses (above 100mm), exaggerate handheld camera shake, just as binoculars exaggerate hand movement. So you need a fast shutter speed to freeze your hand movement too—if you are not using a tripod or other camera support, or an image stabilization (IS) lens, which helps reduce camera shake.

Slow shutter speeds blur action, as the 1/15th second shutter speed did when I photographed the horse and rider below, also at the Double JJ. Slow shutter speeds are often used to convey a sense of motion or speed. And as you'll see in other examples in this book, slow shutter speeds can also add a dreamy and creative effect. Slow the shutter speed too much, and the result can be just blurry. That said, here's a photography joke: One blurry picture is a mistake. Twenty blurry pictures is a style.

TECH INFO: Canon EOS 1D Mark II, Canon 100-400 IS lens @ 400mm, ISO 400, 1/15th sec. @ f/5.6

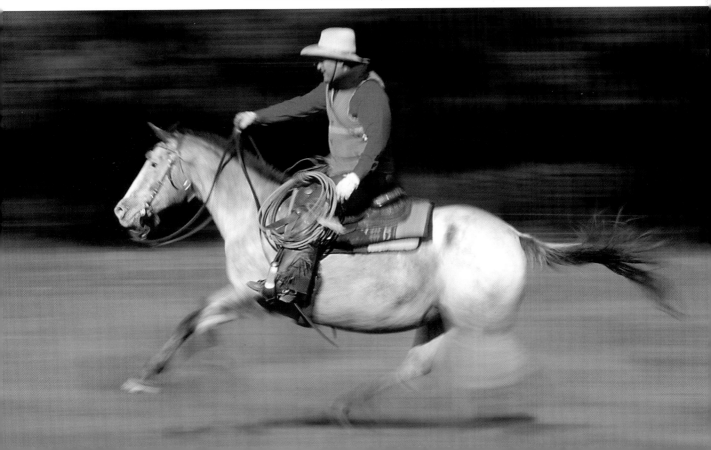

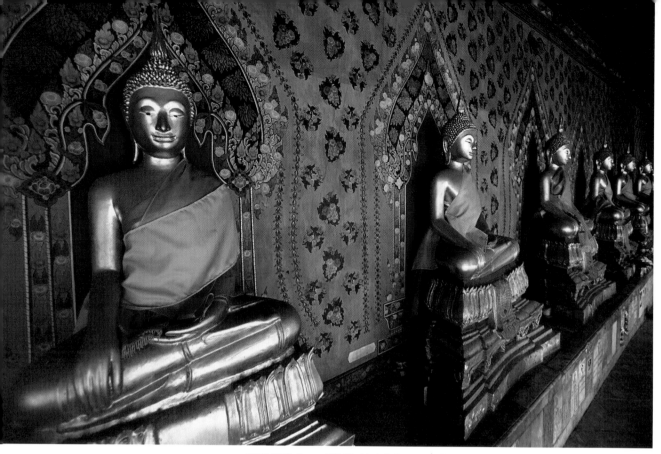

TECH INFO: Canon EOS 1Ds Mark II, Canon 16–35mm lens @ 16mm, ISO 400, 1/125th sec. @ f/16

Understanding F-Stops

The f-stop (or aperture or lens opening) you choose is important. Large f-stops (small numbers like f/2.8 and f/3.5) let more light into a camera and onto the image sensor than small f-stops (large numbers like f/16 and f/22). To use the room analogy again, fully opening a window shade lets in a large amount of light; a small window shade opening lets in less light.

Small f-stops offer more depth of field—more of the scene behind and in front of the actual focus point is in focus. When getting an entire scene in focus is important, as it was when I was photographing these Buddha statues at the Temple of the Moon in Bangkok, Thailand, choosing a small f-stop is the way to go.

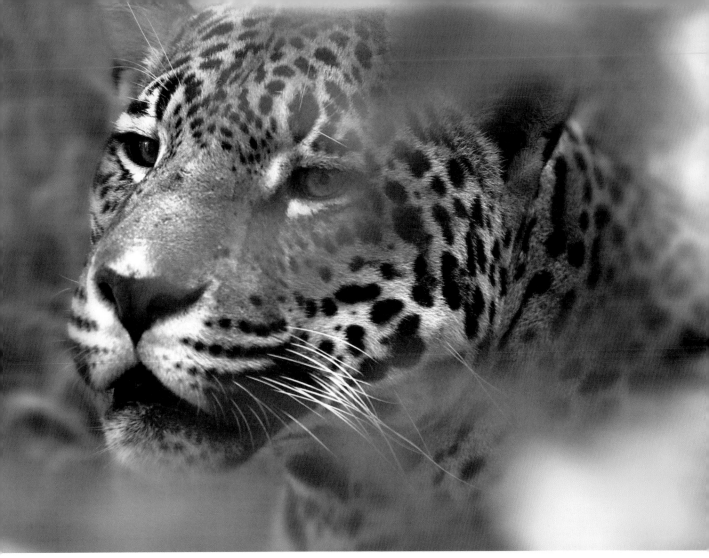

TECH INFO: Canon EOS 1Ds Mark II, Canon 70–200mm IS lens @ 200mm, ISO 800, 1/250th sec. @ f/4.5

Wide f-stops, which offer less depth of field than small f-stops, are ideal when you want to selectively blur foreground and background elements, as I did when photographing this jaguar at the Fort Worth Zoo in Texas. The animal is very sharp, and the surrounding leaves are quite blurred.

Find the Right Focal Length

The focal length of the lens also affects the depth of field. Check out these two pictures. They were taken using two different lenses, both set at f/8. The depth of field around the musician is quite narrow, *and* the entire photograph of Buddhist monks is in focus. All with the same f-stop!

From the same shooting position, telephoto lenses have less depth of field than wide-angle lenses set at the same f-stop—and vice versa. So the lens you choose also affects the depth of field.

Here's the deal: by choosing the appropriate lens and by adjusting the shutter speed and f-stop, which

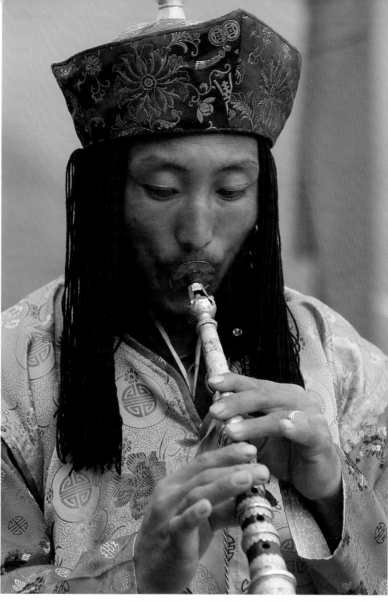

TECH INFO: Canon EOS 1Ds Mark II, Canon 70–200mm IS lens @ 200mm, ISO 400, 1/250th sec. @ f/8

we'll cover in detail in Lesson 6, "Creative Exposure Modes," Lesson 9, "Flash Exposures," and Lesson 11, "Control Natural Light," you can either blur or freeze the action and change the depth of field in the same lighting conditions.

Keep in mind that when using a digital single-lens reflex (SLR) camera, the f-stop at which you view a scene in the viewfinder can be and usually is different than the f-stop at which you view and take the picture. That's

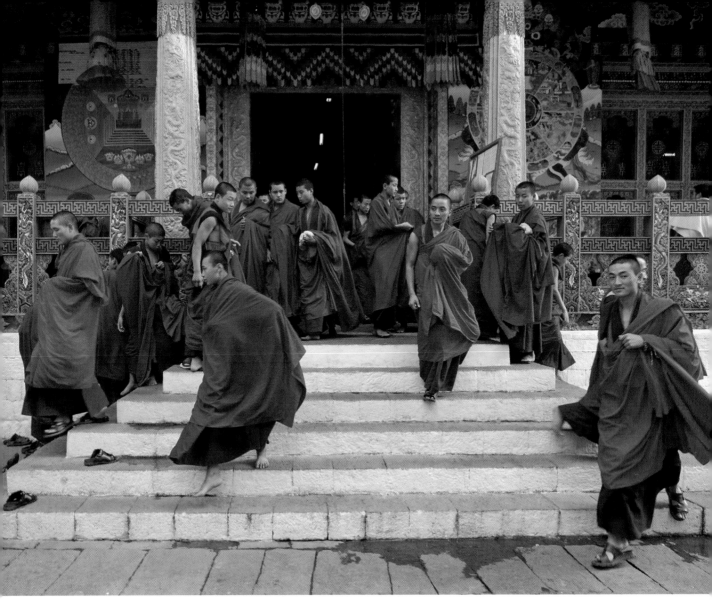

TECH INFO: Canon EOS 1Ds Mark II, Canon 17–40mm lens
@ 20mm, ISO 200, 1/125th sec. @ f/8

because one of the cool things about a digital SLR is that you look
through the viewfinder at the widest opening of the lens, which lets in
the maximum amount of light so you can easily see the scene. When
you press the shutter release button, the lens stops down to the
selected f-stop. Some cameras offer depth-of-field preview buttons,
which, when pressed, stop down the lens to the selected aperture to
show a preview of what's in focus and what's not.

Control Light Independently

There's more! When taking a flash exposure, you can control the light from the flash and the natural light independently, if you choose to do so. That's especially true when you set your camera to the manual exposure mode (see Lesson 6, "Creative Exposure Modes").

That's what I did in this pair of moth images photographed at Butterfly World in Coconut Creek, Florida, while working on my butterfly book, *Flying Flowers*.

TECH INFO: Canon EOS 1D Mark II, Canon 50mm macro lens, Canon Ring Lite MR-14EX, ISO 100, 1/60th sec. @ f/16

TECH INFO: Canon EOS 1D Mark II, Canon 50mm macro lens, Canon Ring Lite MR-14EX, ISO 100, 1/60th sec. @ f/5.6

TECH INFO: Canon EOS 1Ds Mark II, Canon
50mm macro Lens, Canon Ring Lite
MR-14EX, ISO 100, 1/60th sec. @ f/4.5

TECH INFO: Canon EOS 1Ds Mark II, Canon
28–105mm lens @ 50mm, ISO 200,
1/125th sec. @ f/4.5

Putting It All Together

Having an understanding of what shutter
speeds and f-stops can do opens up a
whole new world of creativity for
photographers. These two pictures show
part of the subject blurred, while other
parts remain sharp. Both images are
correctly exposed. Unless you get what
pros call a "dumb luck shot," you won't get
these creative results if you set your
camera on automatic and shoot away.
Knowing how to adjust the f-stop and
shutter speed made these photographs
possible.

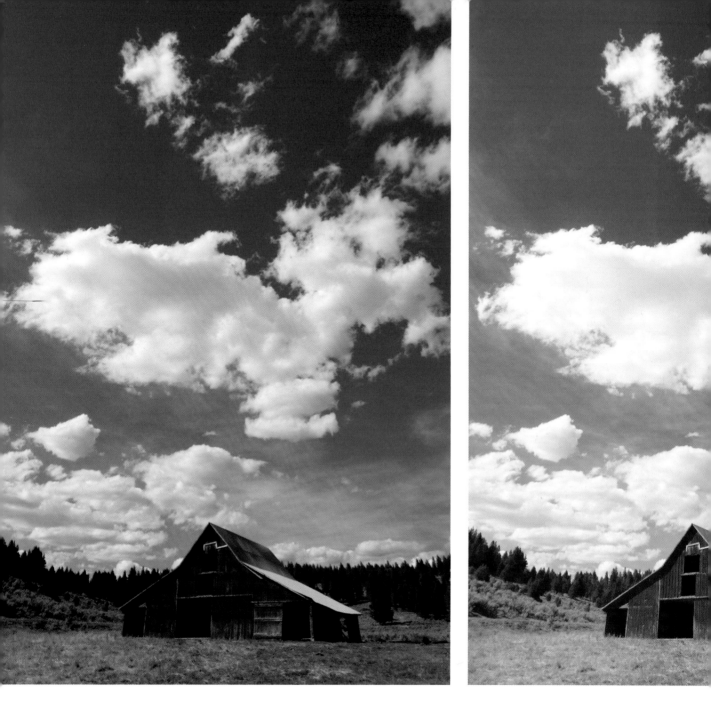

Bracketing

I'll end this lesson with a series of exposures of an old homestead in Oregon to illustrate a correct exposure, a one-stop overexposed picture (the lighter image), and a one-stop underexposed picture (the darker picture).

Getting a sequence of different exposures is called "bracketing." You take a picture at the correct exposure, and then take additional photos over and under that exposure. Bracketing ensures a good exposure in a tricky lighting situation. That said, if we learn how to see the light, which I cover in Lesson 3, "See the Light," and then make exposure settings accordingly, we'll have a good chance of getting a good exposure.

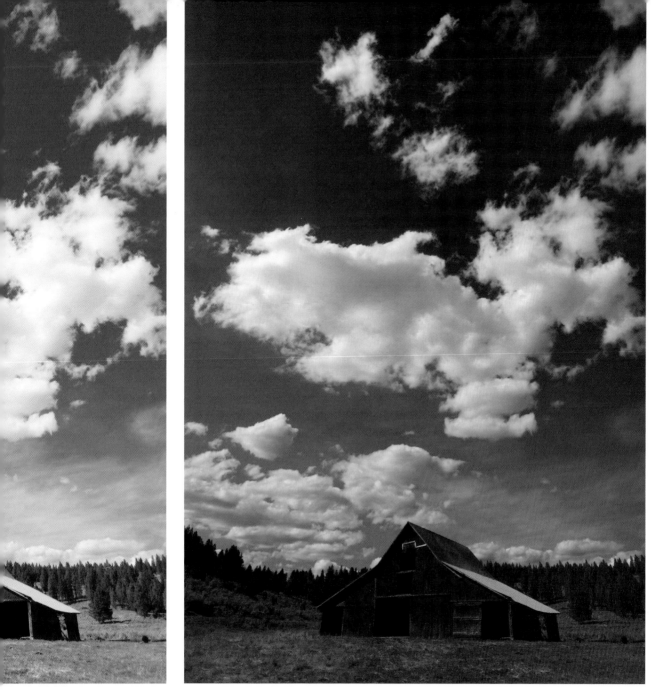

TECH INFO: Canon EOS 1D Mark II, Canon 100–400mm IS lens @ 320mm, ISO 640, 1/250th sec. @ f/5.6 (left); and then at f/4.5 (middle); and then at f/8 (right)

Most digital SLRs offer a feature called automatic exposure bracketing (AEB). Set your camera on AEB and on rapid frame advance, press the shutter release button, and in an instant you get three different exposures. Bracketing can also be accomplished in the Manual exposure mode.

Bracketing is covered in Lesson 6, "Creative Exposure Modes." I am giving you a peek at this technique now to show you its effect, and because it helps fine-tune exposures.

Now that we've taken a look at exposure basics, let's move on to the next lesson, where we'll explore "good" exposures.

LESSON 2

A Good Exposure Is Like a Slice of Pizza

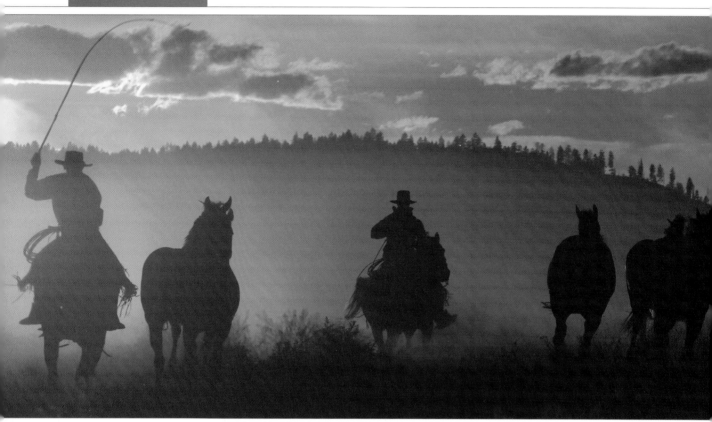

TECH INFO: Canon EOS 1D Mark II, Canon 100–400mm lens @ 400mm, ISO 400, 1/500th sec. @ f/8

As with all the lessons in this book, I'll lead off with one of my favorite pictures, this time an exposure I took at sunset of two cowboys rounding up a small herd of horses on the Ponderosa Ranch in Oregon. I think it's a good exposure. By silhouetting the subjects, I was able to create a dramatic picture that captures the feeling of the Old West. I created the silhouette by setting the camera's exposure compensation to –1 with my camera in the Shutter Priority mode. We'll go more into exposure compensation in Lesson 6, "Creative Exposure Modes."

Outtake

Here is a picture taken several minutes before the opening exposure. It's not really a good exposure for several reasons: too much dead space at the top and bottom of the frame, lens flare at the top left and bottom right of the frame (caused by direct light falling on the front element of the lens), too light at the top of the frame, too dark at the bottom of the frame, and finally, the image is out of focus. Plus the color is rather dull. Consider it an outtake. That's my critique of my own photograph! We should all critique our photographs with the goal of improving our images. However, just because we don't get a perfect in-camera exposure, there is still hope. Read on!

TECH INFO: Canon EOS 1D Mark II, Canon 100–400mm lens @ 400mm, ISO 400, 1/125th sec. @ f/5.6

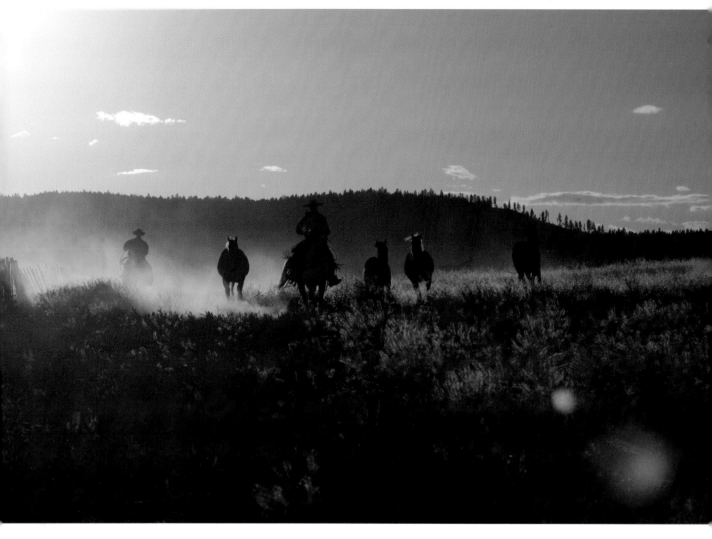

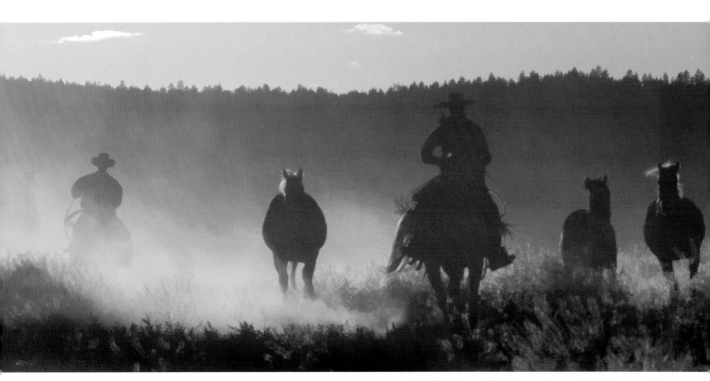

TECH INFO: Canon EOS 1D Mark II, Canon 100–400mm lens @ 400mm, ISO 400, 1/125th sec. @ f/5.6

From Outtake to Keeper

Here is a nicely exposed image. As you can see, it's from the same image file as the "outtake" on the previous page. With some cropping and an increase in saturation, accomplished in Photoshop in a minute or so, I was able to create a good exposure. I'll cover some Photoshop stuff in Lesson 13, "Change, Improve, and Rescue Exposures in Photoshop," but I'm showing you an example of the power of Photoshop now just to give you an idea of what you can do, and to encourage you not to be so quick in deleting bad exposures.

There is an old photography adage: "There is no such thing as a bad photograph," meaning that if someone likes a picture—even if it's out of focus, poorly composed, and over- or underexposed—it's a good photograph. I can see the logic in that. Photography is a personal thing—like pizza. Let me explain.

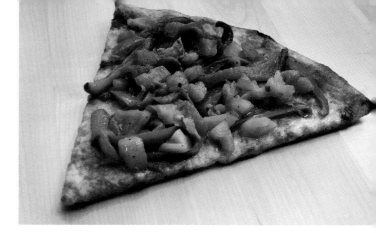

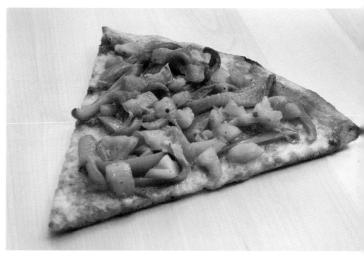

Exposure Preferences

We all have our favorite pizza place. Mine is
Cappricio, in Croton-on-Hudson, New York, where I
live. My bet is that if I came to your neighborhood,
you'd show me the place that makes the best pizza.
Our personal taste determines our favorite slice.

The same is true, for the most part, for exposures.
Some people prefer slightly darker pictures to lighter
ones, while some folks prefer slightly lighter pictures.
In this series of pictures of a Cappricio's slice, I like the
first shot, but some of you may prefer the darker or
lighter image.

While the shutter speed remained constant, the
lighter picture is the result of using a larger aperture
(more light reached the image sensor) and the darker
picture is the result of using a smaller aperture (less
light reached the image sensor).

You might argue that there is no such thing as a
bad exposure. However, that's not totally true. Just as
you can have a bad slice of pizza—one that has a crust too soft,
or too much garlic, or perhaps worst of all, a slice from which the
cheese falls off as soon as you pick it up—you can have a bad exposure.

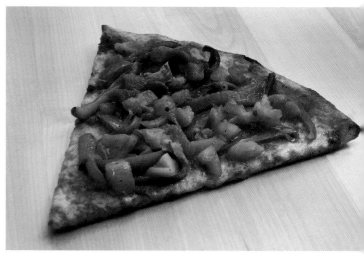

TECH INFO: Canon EOS 1D Mark II, Canon 50mm macro
lens, ISO 200, 1/125th sec. @ f/8 (camera-suggested
exposure in Manual mode); then f/5.6 (lighter
exposure); and then at @ f/11 (darkest exposure)

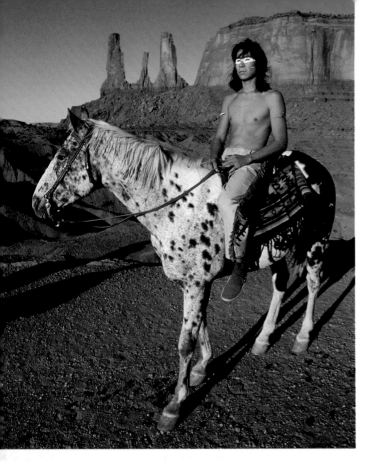

Normal, Darker, and Lighter Exposures

This series, taken in Monument Valley, Arizona, with my camera set on AEB, provides a more practical example of how different exposure settings affect a picture. I used the same increase and decrease in exposure as I did with the slice of pizza. I like the first image in the series. It was taken with the camera-suggested settings in the Manual mode. Which image do you prefer?

Let's take a look at a few more exposure examples. In the following lessons, I'll go into more detail about how you can easily avoid bad exposures. For now, I'll share a few quick tips, along with some keepers and some outtakes.

TECH INFO: Canon EOS A2E, Canon 28–105mm lens @ 35mm, ISO 200, 1/125th sec. @ f/8; then at f/5.6; and then at f/11

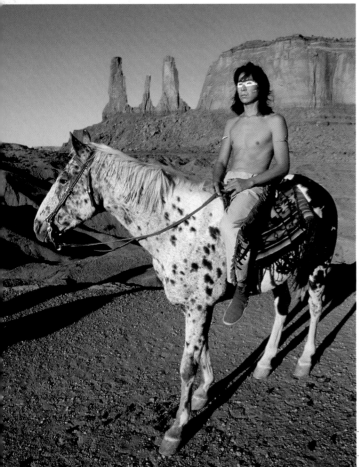

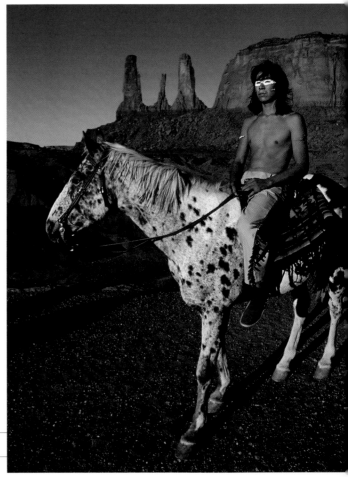

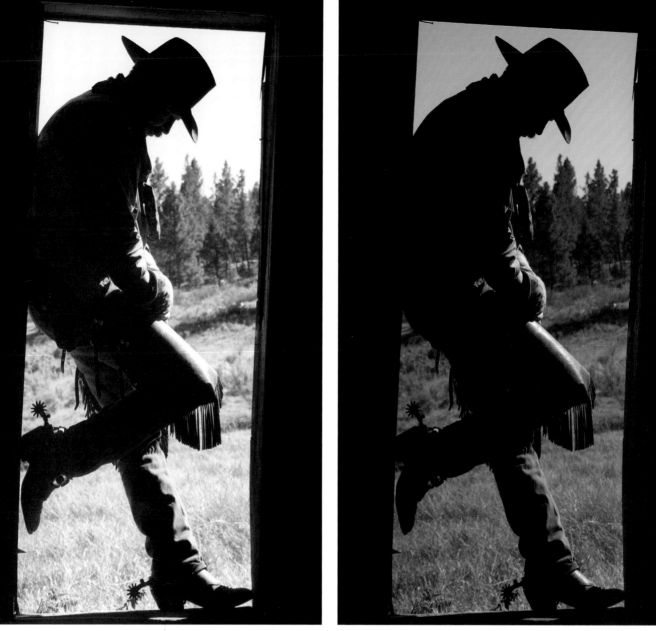

TECH INFO: Canon EOS 1D Mark II, Canon 28–105mm lens @ 35mm, ISO 400, 1/125th sec. @ f/5.6 (left); and then at f/8 (right)

Enter Exposure Compensation

In the bad exposure of the cowboy photographed at the Ponderosa Ranch (left), the background is overexposed. In the good exposure, the background is correctly exposed. I achieved a good exposure by setting my exposure compensation to –1 while shooting in the Aperture Priority mode.

Exposure compensation is like fine tuning a picture with the + and – buttons or dial on your camera. You increase the exposure, or add more light to make a picture brighter, with the + button. Decrease the exposure, or make the picture darker, with the – button.

Different cameras offer different exposure compensation settings. Low-end cameras offer exposure compensation in 1/2-stop increments. Higher-end cameras offer exposure compensation in 1/7-stop increments, giving you more control over the exposure.

TECH INFO: Canon EOS A2E, Canon 70–200mm lens @ 200mm, ISO 100, 1/125th sec. @ f/5.6

Exposure Exceptions

But hey! Check this out. The background in this photograph of model Karen Trella, taken at Lake Powell in Arizona, is overexposed. That's because I used the Spot metering mode in my camera and took a reading off the model. In this photograph, the bright background does not bother me because this effect is common in fashion, beauty, and glamour photography. So much for a "bad" exposure.

TECH INFO: Canon EOS 1Ds Mark II, Canon 17–35mm lens
@ 17mm, ISO 640, 1/125th sec. @ f/5.6

Two Good Exposures

And speaking of a bad exposure, look at these
photographs of my friend Andrea Laborde.
The first picture is "correctly" exposed. But so
is the darker picture, in my opinion. For the
darker picture, I darkened the exposure in
Photoshop and added the Midnight Sepia
filter in Color Efex Pro 2.0, a Photoshop plug-
in from Nik Software. I like both images.
Which is your favorite?

TECH INFO: Canon EOS 1Ds Mark II, Canon 16–35mm lens @ 16mm, ISO 200, 1/125th sec. @ f/11 (top); and then at f/5.6 (bottom)

Recompose for a Better Exposure

While driving on the highway in Big Sur, California, I stopped for several sunset shots. The too-dark photo is the result of two factors: the sun fooling the camera's light meter into thinking that the scene was brighter than it was, and my forgetting to reset my exposure compensation from –2, which I had used on a previous exposure. (Pros make mistakes, too!)

After moving my position and recomposing the picture so that the contrast range was not as great as in the previous scene, I got a much better image.

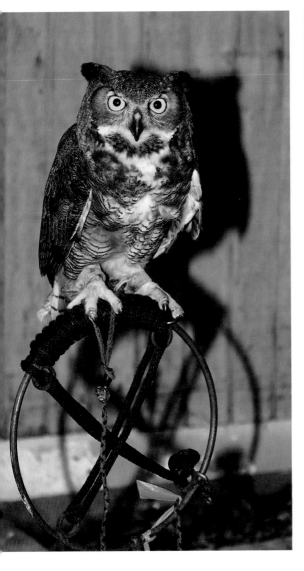

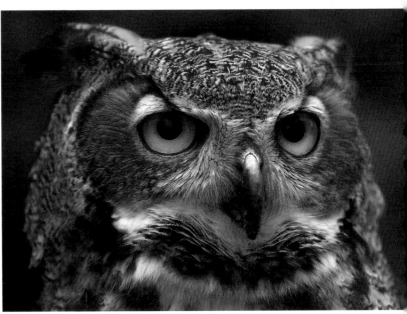

TECH INFO: Canon EOS 1D Mark II, Canon 28–105mm lens @ 105mm, Canon 580 EX Speedlite, ISO 200, 1/125th sec. @ f/5.6 (both)

Watch the Background

Who would give a hoot about the flash picture of the owl with the harsh shadow in the background? The composition is pretty amateurish. That's a bad picture. But it illustrates a good point: Take the time to carefully position the subject and set the flash or natural light exposure carefully. If we do take the time, we can get a nice picture, as illustrated in the headshot of the same owl. The exposure was the same for both pictures; it's the background, which was very close to the subject in the first photograph, that made the difference. We'll go into detail on flash photography in Lesson 9, "Flash Exposures."

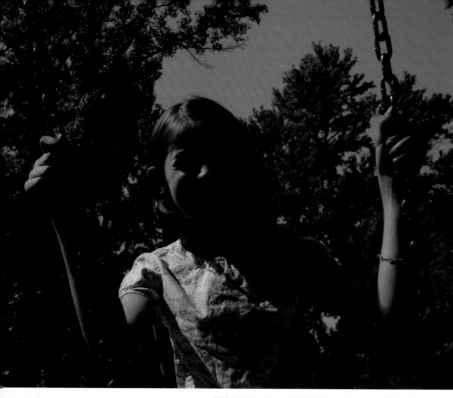

Think Outdoor Flash

Using a flash is sometimes important in getting good exposures—indoors and out. Here is another example, this one of my niece, of how we can turn a potentially bad exposure situation into a good one.

TECH INFO: Canon EOS 1D Mark II, Canon 28–105mm lens @ 35mm, ISO 200, 1/250th sec. at f/5.6 (top); and then at the same exposure settings using a flash (bottom)

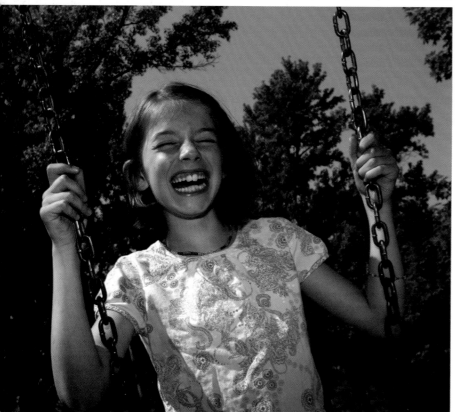

Increase the ISO

The brightness level and range of picture are not the only things that determines a good exposure. You must pay careful attention to your shutter speed and f-stop, making sure, as I mentioned in the previous lesson, that you either freeze or blur the action and get the desired depth of field. In the set of pictures on the opposite page, taken from a mountaintop in Montana, the outtake is not only too light, in my opinion, but the image is blurry, because the shutter speed was too slow. For the keeper, I increased the ISO setting, which let me shoot at a faster shutter speed, and then set the exposure compensation to –1.

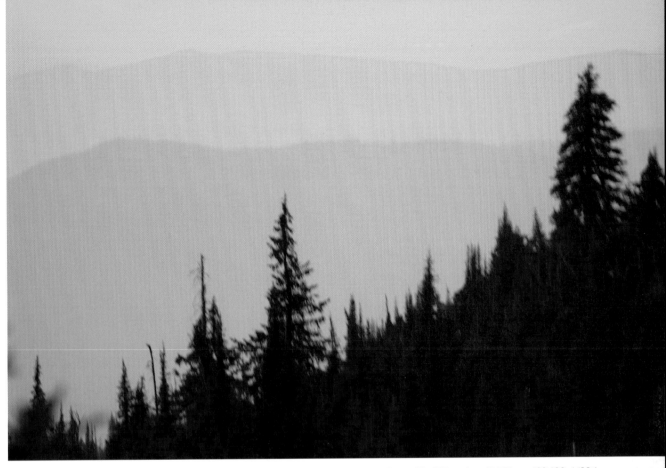

TECH INFO: Canon EOS 1Ds Mark II, Canon 70–200mm lens @ 180mm, ISO 100, 1/60th second at f/8 (top); and then ISO 400, 1/250th sec. at f/3.5 (bottom)

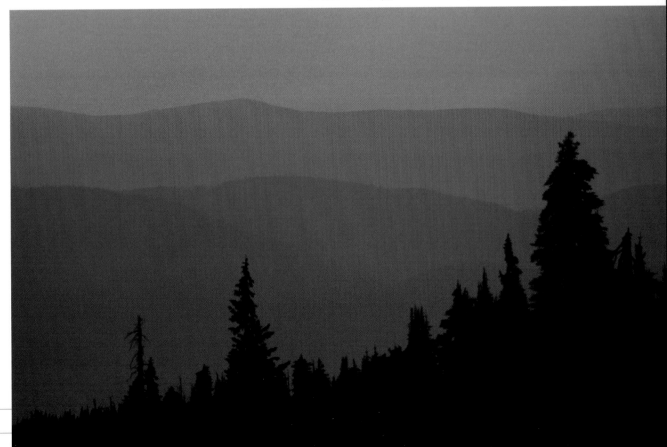

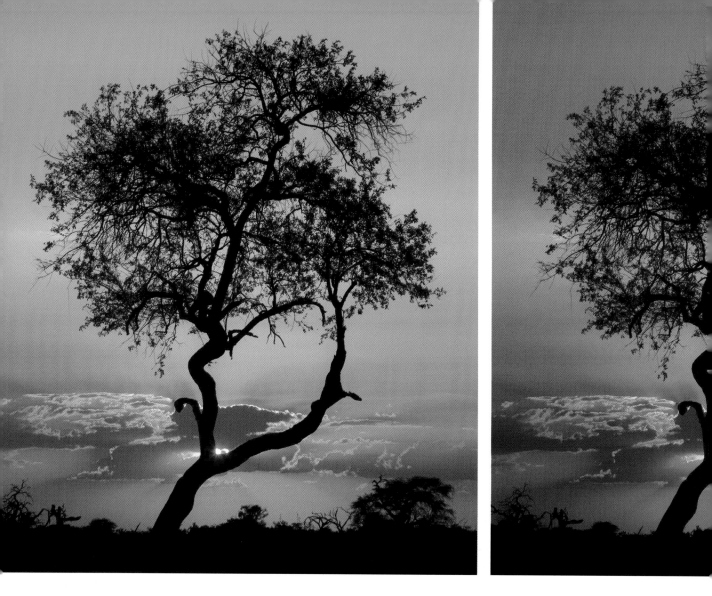

From Good to Great

By now you should be getting an idea of what it takes to make a good exposure. But let's not settle for just good. Let's go for great!

In this series of Botswana sunset photographs, the first image is pleasing enough. But by underexposing the image in my camera, using the –1 exposure compensation setting, I not only got a darker picture, but one with more saturated colors. The last picture in the series is even darker and has even more saturation. That last image was created in Photoshop by increasing the saturation. As I mentioned, I'll cover some basic Photoshop enhancements in Lesson 14, "Adobe Photoshop CS3 Changes the Exposure Rules." Don't skip ahead. Why? Because it's very important to start with the best possible in-camera picture. So please read on!

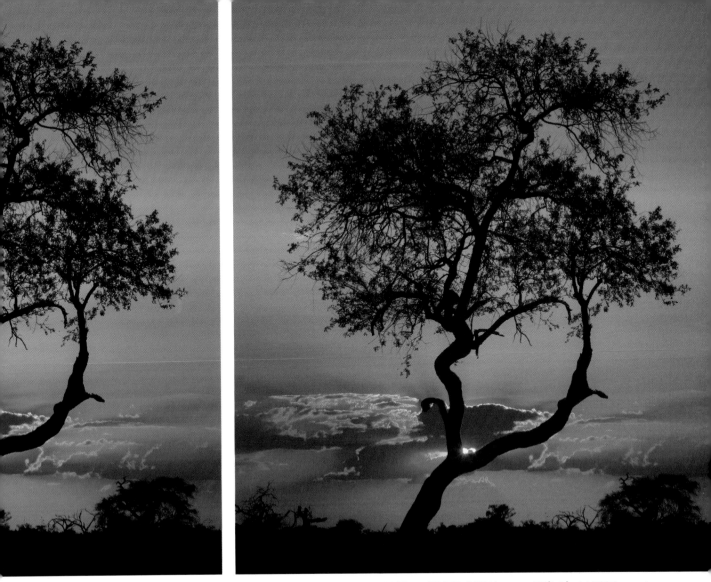

TECH INFO: Canon EOS 1Ds Mark II, Canon 70–200mm lens @ 100mm, ISO 200, 1/125th sec. at f/8 (left); at 1/125th sec. at f/11 (center); after enhancing the image in Photoshop (right)

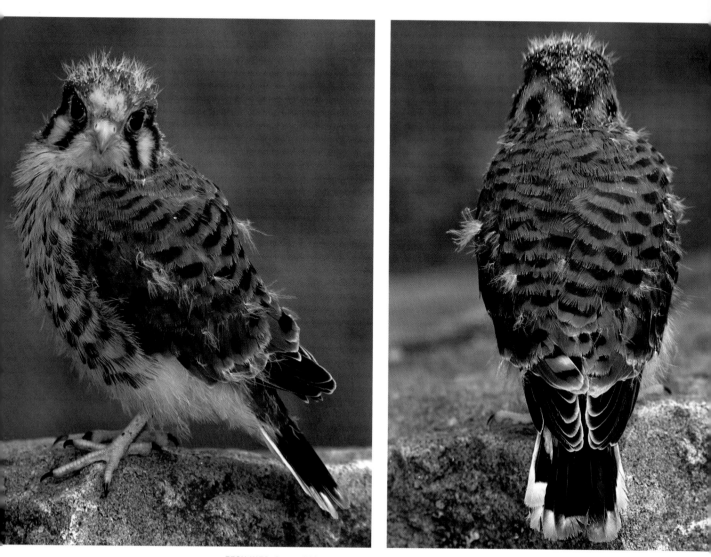

TECH INFO: Canon EOS 1D Mark II, Canon 70–200mm IS lens @ 200mm, ISO 200, 1/125th sec. @ f/5.6

Think Tech but Tell a Story

As I said in the book's introduction, don't get so caught up with photography's technical aspects that you forget to look for interesting pictures—pictures that tell a story.

Check out these two images of a juvenile American kestrel. Both images are properly exposed. When the two images are shown together, one can marvel at nature's design of this animal: When viewed from behind, it looks as though the bird has eyes in the back of its head. Now that's a picture that tells a story—a story that may scare away predators that attack from behind!

See the Light

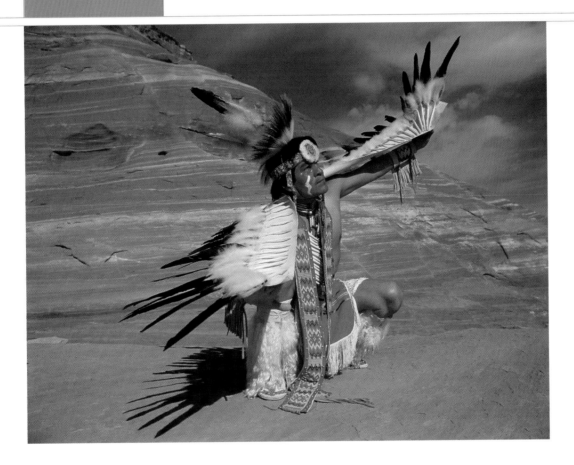

As you'll notice, I've included more photographs in this lesson than in any other, and for a good reason: seeing the light is one of the key ingredients to getting a good exposure. If we learn how to see the light—the highlights and shadows in the scene, the contrast and color of a scene, the direction of light, the subject's and the background's brightness, and even the movement of light—we will make better exposure decisions and therefore become better photographers. We'll also know when we need to control the light, using a reflector, a diffuser, or a flash. And sometimes we'll learn that if the light is not right in a certain location, we'll need to move the subject or change the photograph's composition, as was the case when I was setting up this picture of a Native American in ceremonial dress near Lake Powell, Arizona.

What follows is a collection of my photographs that I use in workshops to help students see the light. In this lesson, I will not include exposure data for each photograph. Concentrate on seeing the light.

To digress for just a moment . . . have you ever heard the term "tone-deaf" used to describe a person who can't tell the difference between musical tones? In photography, "value blind" describes a person who has a hard time seeing subtle differences between light and dark areas of a scene.

Fortunately, there is hope for the value blind photographer—we can all learn to see the light.

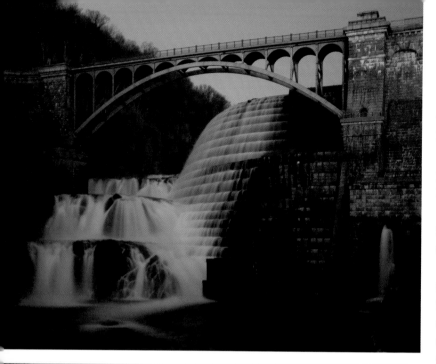

Learn from an Old Joke

Here's the joke: Everything is within walking distance . . . as long as you have time.

There's always enough light for a picture . . . as long as you have time to leave open the shutter.

Sometimes, leaving open the shutter may actually mean several minutes or even hours.

Here's an example. I took the darker of these two pictures of the Croton Dam, in Croton-on-Hudson, New York, about an hour after sunset with just a faint hint of light in the sky. My camera's exposure meter told me I needed a one-minute exposure at f/11.

The lackluster picture is the straight-out-of-the-camera shot. It lacks luster because there was no dramatic color in the scene. The brighter picture is the result of a few Photoshop enhancements (Levels, Contrast, and Color Balance).

So, just because it seems like there is not enough light for a photograph, there always is . . . as long as you have time.

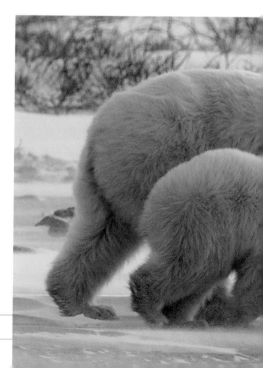

Dynamic Range

In a discussion about seeing the light, we need to begin with what we see with our eyes versus what our digital camera records. Our eyes are amazing light-detecting devices. We can see a dynamic range of about 11 f-stops, which is why we can see shadow and highlight areas of a scene without the shadows being blocked up and the highlights being washed out. A digital image sensor records only about five f-stops, about the same as slide film. So, when shooting with a digital camera you should expose the scene as though you are using slide film: Pay very careful attention to the highlights in a scene, and be very careful not to overexpose them. That was one of the things I was thinking about when I took this picture of a mother polar bear and her cubs. Had the fur or snow been washed out, the whole picture would have been a wash out.

It's possible to pull out shadow detail and rescue some overexposed highlights in Photoshop (especially with RAW files), which I cover in Lesson 13, "Change, Improve, and Rescue Exposures in Photoshop." We can even go beyond what our eyes can see when using High Dynamic Range in Photoshop/Camera RAW.

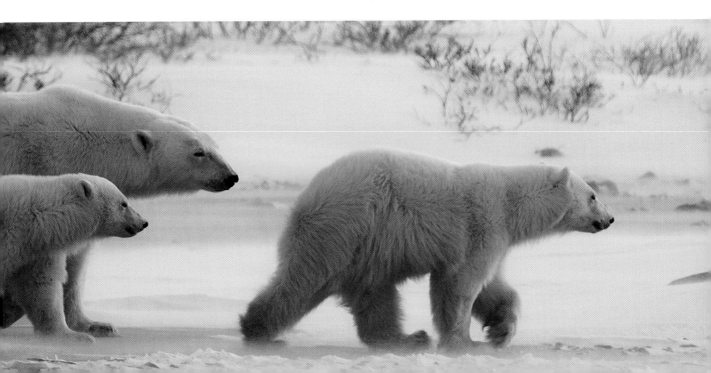

Seeing Differently

Here is an idea that most novice photographers don't think about, brought to mind in this quote by Norwegian symbolist painter Edvard Munch (1863–1944): "At different moments you see with different eyes. You see differently in the morning than you do in the evening. In addition, how you see is also dependent on your emotional state. Because of this, a motif can be seen in many different ways, and this is what makes art interesting."

I photographed these polar bears early one morning, when my eyes and I were just waking up. The softness of the image, and my emotional state (I was missing my family on Thanksgiving), drew me to the scene, one of many on the tundra. Perhaps the close cropping was a reflection of the closeness of my family.

So read on and learn about seeing the light, but don't forget that how you feel also affects your exposures.

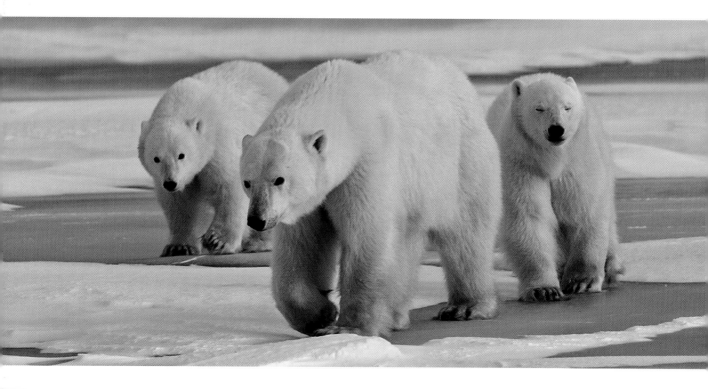

Seeing, Recording, and Adjusting Light

These three images, from a picture I took in a cathedral in Spain, illustrate the aforementioned points about seeing, recording, and rescuing the light.

The first image shows how I saw the scene. The second image shows how the camera recorded the scene; I deliberately underexposed the shot so as not to blow out the highlights. The third image shows how I rescued and improved the light (the exposure) in Photoshop.

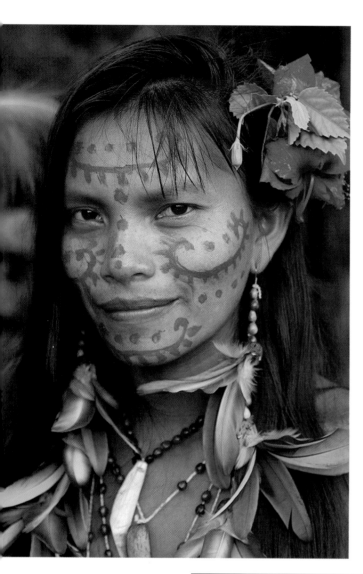

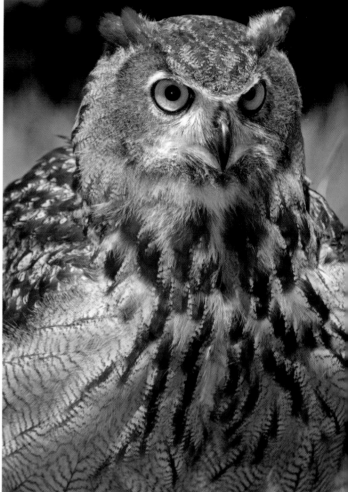

Soft Light Equals Easy Exposures

These photographs—a head shot of a Tariano woman in Amazonas, a portrait of an African eagle owl in upstate New York, a close-up of a butterfly in Florida, and an Alaskan seascape—have something in common. Unlike the opening picture for this lesson, which has strong and dramatic shadows, there are no strong highlights or shadows in these pictures. The light is soft, making for a relatively easy automatic exposure, which I'll cover in Lesson 5, "Fully Automatic Photo/Exposure Modes." I like shooting when the light is soft—under an overcast sky, or with diffused natural or flash lighting. That said, I also like to use shadows to add a sense of depth, which is why I like the opening photograph of the Native American in ceremonial dress.

Let's take a look at the different types of lighting and how they affect a photograph.

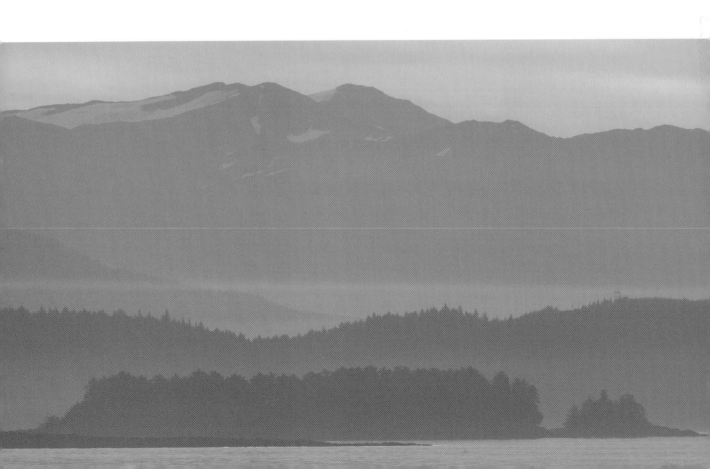

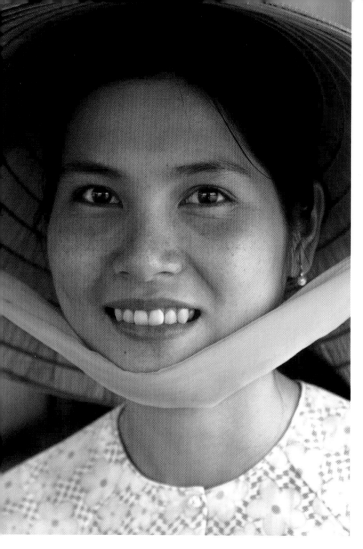

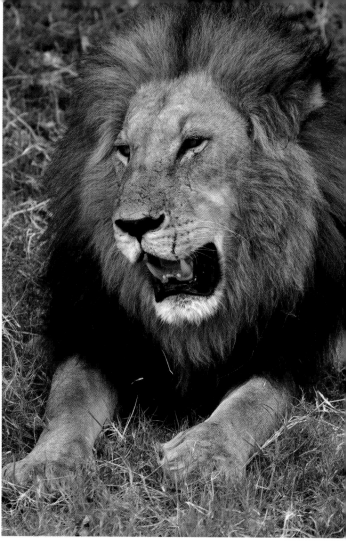

Soft Front Lighting

Front lighting is nice for portraits when you want the subject's face evenly illuminated, as was the case when I photographed my guide in Vietnam. This is another example of an easy automatic exposure.

Overcast Lighting

Overcast conditions are perfect for taking portraits of animals and people, because harsh shadows are eliminated by the clouds. The soft light makes for somewhat soft images. This is another automatic exposure.

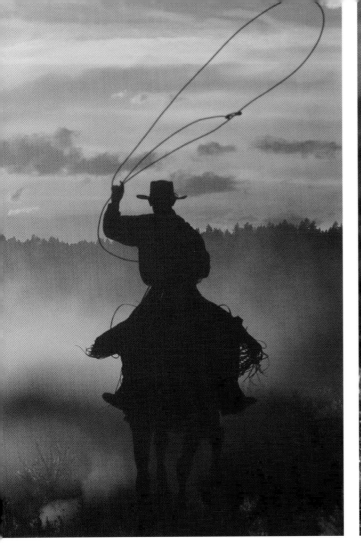

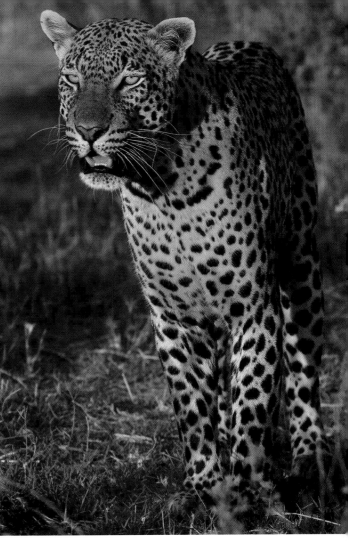

Backlighting

Backlighting creates dramatic silhouettes, as illustrated by this picture that I took in Oregon. Speaking of backlighting, here's a photography joke: Someone asks a pro, "What is your day rate?" He replies, "$5,000, but it is $7,500 if I have to shoot into the sun." It's harder to shoot into the sun than away from it. We'll talk more about shooting into the sun in Lesson 8, "Challenging Exposure Situations."

Soft Side Lighting

Soft side lighting makes more dramatic pictures than overcast lighting does. Pictures also appear sharper, due to the increased contrast. In this leopard photograph, you can see every whisker on the animal's face.

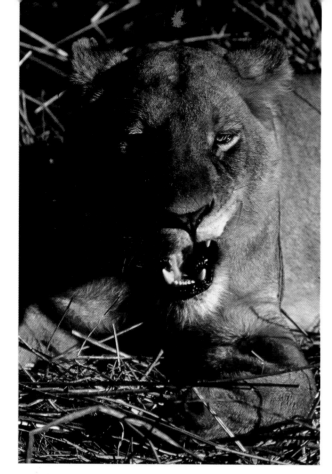

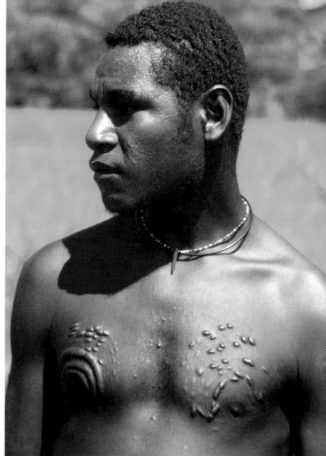

Strong Side Lighting

Strong side lighting can be dramatic, but you need to be attentive to elements hidden in the shadow, in this case half of the lioness's face. The harsh light makes this picture an outtake in my book. No amount of exposure compensation or work in Photoshop could save this shot.

Strong Top Lighting

Strong top lighting is the worst, and I mean the worst, for portraits, because it obscures the eyes by casting harsh shadows into the sockets. I photographed this man in Papua New Guinea to illustrate that point. This image is also an outtake that cannot be saved. A diffuser or a flash, which help control the light, would have reduced the contrast range in the scene and saved the shot. Avoid shooting in top lighting conditions at all costs—unless you can control the natural light (see Lesson 11, "Control Natural Light").

Soft Top Lighting

Soft top lighting, which illuminated my friend Chandler at the Bronx Zoo's Jungle World is not as bad as strong top lighting and can easily be fixed.

Soft top lighting can be corrected by simply asking the subject to look upward. Now that was easy.

Bottom Lighting

Bottom lighting, also known as Halloween light, casts unflattering shadows onto a subject's face. In this image, taken near Lake Powell, Arizona, a reflector was held below the subject, bouncing unflattering light from a low angle. (I cover reflectors in Lesson 11, "Control Natural Light.") This is another lighting effect you should avoid, unless you are taking pictures for October 31.

In addition to learning how to see the light, we also need to learn how to see the brightness intensity of the subject, because that also affects the exposure.

Dark and Light Subjects

Here you see two subjects: a leopard seal, photographed in Antarctica, and a polar bear, photographed in the subarctic. If these images had been captured with a camera set on automatic exposure mode, the seal would be pictured lighter and the polar bear would be pictured darker. That's because very dark and very light subjects can fool a camera's exposure meter (which measures reflected light) into thinking the scene is darker or lighter than it is, resulting in an incorrectly exposed picture. The remedy in these situations is to use your camera's exposure compensation feature. With dark subjects, a −1 exposure compensation setting is recommended as a starting point for a good exposure. With light subjects, a +1 setting is recommended. I know that sounds backward, but it's true—as I'll explain soon. Exposure compensation is usually necessary when most of the frame is filled with a dark or light subject.

Warm Light vs. Cool Light

In addition to seeing the brightness level of a subject and the direction of the light, we need to see the color of light.

Pictures taken in the late afternoon and early morning, such as this picture of a model that I took near Lake Powell, Arizona, have warm tones: deep shades of red, orange, and yellow. Pictures taken around midday, such as the cloud formation, look cool, having a blue tint.

Seeing the color of light can help us make exposure decisions. Photograph at or near sunrise and sunset to get pictures with warm tones, and at midday for cool. Seeing the color of light can also help us make white balance decisions, either in camera or in Photoshop or Camera RAW—all of which let us change the color of light by changing the white balance.

Next, we are going to spend some time seeing the light and color behind the subject, because that affects exposure, too.

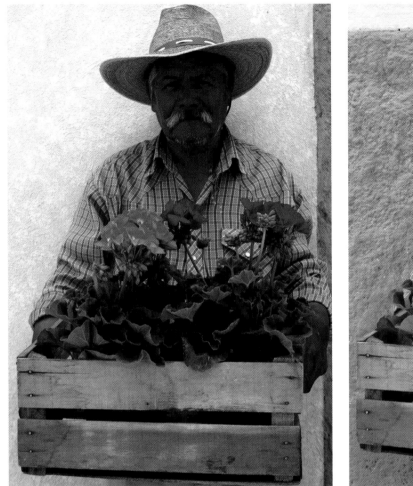
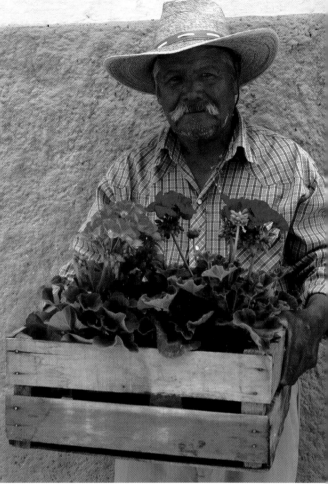

Background Color

Check out these two pictures, taken with my camera set on the Program mode, of a man in San Miguel de Allende, Mexico. In the picture with the white background, the man's face is dark. In the picture with the yellow-orange background, the man's face is properly exposed. What happened in the first picture? Well, the camera sees a white wall the same way it sees a polar bear, and the result is in an underexposed picture (when shooting in an automatic mode). So for a good exposure, I asked the man to pose against a neutral background.

Background Light

Here we see a red macaw with a bad background and a toucan with nice background. In the macaw photo, taken with my zoom lens set at 50mm, the white light coming through the leaves is distracting—because our eyes usually go to the brightest part of a picture first. In the toucan shot, I used a 300mm lens and a wide aperture to totally blur the background and any highlights that would have detracted from the beauty of the subject.

Our Eyes Can Be Fooled

Sometimes, even if the background looks properly exposed to our eye, it may be overexposed in a photograph.

I photographed this girl in the Maldives. She was standing in the shade and beautiful blue water filled the background of the frame. However, because I set the exposure for her face, using the Spot Meter mode in my camera (see Lesson 7, "Choose a Metering Mode"), the much brighter background is overexposed in my picture.

The quick fix was to make a picture, rather than just take a picture. I asked her to move just a few feet to a spot where the background was much darker than the water.

Reducing Flash Shadows

In flash photography, we need to pay attention to where and how the light from the flash is falling on and around the subject. I cover this in detail in Lesson 9, "Flash Exposures," but for now, see how the light from the flash casts a harsh shadow behind the holy man that I photographed in Nepal (above).

With a little effort, shadows can be greatly reduced and even avoided. For the picture of a performer at the Peking Opera (above right), I balanced the light from the flash to the natural light by setting my camera to the Manual mode, dialing in the correct exposure, and then turning on my flash and reducing the flash output to a point where shadows from the flash were eliminated. For the picture of the young clown (right), I bounced the light from the flash off the ceiling for a diffused light effect.

Watch the Foreground

We also have to pay attention to how the light is falling on foreground subjects. Both of these pictures were taken in Mexico at the site of the annual monarch butterfly migration. In the horizontal image, the foreground is overexposed, because that part of the tree was in brighter light than the top of the tree. At first sight, to the untrained eye, it may not appear that way. In the vertical shot, the exposure is even, because the illumination on the tree was even.

Now let's take a look at seeing another important part of exposure: shadows.

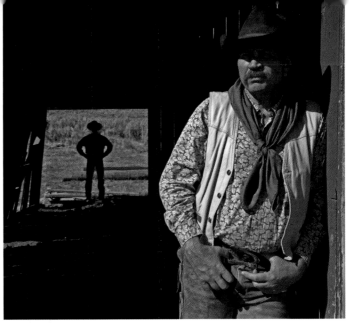

Shadows Add Depth

Shadows add a sense of depth and dimension to a photograph. Without them, pictures look flat—which is not always a bad thing, as illustrated by some of the preceding pictures. The pictures on this page—taken in Upper Antelope Canyon, Arizona; Ponderosa Ranch, Oregon; Old Havana, Cuba; and Croton-on-Hudson, New York—have strong shadow areas that add to the interest of the image.

To record strong shadows without washing out the highlights, you need to set your exposure for the highlight, the brightest area of the scene, with your camera's exposure lock (see Lesson 7, "Choose a Metering Mode").

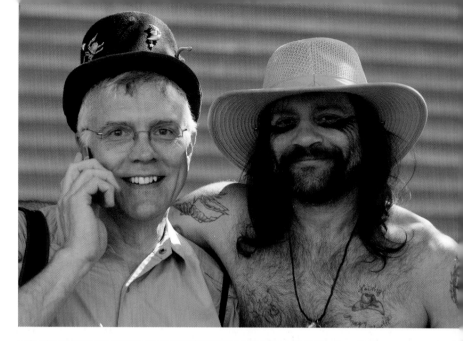

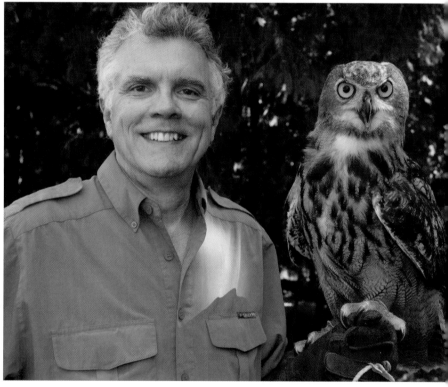

Look Carefully

Here are two pictures of me with two "friends." I like both pictures, but one has an exposure problem. Do you see it? Sure, it's minor, and it's still a great, fun shot. However, the flaw is something that bugs me, and when you learn how to see the light, it may bug you, too.

In the photograph where I am wearing a hat, my white hair is overexposed on the left side of my head by a couple of stops. (I told you it was a minor flaw.) Personally, I try to avoid overexposed areas at all costs when taking a serious picture (this was a quick, fun grab shot). To prevent this flaw, I could have quickly dyed my hair, or moved into the shade, or asked the photographer to slightly underexpose the picture, which is what my wife, Susan, did for the picture of me holding the African eagle owl.

Movement of Light

Here's something else about seeing the light: we need to see its movement. While I was teaching a workshop in the South Beach section of Miami Beach, I photographed this night scene. I used a shutter speed of 1/30th second for the picture in which a car is slightly blurred. For the more dramatic photograph, which shows the light streaking through the frame, I mounted my camera on a tripod and opened the shutter for 10 seconds. I adjusted the ISO and f-stop to prevent the neon lights from being overexposed and washed out during the longer exposure time.

Seeing the movement of light, and choosing how to either freeze or blur it, is also an important part of exposure.

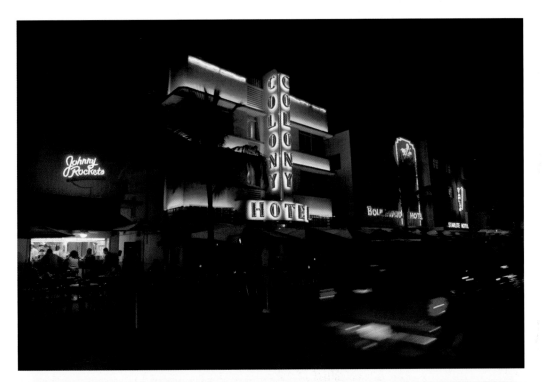

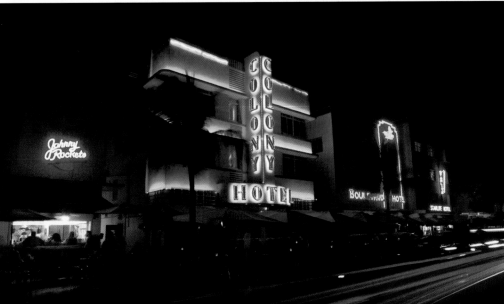

Moving Natural Light

In addition to seeing the movement of light, we need to pay attention to the movement of natural light, which has its own nuances.

In these examples, taken at the Flume in New Hampshire's Franconia Notch State Park, we see how a slow shutter speed, 1/20th of a second, produces a much more pleasing photograph than that of the same subject photographed using a shutter speed of 1/1000 of a second.

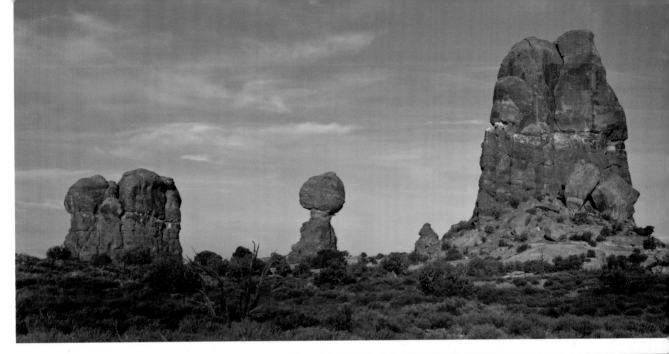

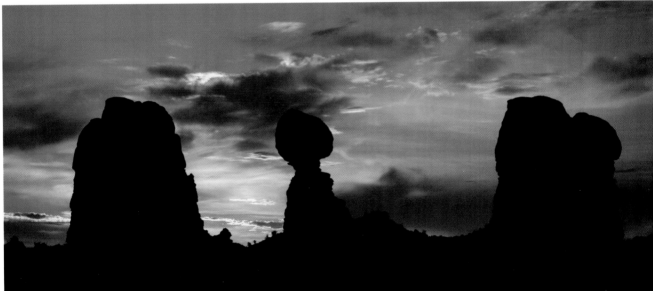

Seek Out Pictures

Okay, we've covered seeing the light. Now I want to leave you with one more thought: See the light, but don't forget to see and seek out unique pictures. That's one of my top photography tips! These pictures, taken of the same subject in Arches National Park, Utah, were taken only minutes apart. I saw both pictures before I snapped the shutter, because I saw the light, and how very different it was when I moved around to the opposite side of the rocks.

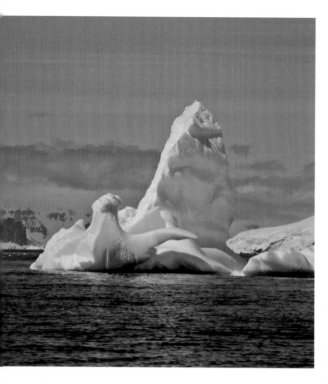

Shoot from Different Angles

While in Antarctica, I was seeing the light and looking for pictures. While cruising a bay in an inflatable boat, I noticed an iceberg with an interesting structure. Looking for the picture, I saw, even from the original angle, that the natural ice carving looked like a polar bear on its back. Directing my guide to drive around the iceberg, I got a full frame, side view photograph of the polar bear ice sculpture.

See the light, and think about your exposure settings, but don't get so caught up in the technical aspects of picture taking that you miss photographic opportunities.

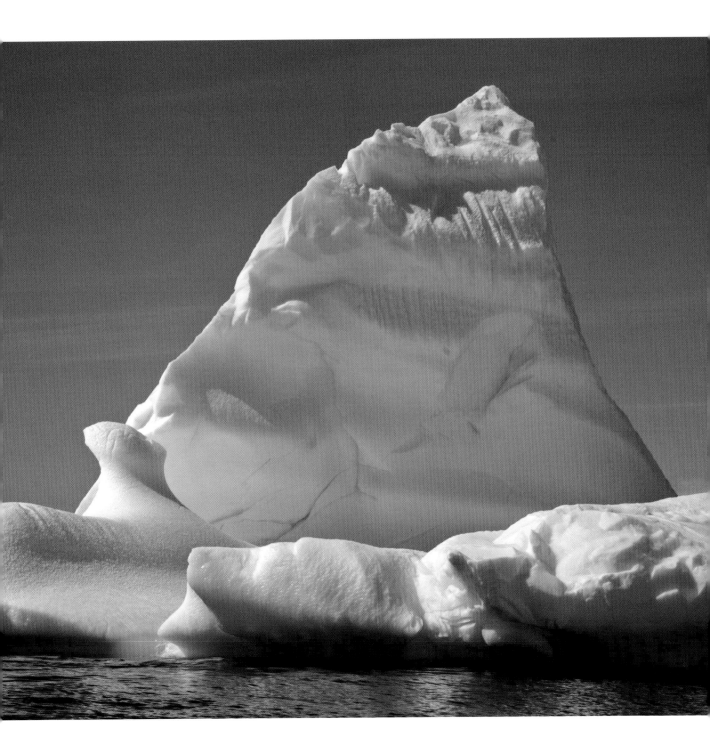

Indeed, seeing the light, and learning how to make exposure adjustments to accurately capture that light, is one of the keys to getting a good picture. But so is seeing when the light is *not* right for the picture that we see in our mind's eye, and knowing how we can use Photoshop to make that vision a reality. The images here illustrate this point. This is not the Photoshop part of this book (wait for Lessons 13–15)—I just want to give you a quick idea of the possibilities that await in the digital darkroom.

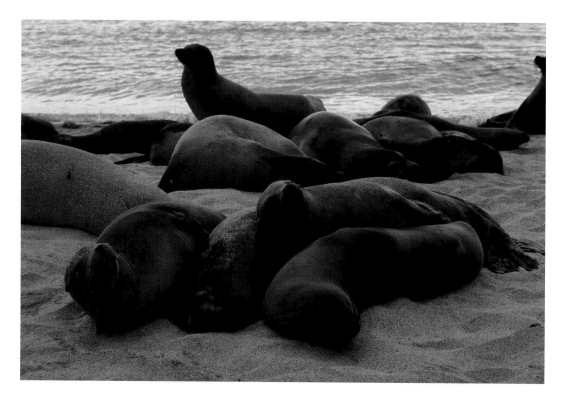

While I was walking on a beach in the Galapagos, I saw several sea lions resting on the sand and one silhouetted against the water in the background, and thought, "What a great group shot!" But I knew that the backlight was not right for the picture I envisioned. Luckily I also knew that Photoshop could turn an outtake into a keeper.

I composed the image carefully in the camera's viewfinder. To avoid washing out the water, I underexposed the image by one-third of an f-stop, which caused the sea lions to appear too dark. In addition, it was overcast that day, and the color of the light was cool, adding a bluish tint.

In Photoshop, I was able to create the exposure I saw in my mind's eye by using some basic tools (Levels, Adjust Color Balance, and Shadow/Highlight) and by selectively burning and dodging different areas of the scene.

As you can see, the final picture looks different from the original. Always keep the power of Photoshop in mind when taking pictures. I do!

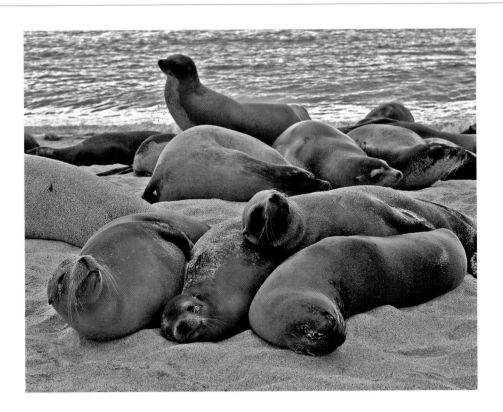

In addition to seeing when the exposure is not ideal, it's important to see when the color in a scene can be improved—or even enhanced or manipulated. Again, that's when Photoshop can help.

Below is an original image, which is properly exposed, taken near my home.

In Photoshop, I increased the saturation (**Image > Adjustment > Hue/Saturation**) and boosted the blue tones (**Image > Adjustment > Color Balance**).

Creating this dramatic image was easy. I simply decreased the blue tone and increased the red tones (**Image > Adjustment > Color Balance**).

For this "moonlight" scene, I boosted the blue tones (**Image > Adjustment > Color Balance**) and applied the Gaussian Blur filter (**Filter > Blur > Gaussian Blur**).

Enough Photoshop talk for now. On to the next lesson!

Digital SLR Camera Basics

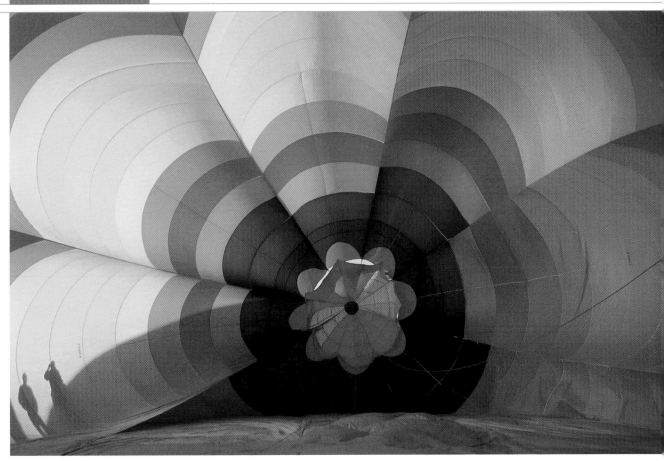

TECH INFO: Canon EOS 1Ds Mark II, Canon 16–35mm lens @ 16mm, ISO 400, 1/125th sec. @ f/11

"Cameras don't take pictures, people do" is a well-known photo adage. However, you not only need a camera to take pictures—to get good exposures, you need to know what your camera can and cannot do. For example, to capture this image of the inside of a hot-air balloon, I selected the appropriate settings on my digital single-lens reflex (SLR) camera to maximize the quality of the exposure as I saw it in the moment.

In this lesson we'll explore how we can use camera settings to record the images we see in the viewfinder and in our mind's eye.

Image Quality

While all camera controls are important, some are more important than others. Image quality is very important.

Basically, you have two image quality choices: JPEG or RAW. JPEG files are compressed files. In the process of compressing a JPEG image, more than one-third of the data is lost, mostly in the highlight areas. That said, newer digital cameras have improved JPEG processing systems that retain more detail.

When you shoot RAW files, you retain all the data, and you never lose your original file. You can't copy or write over it, as you can with a JPEG file.

Some people call a RAW file a digital negative, but that's not quite true. RAW files are RAW data. That data can be processed by a number of RAW processing programs, and each program processes that data a bit differently, resulting in different results (usually slight).

Due to their large size, RAW files take up more room on a memory card and hard drive than do JPEG files. RAW files also take longer to open. Once upon a time, these were big concerns. But memory seems to get cheaper by the day, and computer (and camera) processors have become faster. It is now easier than ever to work with RAW files.

The Contrast Factor

I always shoot RAW files because I like to process my images in Adobe Camera RAW and Adobe Photoshop Lightroom, where I have total control over image

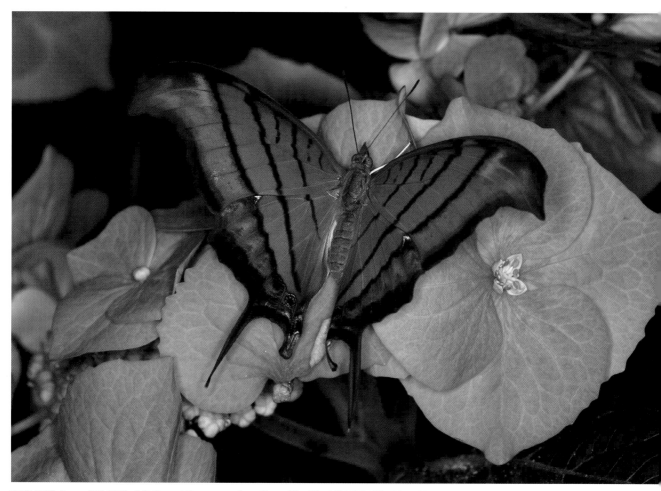

TECH INFO: Canon EOS 1D Mark II, Canon 50mm macro lens, Canon Ring Lite MR-14EX, ISO 100, 1/60th sec. @ f/22

TECH INFO: Canon EOS 1D Mark II, Canon 50mm macro lens, ISO 100, Canon Ring Lite MR-14EX, ISO 100, 1/60th sec. @ f/22

TECH INFO: Canon EOS 1Ds Mark II, Canon 28–105mm lens @ 105mm, ISO 100, 1/250th sec. @ f/8

processing without sacrificing any data to compression. However, if a scene does not have a lot of contrast, you might not be able to tell the difference between a JPEG file and a RAW file of the same scene—even when making an 11 x 14-inch print.

When a scene does have a lot of contrast, shooting RAW is a must, especially if you want to retain all the details in the scene, or if you want to make a large print or enlargement from only part of the scene.

RAW Forgiveness

When it comes to exposure, RAW files are more forgiving than JPEG files. You can recover up to one-stop of an overexposed area in Adobe Camera RAW and other processing programs. That's what I did to rescue the overexposed neck area of the caracara that I photographed in southern Florida. As with the photo on page 80, this scene had a wide brightness range, this time between the dark and light feathers.

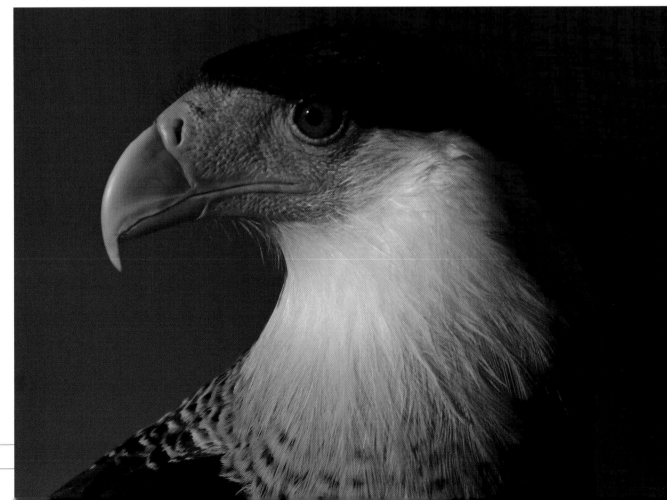

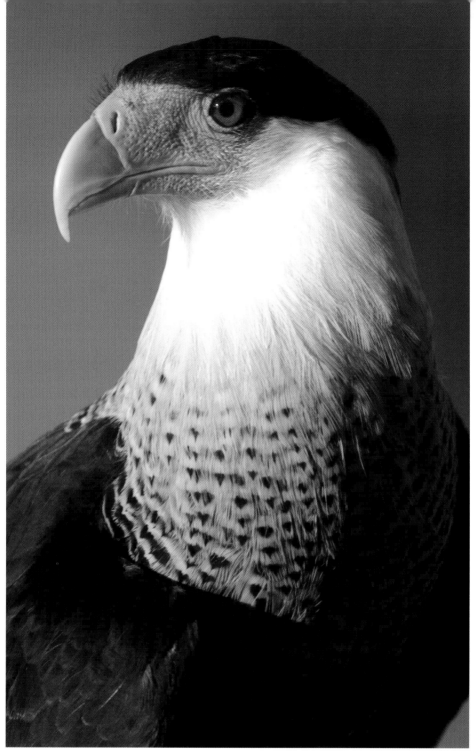

Losing Highlights

If an area in a JPEG file is overexposed, you're sunk. You won't be able to recover that data. As you can see in this JPEG file, much of the detail is lost on the beautiful bird's white feathers. For me, JPEG files are for the birds.

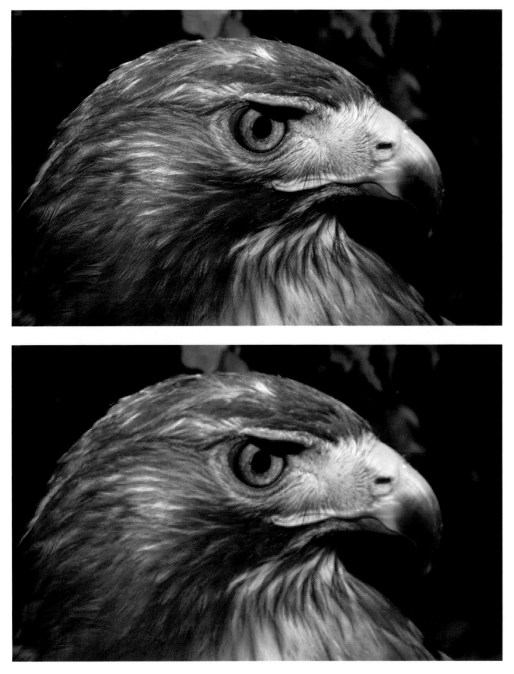

TECH INFO: Canon EOS 1Ds Mark II, Canon 28–105mm lens @ 105mm, ISO 400, Canon Speedlite 580EX, 1/125th sec. @ f/11

JPEG Quality Choices

When shooting JPEG files, you have a choice of settings: low, medium, high, and best. For viewing on a computer screen, the low setting is okay. If you want to make big prints, you need to shoot at the highest quality setting.

These hawk images show the difference shooting at the low and high settings causes if you were to make an 8 x 10-inch print. The bottom image, shot at the low setting, is pixilated. That's something you don't want to see in a print.

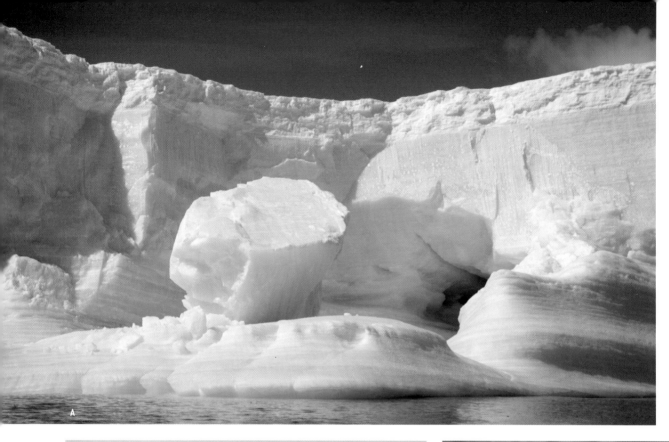

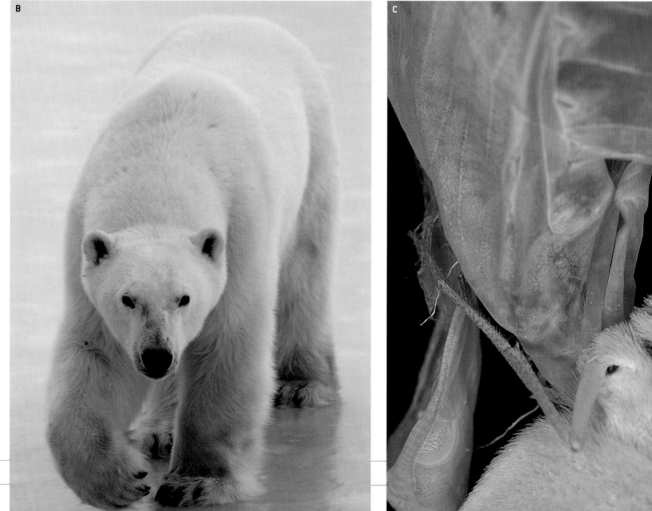

Once-in-a-Lifetime Shot

There is yet another reason to shoot RAW files: to capture a once-in-a-lifetime photo opportunity. That's what I did when photographing an ice formation in Antarctica, a polar bear in the subarctic, and a butterfly emerging from its chrysalis.

As I write, you have more control over your images in Camera RAW than you do with a JPEG in Photoshop. But just imagine what future RAW processing programs will provide. If you have JPEG files, you'll be stuck with them. If you have RAW files, more creative possibilities will be at your fingertips—and will continue to expand as digital processing programs grow more advanced.

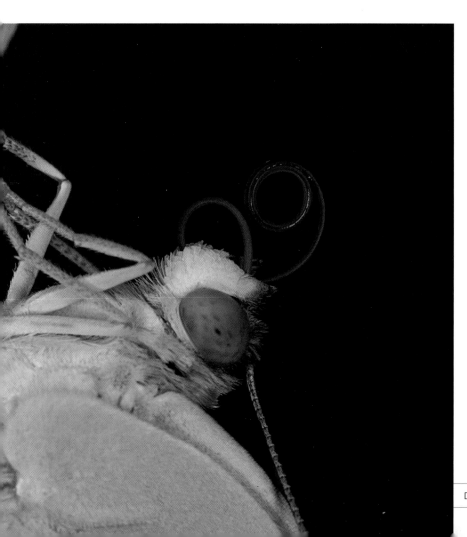

A) **TECH INFO:** Canon EOS 1Ds Mark II, Canon 17–40mm lens @ 17mm, ISO 100, 1/125th sec. @ f/11

B) **TECH INFO:** Canon EOS 1D Mark II, Canon 100–400mm IS lens @ 400mm, ISO 400, 1/250th sec. @ f/5.6

C) **TECH INFO:** Canon EOS 1D Mark II, Canon 50mm macro lens, ISO Canon Ring Lite MR-14EX, ISO 100, 1/60th sec. @ f/11

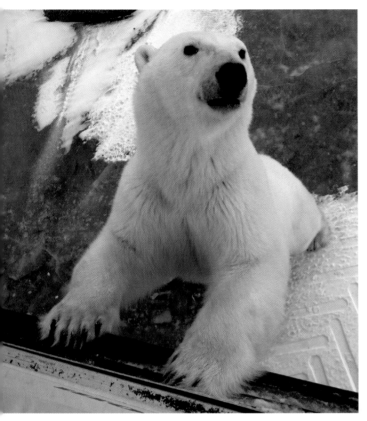

ISO Setting

The ISO (formerly known as ASA in film cameras) is another very important camera setting. By setting the ISO, you set the light sensitivity of the camera's image sensor. High ISO settings are more sensitive to light than low ISO settings.

The light level determines the ISO setting we choose. Low ISO settings, such as ISO 100, can be used in bright light. That's what I did when photographing a polar bear in Churchill, Canada. High ISO settings, such as ISO 800, are needed in low-light situations, as was the case when I was photographing the sunset in Botswana.

Low ISO settings offer less digital noise than high ISO settings; the higher the ISO, the more noise you'll get in the picture. However, a top-of-the-line digital SLR will have less noise, say at ISO 400, than an entry-level digital SLR, due to the way the image is processed in the camera and the quality of the image sensor.

I recommend always shooting at the lowest possible ISO so you get the cleanest possible picture, a picture with the least amount of digital noise.

TECH INFO: Canon EOS 1D Mark II, Canon 17–40mm lens @ 20mm, ISO 100, 1/125th sec. @ f/11

TECH INFO: Canon EOS 1D Mark II, Canon 17–40mm lens @ 17mm, ISO 800, 1/60th sec. @ f/11

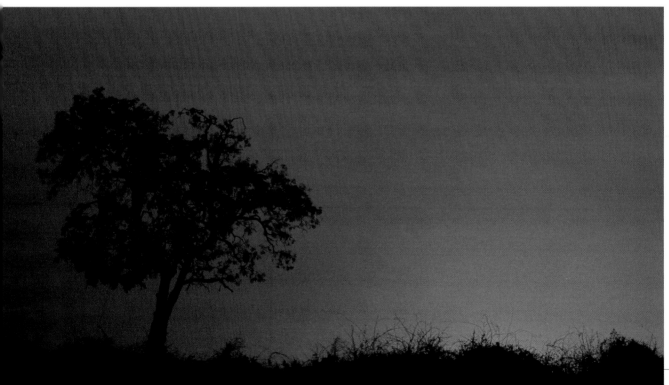

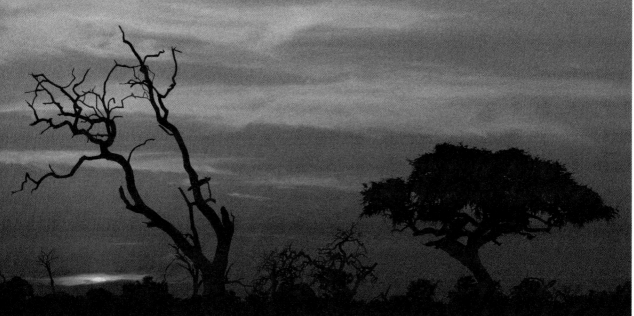

TECH INFO: Canon EOS 1D Mark II, Canon 17–40mm lens @ 17mm, ISO 800, 1/60th sec. @ f/5.6

Choose Your ISO Carefully

Digital noise is not necessarily a bad thing. In this example, the noise I added in Photoshop makes the picture on the bottom look a bit more artistic. What's more, as my dad told me when I was just starting out in photography and shot film, "If a picture is so boring that you notice the grain, it's not a good picture anyway."

Often, the lighting conditions dictate the ISO setting. There are times, however, when you might intentionally choose a lower or higher ISO setting. Read on.

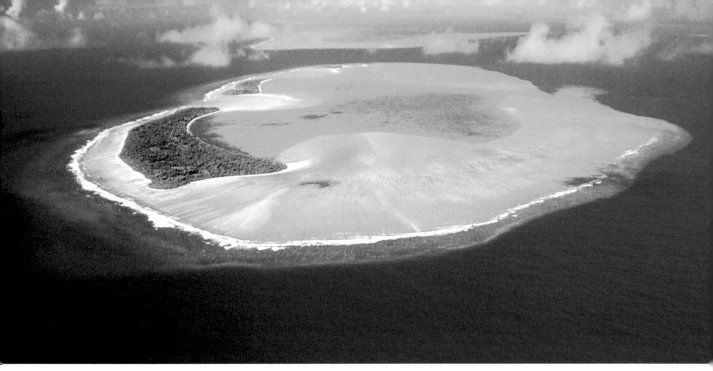

TECH INFO: Canon EOS A2E, Canon 28–105mm lens @ 35mm, ISO 400, 1/500th sec. @ f/8

Avoid Camera Shake

When you are moving, or when the vehicle in which you are riding is vibrating or shaking, as was the case when I was photographing the atoll in Palau, Micronesia, from a light plane, choose a high ISO so that you can use a fast shutter speed and avoid camera shake.

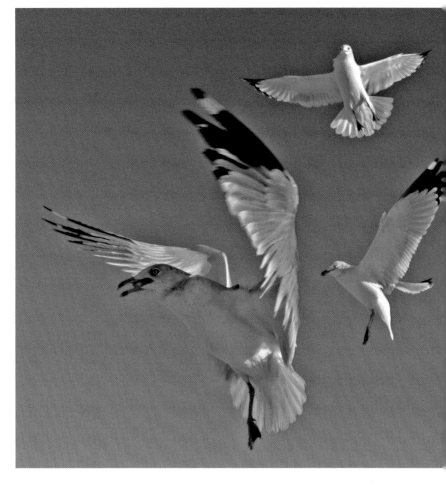

Stop Action

When a subject is moving fast, boost the ISO in order to get a fast shutter speed and freeze the action in a sharp picture. These seagulls were photographed in bright light, yet I used an ISO of 800 and a fast shutter speed to ensure a sharp shot.

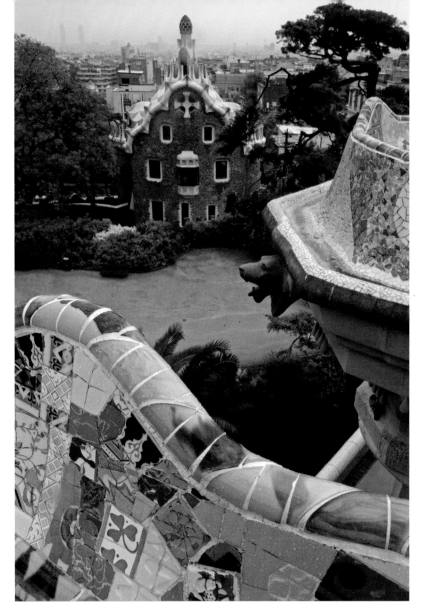

Increase Depth of Field

When you want more depth of field than a low ISO and its accompanying wide aperture offers, you can increase the ISO, which lets you shoot at a smaller f-stop. By selecting an ISO of 800, I was able to get everything in this Barcelona scene in focus, the near foreground as well as the distant background.

TECH INFO: Canon EOS1Ds Mark II, Canon 17–40mm lens @ 17mm, ISO 800, 1/60th sec. @ f/16

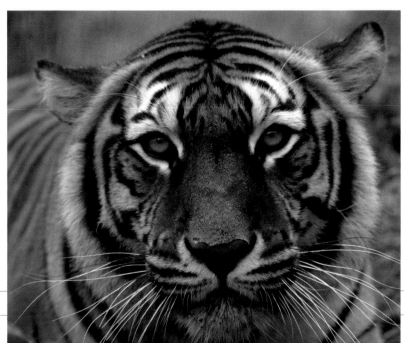

Reduce Depth of Field

You can also use the ISO setting to get a wide f-stop for less depth of field. By choosing an ISO of 200, I was able to photograph this tiger at Big Cat Rescue near Tampa, Florida, and get an exposure in which the tiger's head is sharp and the background beautifully blurred.

TECH INFO: Canon EOS 1D Mark II, Canon 100–400mm IS lens @ 300mm, ISO 200, 1/250th sec. @ f/5.6

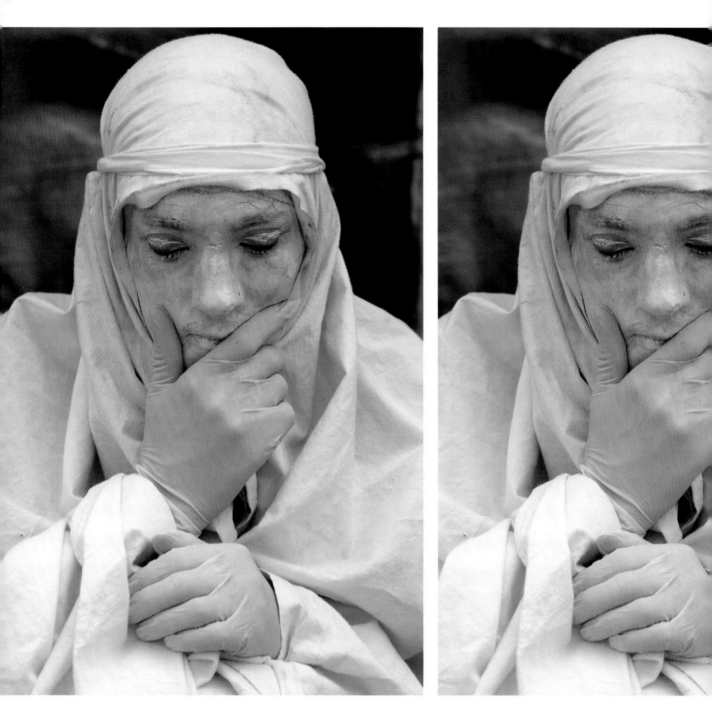

White Balance

Another important setting is the White Balance. If you shoot JPEG files, the white balance is embedded in the image. If you shoot RAW files, you can quickly and easily change the white balance settings in a RAW processing program, because the setting is not embedded in the image.

Take a look at these three images, taken of a mime performing in the shade on a Barcelona street. They look the same, expect for the color and tone. What caused the difference? In Photoshop, I simulated the effect of changing the white balance setting, which you can do in-camera, from Shade to Cloudy to Tungsten (these are just a few options).

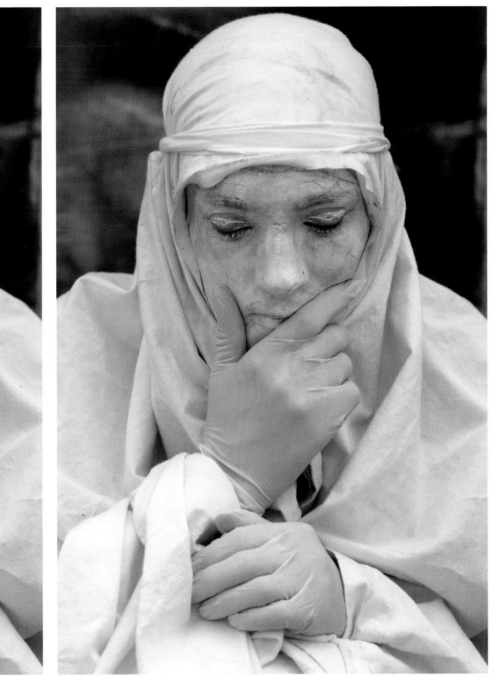

TECH INFO: Canon EOS 1D Mark II, Canon 70–200mm lens @ 100mm, ISO 400, 1/250th sec. @ f/8

Which photo has the accurate color? The first image, the one in which the performer's costume is white. That's because I set my camera's white balance to Shade, the setting for the existing situation. When you set the white balance, you are telling the camera that the white tones in the scene should be white, and therefore, all the other colors should be recorded correctly, too. That's how white balance works.

Daylight.

Tungsten.

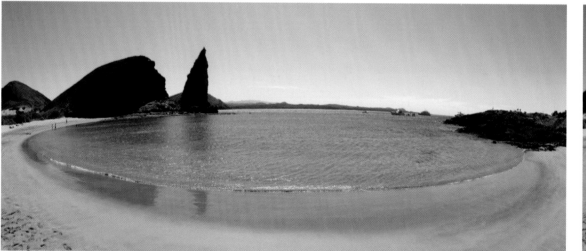

Cloudy.

Fluorescent.

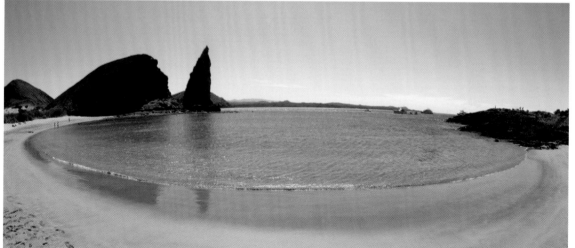

Shade.

Flash.

White Balance and Color

In the mime examples, it was easy to see the effect of different white balance settings. Using a picture I took in the Galapagos, let's take a look at how the different in-camera white balance settings (simulated here in Camera RAW) affect a picture. The caption indicates the name of the lighting conditions or light source under which you'd used the setting. You'll notice that the auto setting is not shown. That's because I don't recommend using it, unless you are shooting under mixed lighting conditions, such as when you are taking pictures indoors by a window and the subject is illuminated by both window light and the room's lamps.

TECH INFO: Canon EOS 1Ds Mark II, Canon 15mm lens, ISO 100, 1/125th sec. @ f/16

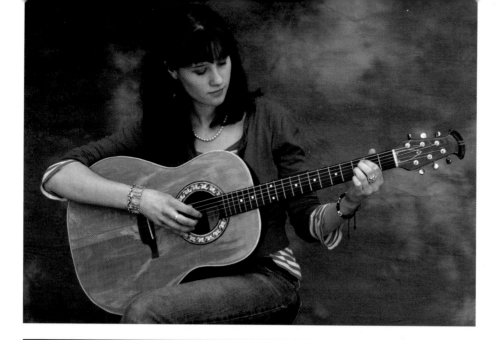

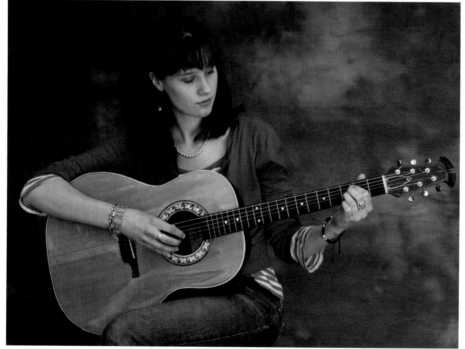

TECH INFO: Canon EOS 1Ds Mark II, Canon 28–105mm lens @ 80mm, ISO 100, 1/60th sec. @ f/8

Warm It Up

Which of these two pictures do you prefer? My guess is the bottom picture with warmer colors—the kind of colors we see and get in our sunrise and sunset exposures.

Most people prefer pictures with warmer colors, which is why we see sunset and sunrise pictures on the covers of calendars and magazines. Although I recommend setting the white balance for the existing lighting situation, you can warm up a picture—get deeper shades of red, orange, and yellow—by setting the white balance to cloudy when taking outdoor pictures—in shade and in direct sunlight. Yes, this picture of a friend playing guitar was taken outdoors on a sunny day in the shade! I propped the background against my garage to simulate a professional studio setting.

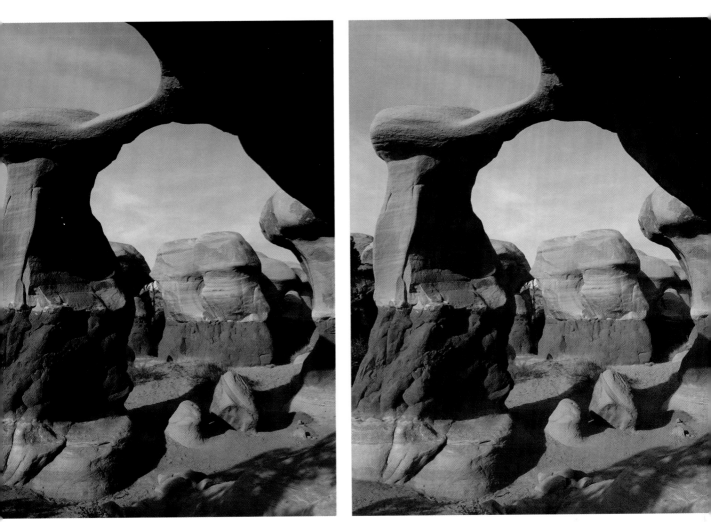

TECH INFO: Canon EOS 1Ds Mark II, Canon 17–40mm lens @ 17mm, ISO 100, 1/125th sec. @ f/11

Warm vs. Cool

Here is another set of pictures that compares a warm-tone image to a cool one. Again, which photograph of Utah's Devil's Garden do you prefer? The second (warmer) image is an example of setting the white balance to cloudy when shooting on a sunny day.

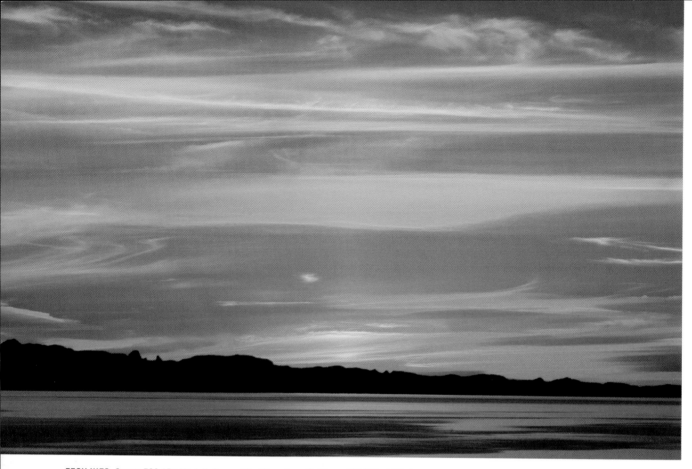

TECH INFO: Canon EOS 1Ds Mark II, Canon 17–40mm lens @ 17mm, ISO 400, 1/60th sec. @ f/8

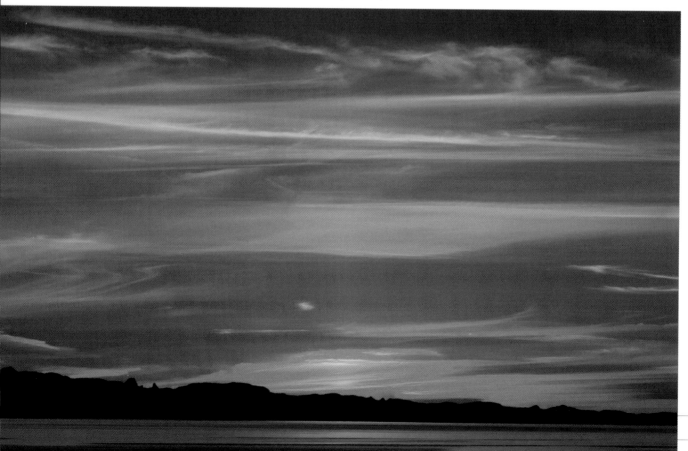

Enhance a Sunset

To intensify the colors of a sunset, which already has warm tones, and to slightly darken the image, try setting the white balance to cloudy, as I did for the bottom photo taken during a cruise in Alaska.

Keep It Cool

Sure, warm-tone photographs are hot! But so are pictures that have cool tones, such as this image of an Antarctic iceberg. This is a photograph even I, a person who loves Camera RAW and Photoshop, would not dare to warm up. The result of losing the blue tones would melt its drama, so to speak. So please don't get carried away with warming up your photographs.

The next time you pick up your camera to take a picture, think carefully about your camera settings. Choosing the right setting can not only help you get the best possible in-camera exposure, but can save you time in the digital darkroom as well.

TECH INFO: Canon EOS 1Ds Mark II, Canon 28–105mm lens @ 28mm, ISO 400, 1/250th sec. @ f/5.6

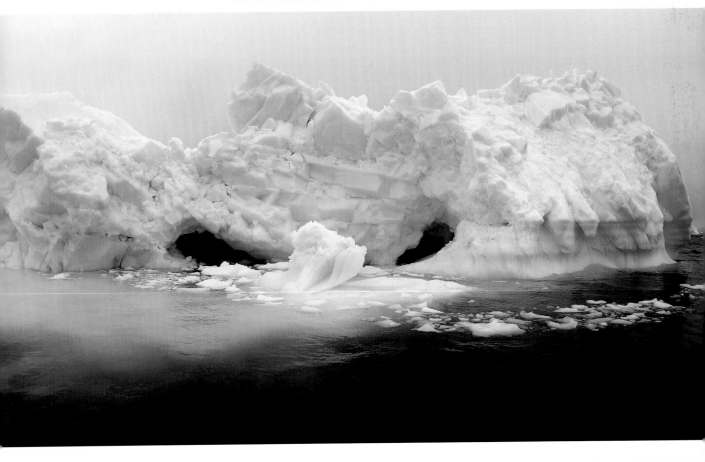

Fully Automatic Photo/Exposure Modes

As picture takers, we like to shoot portraits, landscapes, cityscapes, and close-ups. Serious shots and fun shots. We like still-life photography, and we like to capture sports and wildlife action. We shoot day and night.

Sometimes we simply want to point and shoot, as I did when I a saw this pre-sunrise scene in Kenya. That's when we can use fully automatic photo/exposure modes, which is what I did in choosing the Landscape mode.

On other occasions, we want to take our time and be more creative with our cameras, fine-tuning the composition and exposure. That's the time to use creative photo/exposure modes, as well as manual exposure. I'll cover those in the next lesson.

For now, let's take a look at automatic photo/exposure modes—when to use them, and when perhaps it's not a good idea. I'm not including exposure data because you can't control the shutter speed or the f-stop in the fully automatic photo/exposure modes. On some cameras those settings are not displayed.

Let's go!

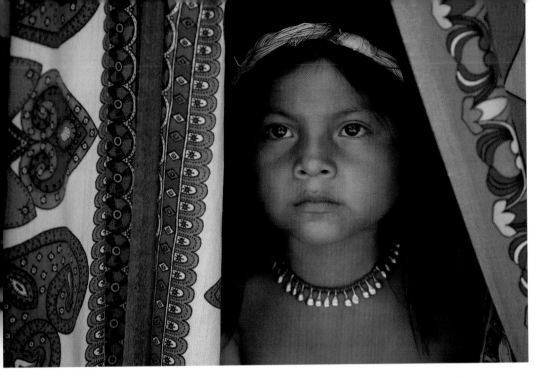

Full Auto Mode

Designed for fast point-and-shoot photography, the Full Auto mode is rather amazing. When set to Full Auto, the camera sets the shutter speed and f-stop. You take the picture. It's that simple.

This mode is a good choice when there isn't a lot of contrast (strong shadows or highlights) in a scene, as is the case with this picture of a young Embera girl in Panama.

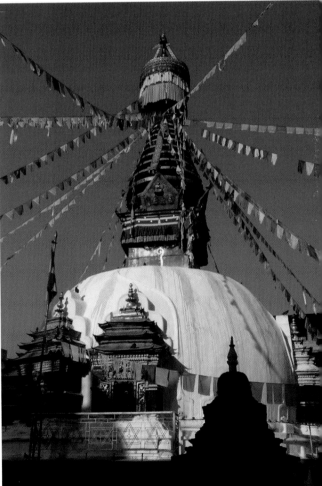

Don't use the Full Auto mode when there is strong contrast in the scene, as in this picture of a stupa in Nepal. Some of the highlights may be washed out and some of the shadows may be blocked up. Choose a creative mode, as described in Lesson 6, "Creative Exposure Modes."

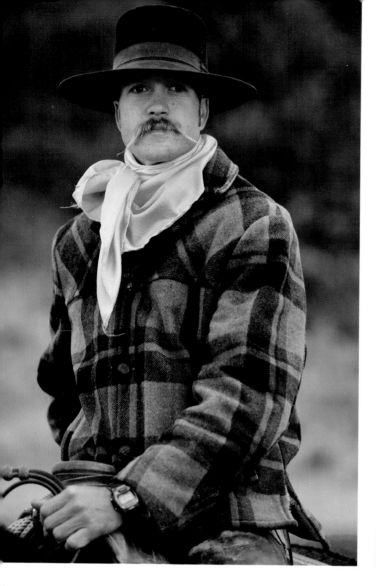

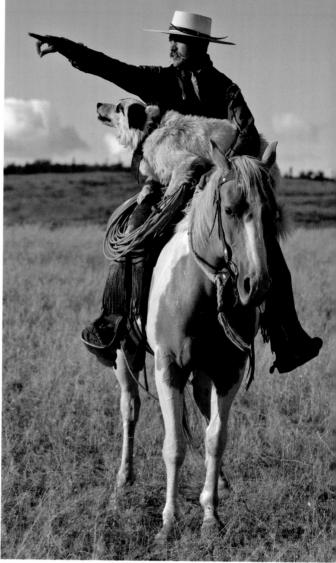

Portrait Mode

Use the Portrait mode for focusing on people, like this cowboy that I photographed in Oregon, and on animals, including pets. The camera automatically sets an appropriate f-stop to blur the background, and your subject stands out in the scene.

Don't use the Portrait mode when you want to control the depth of field. Here I wanted the cowbow and his horse in sharp focus, and the background with as little blur as possible, so I chose the Aperture Priority mode (see Lesson 6).

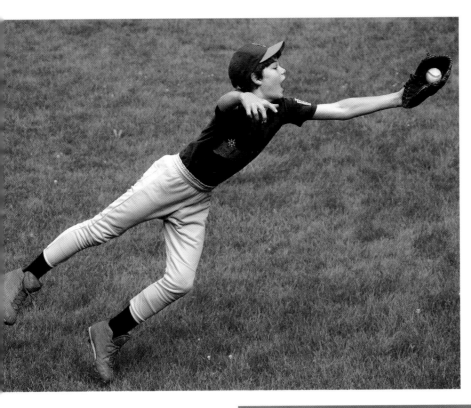

Sports Mode

The Sports mode is designed for all action photography—not just sports. In this mode, the camera automatically sets a higher shutter speed to stop the subject's movement—even the movement of a baseball player flying through the air to make a catch. On some digital SLR cameras, focus tracking, which keeps a moving subject in focus up until the exact moment of exposure, is automatically activated.

When you want to stop the action, this mode will deliver good results in most outdoor, bright-light situations.

When you want total control over how a subject's movement will appear, perhaps when you want to blur the subject slightly or only part of the subject (see the top of the pelican's wings), don't use the Sports mode. Rather, choose the Shutter Priority mode, as described in Lesson 6.

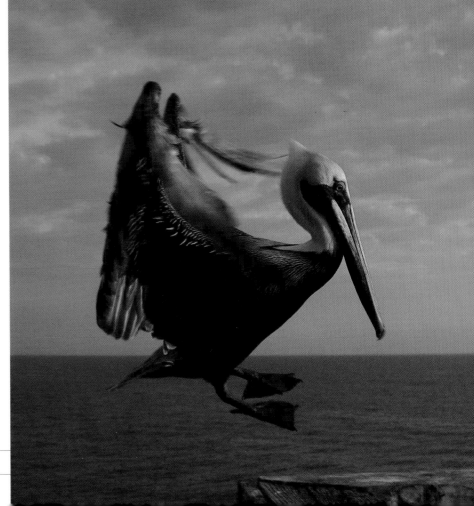

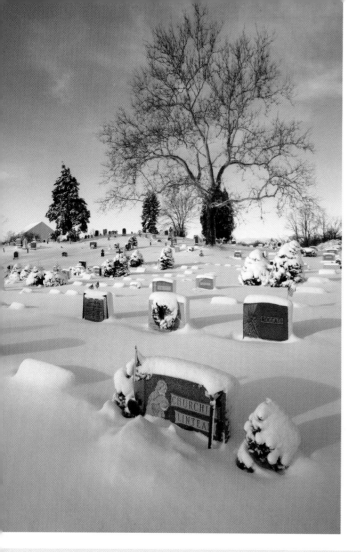

Landscape Mode

In landscape photography (as well as in cityscape photography), you usually want most of the scene to appear in sharp focus, because that's how you see it with your eyes. In the Landscape mode, a digital SLR camera sets a small aperture to produce good depth of field. Notice how all the elements in this photograph of a Hudson Valley cemetery are in sharp focus.

It's okay to use the Landscape mode when there are no foreground elements close to your shooting position. I took the photograph below while standing on the South Rim of the Grand Canyon.

When subjects are both very close and very far away, as in this Monument Valley, Arizona, scene, one or both subjects may be out of focus when you use the Landscape mode. It's better to choose the Aperture Priority mode, described in Lesson 6.

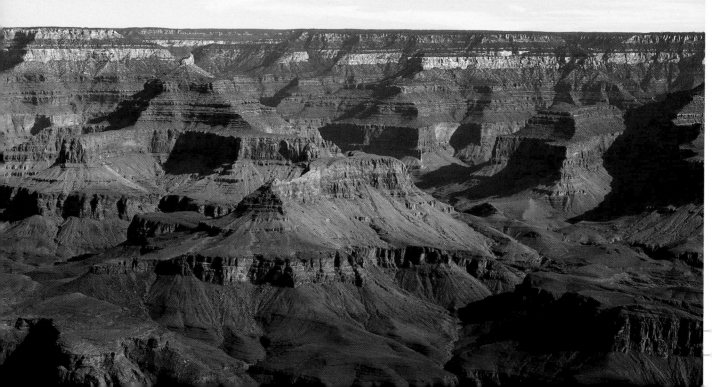

Close-up Mode

Close-up photographs capture fine detail with good depth of field. To help you get a sharp shot in the Close-up mode, the built-in flash in a digital SLR camera automatically pops up (or you can activate an accessory flash) to illuminate the subject, and a small f-stop is set for good depth of field. In the Close-up mode, you have no control over the depth of field or the background's brightness level.

When you want control over the background focus, and want either a darker or brighter background, you'll need to switch to a creative picture mode, such as Manual or Aperture Priority (see Lesson 6).

Night Portrait Mode

Want to use city lights as a backdrop for a portrait? Set your camera to the Night Portrait mode. A slow shutter speed is selected to capture the lights, and the built-in flash automatically pops up (or you can activate an accessory flash) to light your subject. This mode is perfect when you want to get a good exposure of both the subject and an illuminated background, and it's what I used for this portrait of my friend Chandler at Lincoln Center in New York City.

As with the Close-up mode, you can't fine-tune the brightness of the background in the Night Portrait mode. If you want a dark background when the background is illuminated, this night portrait is not the best choice. Manual exposure or the Aperture Priority mode is the way to go (see Lesson 6). I used the Manual mode for this picture of a young woman in a remote Amazon village.

Flash-off Mode

Indoors, there are times when you don't want to illuminate a subject in low-light conditions with a flash—times when you want a more natural look. This was the case when I was photographing this man in Mongolia. In these instances, use the Flash-off mode, and hold your camera steady! In very low light, you'll need a tripod to minimize camera shake, which can cause a blurry picture.

When taking landscape pictures in low light, use the Flash-off mode, or else the flash may illuminate near foreground subjects. Use the Aperture Priority mode, discussed in Lesson 6.

Okay, now it's time to switch gears and move on to creative exposure modes.

Creative Exposure Modes

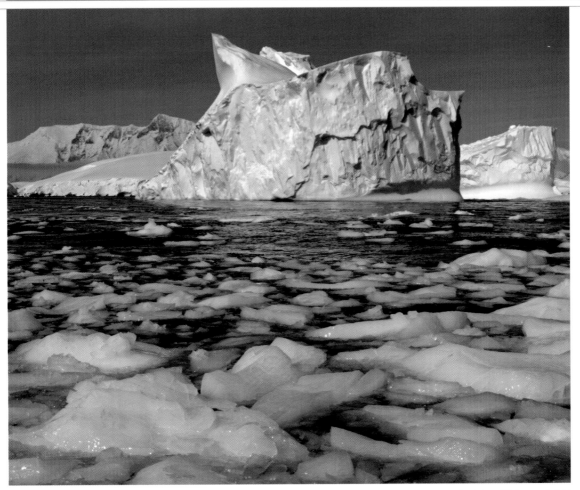

TECH INFO: Canon EOS 1Ds Mark II, Canon 17–40mm lens @ 20mm, ISO 100, 1/125th sec. @ f/11

In Lesson 5 we explored fully automatic photo/exposure modes. Those modes are designed for people who want the camera to make f-stop and shutter speed decisions and for people who generally make these decisions but for whatever reason simply want to grab a shot. Those modes don't offer any creative control, except for the composition of the image.

Now let's take a look at creative exposure modes. In Manual mode, which I used for this picture of an iceberg in Antarctica, the photographer chooses shutter speed, f-stop, everything! Other creative exposure modes—Program, Shutter Priority, and Aperture Priority—are automatic, but not fully automatic. You can still take control and be creative, but don't have to worry about making *all* the decisions.

Program Mode

When set to the Program mode, the camera automatically sets the shutter speed and f-stop for a correct exposure of the scene. At a moment's notice, however, you can change that combination—to a slower or faster shutter speed or to wider or smaller f-stop—because the Program mode is adjustable. You can make adjustments to your shutter speed and f-stop choices while you are shooting. If I had wanted the background behind more or less in focus in this portrait, I could have made that adjustment quickly and easily by turning a wheel on my camera that adjusts the f-stop and shutter speed without changing the exposure.

TECH INFO: Canon EOS 1Ds Mark II, Canon 70–200mm lens @ 200mm, ISO 100, 1/125th sec. @ f/5.6

So you might be asking, "What's the difference between the Program mode and the Shutter Priority and Aperture Priority modes?" In the Shutter Priority and Aperture Priority modes, which I'll cover next, the shutter speed and f-stop, respectively, remain constant, once selected, even if the light level changes. In the Program mode, the camera reverts to the camera-recommended setting after you take a picture.

TECH INFO: Canon EOS 1D Mark II, Canon 70–200mm lens @ 200mm, ISO 400, 1/125th sec. @ f/3.5

Open the Aperture

When blurring the background is important, as was the case when I was photographing this archer in Bhutan, select a wide f-stop (smaller number). The camera will then automatically set the shutter speed for a correct exposure.

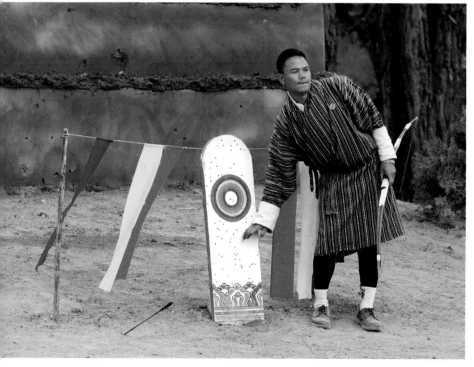

TECH INFO: Canon EOS 1D Mark II, Canon 100–400mm lens @ 400mm, ISO 200, 1/125th sec. @ f/11

Keep the Background Sharp

When keeping the background in focus is important, select a smaller f-stop (higher number) than the camera-recommended f-stop. The camera will then automatically set the shutter speed for a correct exposure. That's what I did for this photograph of another archer in Bhutan.

Freeze the Action

When freezing a subject's action is important, which is what I wanted to do when photographing this pelican in Florida, set a higher shutter speed than what the camera recommends. The camera will automatically set the f-stop for a correct exposure.

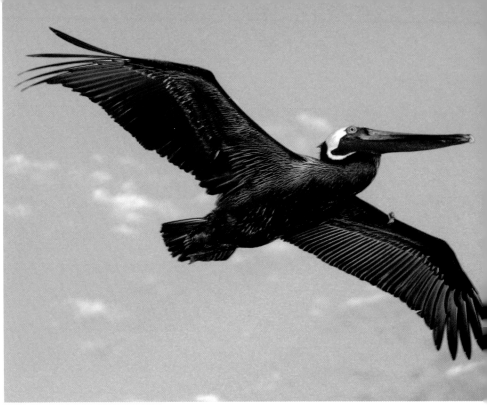

TECH INFO: Canon EOS 1Ds Mark II, Canon 100–400mm lens @ 320mm, ISO 400, 1/125th sec. @ f/5.6

Blur the Subject

When you wish to blur a subject's movement, set a slower speed than the one recommended and let the camera automatically set the aperture for a correct exposure. Setting a slower speed allowed me to blur the water's movement in this picture of the rapids at Niagara Falls.

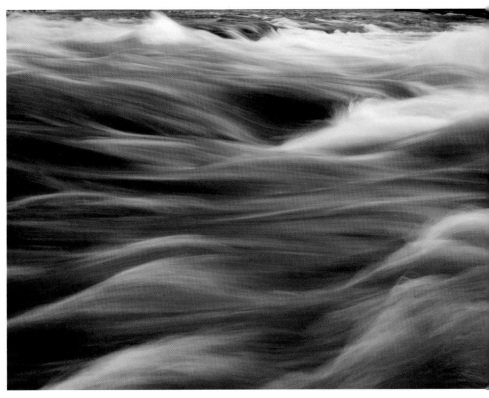

Tech info: Canon EOS 1Ds Mark II, Canon 17–40mm lens @ 20mm, ISO 100, 1/15th sec. @ f/11

Shutter Priority (Tv) Mode

If precisely controlling how motion appears in a picture is your objective, set your camera to the Shutter Priority mode. Use fast shutter speeds to freeze action, slow shutter speeds to blur action.

Controlling how we see a subject's movement is actually quite cool. The pelican and Niagara Falls photos on the previous page provide two examples; here are two more.

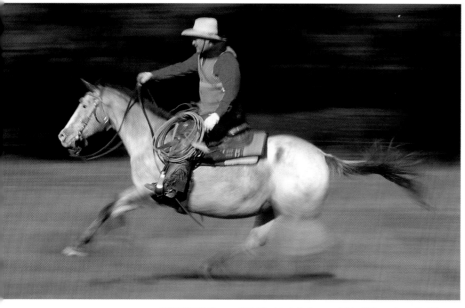

TECH INFO: Canon EOS 1Ds Mark II, Canon 100–400mm lens @ 400mm, ISO 100, 1/15th sec. @ f/11

Panning

Here the rider is in focus and the background is streaked. I used a technique called panning to create the effect. Here's how to do it: First, set a slow shutter speed, say 1/15th of a second or so. Then, as the subject moves across your path, start to follow it. When the subject is directly in front of you, take the picture, and continue to follow the action in the viewfinder for a few seconds.

TECH INFO: Canon EOS 1Ds Mark II, Canon 50mm macro Lens, ISO 100, 1/15th sec. @ f/11

Radial Blur

You can create a circular or radial blur while keeping the center of an image relatively sharp. Set a slow shutter speed, maybe 1/15th of a second. Position the camera level with the subject in the center of your composition. Turn your camera a quarter or half turn clockwise (or counterclockwise). Now push the shutter release button as you rotate the camera back to the initial level position.

Aperture-Priority (Av) Mode

When precisely controlling depth of field is important to the photograph,
use the Aperture Priority mode.

TECH INFO: Canon EOS 1Ds Mark II, Canon 50mm macro lens, ISO 200, 1/60th sec. @ f/4.5

TECH INFO: Canon EOS 1Ds Mark II, Canon 50mm macro lens, ISO 200, 1/60th sec. @ f/16

Wide F-stop

Choosing a wide f-stop offers shallow depth of field
on the chessboard. The background is very blurred.

Small F-stop

Choosing a small f-stop offers greater depth of field.
Almost everything in the scene is in focus.

TECH INFO: Canon EOS 1Ds Mark II, Canon 17–40mm lens @ 17mm, ISO 400, 1/125th sec. @ f/16

Everything in Focus

In this photograph, which I took in Bhutan, everything in the scene, from the young monk in the foreground to the *dzong* (temple) in the background, is in focus. That's not only because I selected a small aperture, but also because I focused on a point one-third into the scene (using the focus lock on my camera), recomposed the picture, and shot. That's a standard technique for getting the maximum depth of field in a wide-angle exposure.

TECH INFO: Canon EOS 1Ds Mark II, Canon 17–40mm lens @ 20mm, ISO 400, 1/125th sec. @ f/8

Lock in the Exposure

Some digital SLR cameras offer a feature called Exposure Lock, which lets you lock in the exposure of a subject, even if it's off center. Press the Exposure Lock button to activate the Exposure Lock, compose your picture with an active focus indicator of your choice placed over the subject, press the shutter release button halfway down (to lock in the exposure), recompose the scene, and shoot! On some cameras, the Exposure Lock is tied into the Focus Lock, so you can lock in both the exposure and focus at the same time.

This feature works well when the background is darker than the subject, as illustrated by the photograph above of a woman releasing a bird in Vietnam. Exposure Lock also works well when the background is brighter than the subject, as in the photograph to the left of an archer in Mongolia.

TECH INFO: Canon EOS 5D, Canon 17–40mm lens @ 40mm, ISO 800, 1/60th sec. @ f/5.6

Manual Exposure Mode

For total exposure control, especially in tricky lighting situations that can fool a camera's exposure meter, choose the Manual exposure mode. In this mode, you separately set both the shutter speed and f-stop for a slightly darker or lighter picture (or background). You can also change the settings to control the degree of subject movement, as well as subject movement against the background movement, and vice versa. (For more on tricky lighting conditions, and how to use what's called Exposure Compensation, see Lesson 8, "Challenging Exposure Situations.")

For now, here are just a few examples of conditions in which you may want to use the Manual exposure mode.

To get a good exposure of this light subject, a Cirque du Soleil performer, against a dark background, I dialed down the "correct" exposure in the Manual mode, after checking my first exposure, which was a bit overexposed, on my camera's LCD display.

TECH INFO: Canon EOS 1Ds Mark II, Canon 70–200mm lens @ 200mm, ISO 800, 1/125th sec. @ f/5.6

This Botswana sunset was already spectacular. To enhance the colors, I set the exposure to one stop under the camera-recommended setting while in the Manual mode.

To capture the beautiful sunset in the background and the couple in the foreground, I used a flash to illuminate the subjects and dialed in the correct f-stop/shutter speed combination for the ambient light in the Manual mode. This let me fine-tune the exposure in a tricky lighting situation.

TECH INFO: Canon EOS 1Ds Mark II, Canon 100–400mm lens @ 400mm, ISO 100, 1/500th sec. @ f/5.6

TECH INFO: Canon EOS 1Ds Mark II, Canon 17–40mm lens @ 40mm, Canon Speedlite 550 EX, ISO 100, 1/60th sec. @ f/5.6

A fast shutter speed and small aperture were selected so the background went black in this flash exposure of some chess pieces.

TECH INFO: Canon EOS 1Ds Mark II, Canon 50mm macro lens, ISO 400, 1/250th sec. @ f/22

TECH INFO: Canon EOS 1Ds Mark II, Canon 50mm macro lens, ISO 200, 1/30th sec. @ f/3.5

A relatively slow shutter speed and wide aperture were selected to blur the background and capture just a touch of movement in this butterfly's wings. Like the above photograph, it's a flash exposure.

Now that you see the reasons for and advantages of the Creative Exposure modes, I hope you take the time to use them—and be more creative with your pictures!

Choose a Metering Mode

TECH INFO: Canon EOS 1v, Canon 70–200mm lens @ 200mm, ISO 100, 1/500th sec. @ f/8

Digital SLR cameras offer different types of light metering modes: evaluative, center-weighted average, spot, partial, and auto exposure lock, which I used for this sunset photograph I took in Rajasthan, India.

Each metering mode has its advantages. If you know which to choose in a particular lighting situation, you'll have a good chance of getting a perfect exposure.

On the next few pages, I'll give an overview of each mode. Keep in mind that different camera models feature different types of metering, and that not all cameras offer all of the modes discussed.

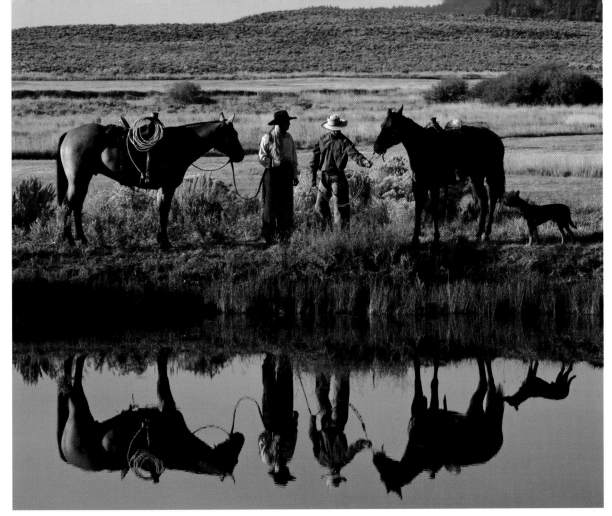

TECH INFO: Canon EOS 1D Mark II, Canon 100–400mm lens @ 200mm, ISO 400, 1/125th sec. @ f/5.6

TECH INFO: Canon EOS 1Ds Mark II, Canon 28–135mm lens @ 100mm, ISO 200, 1/250th sec. @ f/8

Evaluative Metering

Evaluative metering measures the brightness level of the entire scene. It is ideally suited for quick shooting when there is not a lot of contrast in the scene, as illustrated in these two pictures, one taken on the Ponderosa Ranch in Oregon and one at a local fair in Florida. On some cameras, this mode not only measures light, but also identifies some challenging situations, such as backlighting, and automatically adjusts the exposure. Furthermore, on some cameras, this metering mode "knows" where your primary subject is located in the frame, because Evaluative metering is linked to the camera's auto focus system.

Evaluative metering is a good choice in many situations, because it evaluates the different areas of the scene and selects the best exposure.

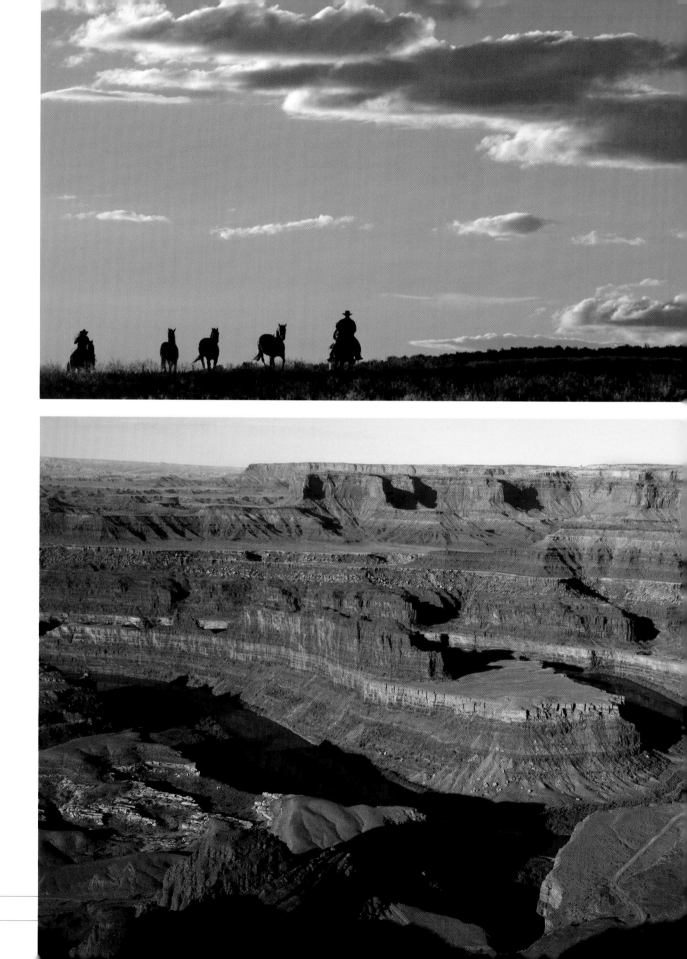

TECH INFO: Canon EOS 1Ds Mark II, Canon 17–40mm lens
@ 20mm, ISO 100, 1/125th sec. @ f/11

Center-Weighted Average Metering

Center-Weighted Average metering gives special emphasis to the center of the frame, but also covers the surrounding area. This is a good mode to select when the surrounding area is only slightly darker or lighter than the center.

Unlike Evaluative metering, which meters virtually the entire picture area, Center-Weighted metering does not attempt to identify and correct situations like backlighting. This means you have to be a bit more careful.

However, many experienced photographers prefer this mode because they can apply their own exposure compensation, covered in Lesson 8, "Challenging Exposure Situations," knowing that the camera has not automatically tried to do likewise. I used this mode to photograph horses on a ridge at the Ponderosa Ranch, and for the picture of Dead Horse Point State Park in Utah.

TECH INFO: Canon EOS 1Ds Mark II, Canon 17–40mm lens
@ 17mm, ISO 100, 1/250th sec. @ f/8

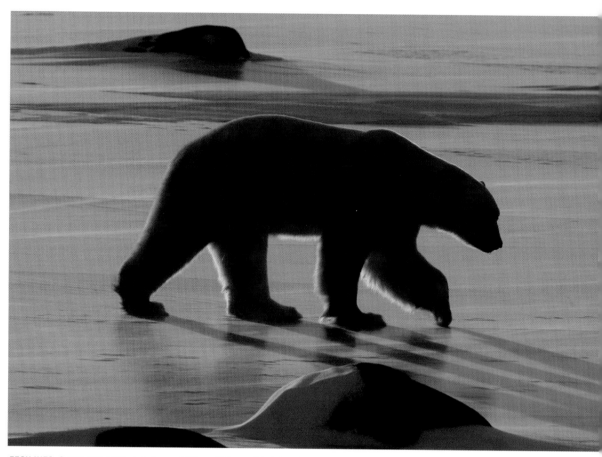

TECH INFO: Canon EOS 1D Mark II, Canon 400mm DO lens with 1.4x teleconverter, ISO 800, 1/250th sec. @ f/8

Spot Metering

Spot metering measures the light condition in a small area in the center of the frame, typically a spot that's only about 2–3 percent of the entire area of the picture. When you have a certain area of a scene, such as the polar bear, the seagull's head, or the cowgirl's face, that you want to precisely measure without factoring in other areas of the subject or background, this mode is the way to go.

The size of the spot varies from camera to camera, with high-end cameras usually having a smaller spot than entry-level cameras.

TECH INFO: Canon EOS 1D Mark II, Canon 70–200mm lens @ 100mm, ISO 200, 1/125th sec. @ f/5.6

TECH INFO: Canon EOS 1D Mark II, Canon 100–400mm IS lens @ 400mm, ISO 400, 1/500th sec. @ f/8

TECH INFO: Canon EOS 1D Mark II, Canon 17–40mm lens @ 20mm, ISO 400, 1/125th sec. @ f/8

TECH INFO: Canon EOS 1D Mark II, Canon 17–40mm lens @ 20mm, ISO 800, 1/125th sec. @ f/4.5

Partial Metering

Partial metering covers an area exclusively at the center of the scene, generally about 10 percent of the total picture area—not quite as small as that of a Spot meter. If the surrounding area is darker or lighter than the main subject, this mode is a good choice; that's why my wife, Susan, selected it for these fun family shots.

Many cameras without a Spot metering mode offer Partial metering.

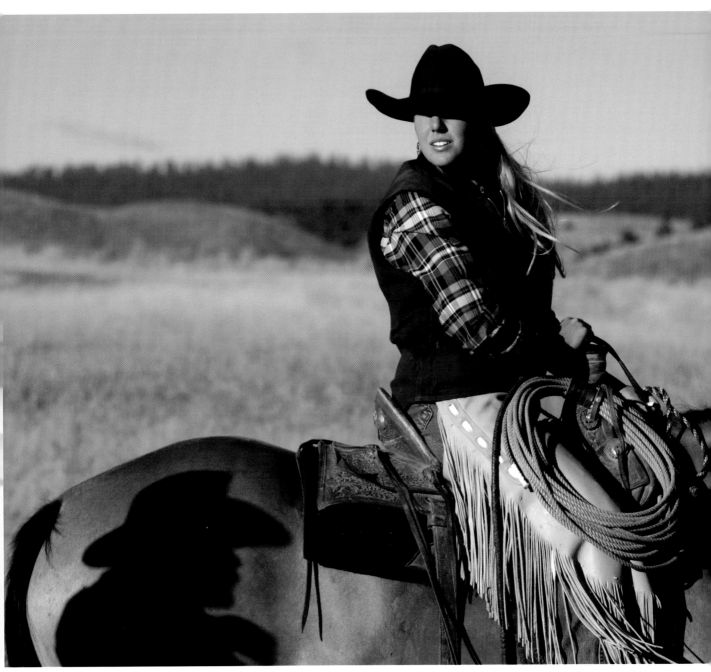

TECH INFO: Canon EOS 1Ds Mark II, Canon 28–105mm lens @ 105mm, ISO 400, 1/125th sec. @ f/11

Exposure Lock

As I mentioned in Lesson 6, some digital SLR cameras feature an Exposure Lock as part of the metering system. With this feature, you can move in or zoom in on an area of a scene, press the Exposure Lock button, and lock in that exposure. Recompose the scene and take the picture: the exposure won't change. This mode helped me get a good exposure of a cowgirl on the Ponderosa Ranch.

I also used Exposure Lock for this picture of an owl in upstate New York. In both situations, locking in the exposure on the subject ensured a good photo.

Exposure Lock is useful when you need an accurate reading of a specific subject surrounded by a dark or light area, and when you have the luxury of being able to move or zoom in to take the reading.

Choose your mode wisely before you shoot!

TECH INFO: Canon EOS 1D Mark II, Canon 17–40mm lens @ 17mm, ISO 100, 1/125th sec. @ f/11

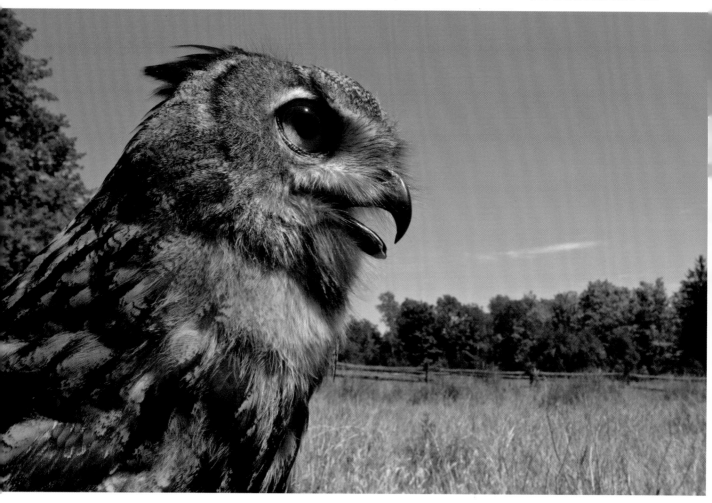

Challenging Exposure Situations

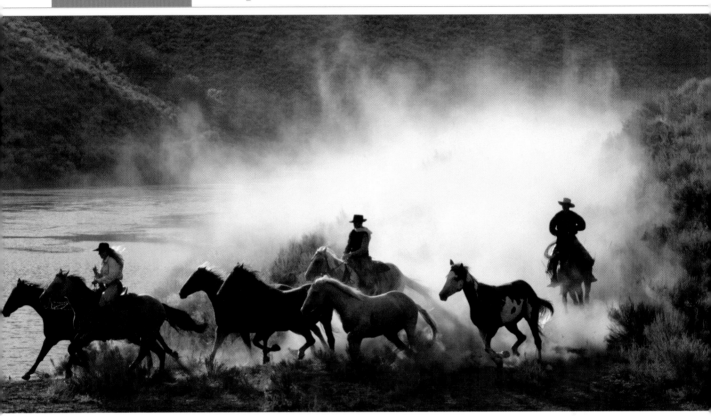

TECH INFO: Canon EOS 1D Mark II, Canon 100–400mm lens @ 400mm, ISO 400, 1/500th sec. @ f/5.6, EV set at −1

This lesson is about shooting in challenging exposure situations, such as this backlit Wild West scene of horses and riders taken near sunset on the Ponderosa Ranch in Oregon. We'll explore situations in which the lighting conditions or the subject or both fool a camera's exposure meter into thinking the scene is darker or lighter than it really is. We'll also talk about times when the light changes quickly, and what happens when the subject moves quickly between different light sources of the same or different intensities. All these topics lead to one thing: getting the exposure that *you* want, which may be different from the exposure that your camera would automatically choose or that other photographers may envision.

In Lesson 3 I talked about the importance of seeing the light. If you skipped that lesson, now is a good time to go back. You must be able to see the light before you can make exposure decisions that will best capture the light in challenging situations. In Lesson 3 I also touched on exposure compensation, which lets you quickly and easily fine-tune an exposure. For the Wild West shot

I set my exposure compensation (often referred to as EV, for exposure value) to –1. You'll understand why by the lesson's end.

In this lesson, I'll focus on using exposure compensation when shooting in Aperture Priority, Shutter Priority, and Program modes. I could have called this lesson "Exposure Compensation to the Rescue in Challenging Exposure Situations," but that title was too long. I also could have tried "Solving Problem Exposure Situations," but if you learn how to see the light and compensate for it (and then control it, as you'll see in Lesson 11, "Control Natural Light"), you will not have problems, only challenges, which are easily overcome with a little photographic know-how.

Note that the +/– EV control does not change the exposure compensation in the Manual mode. In Manual, you simply dial in the camera-recommended exposure and compensate over or under that setting accordingly.

In this lesson, the EV adjustment will be included in the tech info for each photograph. Keep in mind that my suggestions, such as –1 or +1, are just starting points; they are not universal for all similar situations.

So get ready to put those "problem" situations behind you. Before you take control, however, keep in mind that you can also fine-tune your exposures—to a degree—in Photoshop and Camera RAW, which is something I do all the time. But hey, who wants to spend lots of time sitting at a computer when it's easier and more rewarding to get the best possible in-camera photographs?

Bracketing

This series of pictures of Angkor Wat, in Cambodia, demonstrates the use of bracketing, which I first mentioned in Lesson 1. The first image was taken at the camera recommended setting. The second image, a bit lighter, shows what a picture would look like with the EV set to +1. The darkest image shows what happens when the EV is set to –1. Taking pictures at EV settings over and under the camera-recommended setting helps to ensure that you end up with at least one favorable in-camera exposure.

Bracketing Options

With a digital SLR camera, you can bracket the exposure manually, using the +/– control after each exposure, or you can set your camera to automatic bracketing, which does the work for you.

How much you should bracket depends on the lighting situation and the effect you want to create. In low contrast scenes, you don't have to bracket more than 1/3 of a stop over and under the starting point. In high contrast scenes, you may want to bracket more. You can set the start of the bracket point to over or

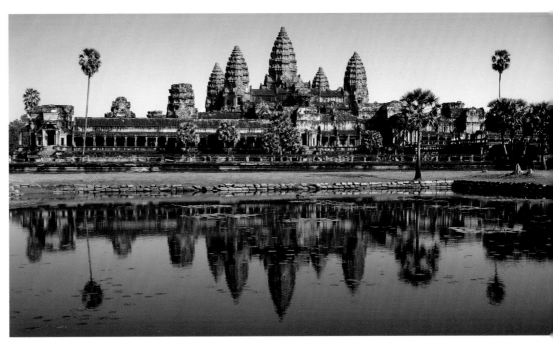

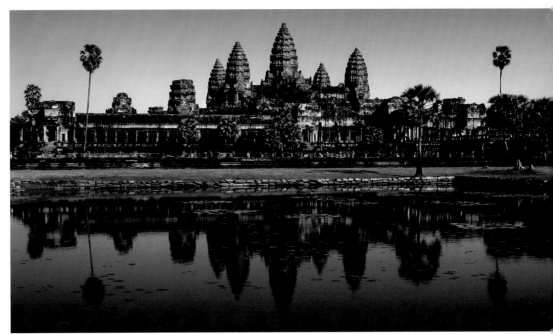

TECH INFO: Canon EOS
1D Mark II, Canon
100–400mm lens
@400mm, ISO 400,
1/250th sec. @ f/5.6,
EV set to 0 (top left);
then +1 (top right); and
then −1 (bottom right)

under the 0 starting point. For example, when shooting sunsets,
I often bracket starting at −1/3 so that I get additional exposures
at 0 (1/3 of a stop over that setting) and then at −2/3 (1/3 of a stop
under that setting). Why do I start at −1/3? Because I never want
an overexposed sunset; I prefer richer, more saturated colors,
achieved when we underexpose a scene.

Camera Setup

I tried to stay away from LCD monitor menu shots in this book. However, I'll include a few here, from the Canon Digital Rebel XT's LCD monitor, in order to show the different automatic bracketing settings, from 0 to +2 to –2.

I also share them for another reason: I want you to think about the +/– control every time you look through the viewfinder. I shoot all my natural light pictures on an automatic mode, using Aperture Priority when a

subject is not moving and Shutter Priority when a subject is moving. I only use the Manual mode when taking flash pictures (see Lesson 9, "Flash Exposures"). So, for me, thinking about the +/– control when I look through the viewfinder is key to getting a good exposure.

Let's take a look at some situations in which automatic bracketing, the easiest way to bracket, can help you get a good exposure.

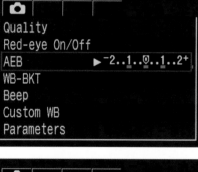

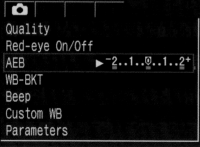

Rapidly Changing Lighting Conditions

When I was photographing Niagara Falls at night, the light level was changing rapidly and constantly because the powerful spotlights on the other side of the falls were changing in intensity and color. To ensure a good exposure of the water, as you see in the first image of the sequence shown here, I automatically bracketed my exposure over and under the camera-recommended setting by one f-stop, because I knew I did not want the water overexposed, which might have happened because the spotlights shining on the falls were constantly changing in intensity.

I shoot with top-of-the-line Canon digital SLR cameras that let me capture several frames per second. That's one of the advantages of a professional camera: you don't miss a shot due to a slower frame-per-second speed.

TECH INFO: Canon EOS 1Ds Mark II, Canon 17–40mm lens @17mm, ISO 400,
1/20th sec. @ f/5.6, EV set to 0 (top left); then −1 (top right); and +1 (bottom)

TECH INFO: Canon EOS 1D Mark II, Canon 50mm macro lens, Canon Ring Lite MR-14EX, ISO 100, 1/60th sec. @ f/11, EV set to −1/3

When You Only Have One Chance

Automatic exposure bracketing comes in very handy when a once-in-a-lifetime photo opportunity presents itself—in this case, a butterfly emerging from its chrysalis—and you simply can't afford to miss the shot, or in this case, a series of shots.

To capture this dramatic sequence, I set my automatic bracketing to 1/3 over and under the 0 setting. These pictures are a few of the –1/3 images from that sequence.

TECH INFO: Canon EOS 1D Mark II, Canon 28–105mm lens
@ 35mm, ISO 200, 1/125th sec. @ f/5.6, EV set to –2

Reducing the Exposure Value

Now let's talk about times when you may want to manually set the EV to a negative
number. Then we'll get to scenarios that require a positive setting.

Silhouettes

When you want a dramatic silhouette, set the EV to –1 or –2. Keep in mind that when
you underexpose an image, you increase the digital noise. However, when shooting
scenes such as this one, a bike rider on a Montana mountaintop, you are not really
underexposing the scene by two stops. Rather, you are really setting the exposure for
the highlights, in this case the sky in the background.

Very Dark Subjects

You may think that a dark subject, such as this bison, would require a positive exposure value. All that dark area, however, can fool a camera's meter into thinking that the scene is darker than it really is, and the resulting image is overexposed. A –1 setting is a good place to start when photographing dark subjects that fill the frame

TECH INFO: Canon EOS 1D Mark II, Canon 100–400mm IS lens @ 400mm, ISO 400, 1/250th sec. @ f/5.6

Avoid Overexposed Areas

This picture of a pilot filling the envelope of his balloon is a very tricky lighting situation. I did not want the flames overexposed, but I also did not want to lose the vibrant color of the balloon or the onlookers, so I set my EV to –1.

TECH INFO: Canon EOS 1D Mark II, Canon 17–40mm lens @20mm, ISO 400, 1/60th sec. @ f/5.6, EV set to –1

Spot Lit Subjects

The spotlights illuminating these performers create a dark, almost black background. To prevent the highlights from being very overexposed, I set the EV to –1.

TECH INFO: Canon EOS 1D Mark II, Canon 70–200mm lens @ 150mm, ISO 800, 1/125th sec. @ f/5.6, EV set to –1

Dark Backgrounds

The sails and hull in this aerial photograph illustrate the use of a regular EV setting to preserve detail in bright areas of a scene. Had I not compensated for the dark area of the water, which fooled the camera's meter into thinking the scene was darker than it was, the sails would have been overexposed, and that detail lost forever. Extremely overexposed areas are impossible to rescue, even in Photoshop and Camera RAW.

TECH INFO: Canon EOS 1D Mark II, Canon 70–200mm lens @200mm, ISO 400, 1/500th sec. @ f/5.6, EV set to –1/2

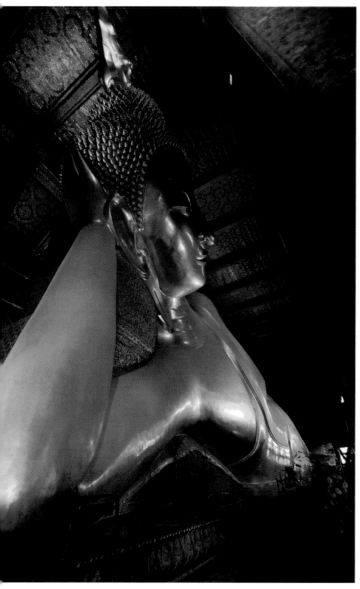

TECH INFO: Canon EOS 1D Mark II, Canon 17–40mm lens @ 17mm, ISO 400, 1/30th sec. @ f/5.6, EV set to −1

TECH INFO: Canon EOS 1D Mark II, Canon 100–400mm lens @400mm, ISO 800, 1/60th sec. @ f/5.6, EV set to −1

Bright Reflections

Highly reflective subjects, such as this statue of a reclining Buddha that I photographed in Bangkok, bounce bright points of light into your lens, and as a result those areas become overexposed. A negative EV setting will remedy that.

By the Light of the Moon

And speaking of bright areas of a scene, check out the moon in this picture, taken in Botswana. It is yet another good example of using a negative EV setting to achieve a good exposure.

TECH INFO: Canon EOS 1D Mark II, Canon 100–400mm lens @ 400mm, ISO 400, 1/500th sec. @ f/5.6, EV set to +1

Increasing the Exposure Value

Let's talk about some situations for which you want to use a positive EV setting.

Just as a dark subject can fool a camera's exposure meter, as in the bison photograph (page 133), a light subject or scene can trick the exposure meter into seeing a composition as lighter than it really is. If you ever get a chance to photograph penguins in Antarctica marching over ice, set your EV to +1. When you are shooting in the snow, at the beach, or in any setting where the background is light, a +1 EV is a good place to start.

Bright Background

In this case, the white Bentley in the background reflects more light than my friend Andrea, who posed for me on the vintage car. All that white, you guessed it, could have fooled a camera's exposure meter. EV +1 to the rescue again.

TECH INFO: Canon EOS 1D Mark II, Canon 28–135mm IS lens @ 35mm, 1/250th sec. @ f/8, EV set to +1

Dark Subject, Light Background

This dark-skinned dancer is standing in front of the white hull of a cruise ship in St. Maarten. To see the detail in her face, I set my EV to +1.

Stage Spotlights

Just as reflections can become overexposed in a scene, as in the reclining Buddha photograph on page 135, so can spotlights on a stage. But in cases like this concert at the Crop Over Festival in Barbados, it's okay, because we want to see the subject clearly, and the overexposed lights add to the mood of the scene (as long as they are not too overexposed). Start bracketing your exposure at +1 in situations such as this one to ensure a good exposure of the subject.

TECH INFO: Canon EOS 1D Mark II, Canon 28–105mm lens @ 105mm, ISO 100, 1/125th sec. @ f/5.6, EV set to +1

TECH INFO: Canon EOS 1D Mark II, Canon 28–105mm lens @ 100mm, ISO 800, 1/125th sec. @ f/8, EV set to +1

TECH INFO: Canon EOS 1D Mark II, Canon 100–400mm IS lens @ 400mm, ISO 400, 1/125th sec. @ f/11 (top); and at 1/60th sec. @ f/5.6 (bottom)

When the Picture Is Not There

Exposure compensation is wonderful, and Photoshop is fantastic for fixing things your in-camera exposure may have missed. But there are times when no amount of EV compensation or image editing can help, as was the case in the picture of the sun setting over a forested mountain range. The contrast range was simply far too great.

Sometimes the correctly exposed picture is simply not there. What to do? One option is to wait for the right light. Another is to recompose the scene, with a lower contrast range. These photos are of the same mountain range; for a better exposure I composed a shot without the bright setting sun.

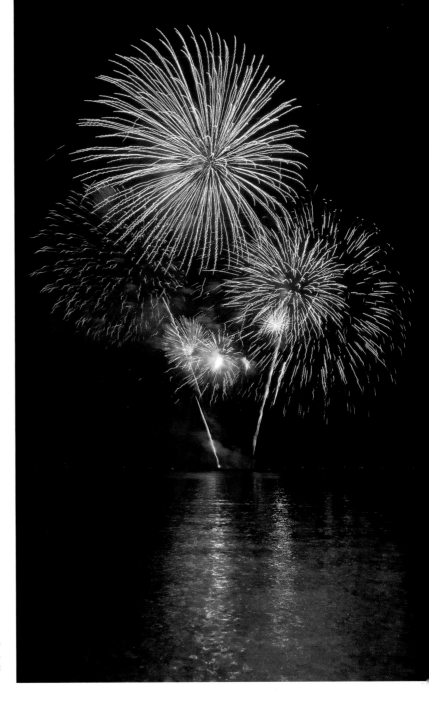

TECH INFO: Canon EOS 1D Mark II, Canon 17–40mm lens @ 17mm, ISO 200, 2 sec. @ f/8

Fireworks

In closing this lesson on challenging exposure situations, I thought I'd leave you with one of the most challenging: fireworks. Why are fireworks challenging to photograph? Because the light level constantly changes, the subject is not always in the same place in the frame, the bursts vary in intensity from frame to frame and within each frame, and the streaming lights move at different speeds.

All these variables make photographing fireworks a BLH (Bracket Like Hell) situation. For your starting point, here are some suggestions.

- Use a wide-angle lens (to capture a large area of the sky).
- Set the ISO to 200.
- Set the aperture to f/8.
- Set the image quality to RAW (because you can recover overexposed highlights up to one f-stop).
- Set your camera to the Shutter Priority mode and select a shutter speed of two seconds (so you get long streaks of light).
- Mount your camera on a tripod (to prevent camera shake during the long exposure).

Once you're set-up, take lots of pictures. Don't frame the fireworks tightly in the frame or the bursts may be cut off by the frame edges. Take exposures at different f-stop settings, over and under f/8. Experiment with different shutter speeds. Vary the ISO. Check your LCD monitor often to see if you like your compensation and exposure. And be sure to have fun!

Photographing fireworks is a very challenging exposure situation, and you may not get perfect shots your first time out—even if the pictures look good on the small LCD monitor on your camera. After all, you will be shooting in the dark! (On that note, bring a small flashlight so you can make camera adjustments and find memory cards in your camera bag.) For more information on checking your exposures as you shoot, see Lesson 12.

Don't get discouraged if you get less-than-perfect results. Learn from your mistakes and try, try again—as I still do.

See the light and compensate for it accordingly—and carefully.

HW5U5864.CR2

Metadata	Keywords	
▶ File Properties		
▶ IPTC Core		
▼ Camera Data (Exif)		
Exposure	: 2.0 s at f/8	
Exposure Mode	: Manual	
Exposure Program	: Manual	
ISO Speed Ratings	: 200	
Focal Length	: 17 mm	
Lens	: 17.0–40.0 mm	
Max Aperture Value	: f/4.0	

Flash Exposures

TECH INFO: Canon EOS 1D Mark II, Canon Speedlite 580EX, Canon 28–105mm lens @ 100mm, ISO 100 1/125th sec. @ f/8

You might ask: "Why is Rick leading off the lesson on flash exposures with an outdoor picture of a little boy blowing bubbles?" The answer is twofold. First, this picture uses a daylight fill-in flash in which the light from the flash is balanced to the available daylight. It doesn't look like I used a flash, which is my goal for most of my flash pictures—indoors and out. Second, I want to point out that learning how to use a flash outdoors is an essential part of photographing people and wildlife outdoors. In addition to filling in shadows, a flash can add desirable catch light in the subject's eyes, caused by the reflection of the flash.

We'll begin this lesson with a discussion of outdoor flash photography principles. Then we'll move on to indoor flash pictures.

Creative flash photography does not begin with your camera and flash, although those items are certainly necessary. The creative process, rather, begins with you, and your vision of how a scene can be lit with a flash or flashes.

Once you learn how to see the light, you can choose a flash or flash set-up to help you capture that vision with your camera.

TECH INFO: Canon EOS 1D Mark II, Canon 28–105mm lens @ 100mm, ISO 100 1/125th sec. @ f/8

Fill-in Flash

Compare these two pictures that I took in Gibraltar. The top photograph is an available light shot, the one below a daylight fill-in flash shot that clearly shows the monkey's face. As with the photograph of the little boy, the flash photograph does not look like a flash photograph. Here's how to reach that goal.

• First, you'll need a flash with variable flash output control, that is, a +/− exposure control.
• Set your camera to the Manual exposure mode.
• Turn off the flash.
• In the Manual mode, set the exposure for the existing light.
• Turn on your flash, and take an exposure with the flash set at −1 1/3. If your picture looks too much like a flash shot on the camera's LCD monitor, reduce the flash output to −1 1/2. If it's still too "flashy," continue to reduce the flash until you are pleased with the results.

This technique works because even in the Manual mode, the flash operates in the TTL (through the lens) Automatic flash metering mode.

Some newer digital SLR cameras and flash units help the flash metering system determine the main subject's distance, and actually calculate the aforementioned settings automatically. Still, I suggest you master this technique if you are serious about your flash photography.

TECH INFO: Canon EOS 1D Mark II, Canon Speedlite 580EX, Canon 28–105mm lens @ 35mm, ISO 100 1/125th sec. @ f/8

TECH INFO: Canon EOS 1D Mark II, Canon Speedlite 580EX, Canon 100–400mm lens @ 300mm, ISO 400, 1/125th sec. @ f/3.5

TECH INFO: Canon EOS 1D Mark II, Canon Speedlite 580EX, Canon 28–105mm lens @ 105mm, ISO 200 1/60th sec. @ f/8

Darken the Background

Balancing the light from the flash to the available light basically means that both the subject and background have the same amount of illumination, so one is not darker or lighter than the other. However, it's sometimes nice to have a darker background, so that the subject stands out more in the picture.

These two exposures, one of a monkey that I took in Jungle World at New York's Bronx Zoo and one of a Thai dancer that I took in Bangkok, illustrate how a darker background can be complimentary to the subject.

Unlike my daylight fill-in flash Gibraltar exposure, which shows the background properly exposed, these pictures are the result of intentionally underexposing the background. For the Jungle World shot, I set the available light exposure one stop under the camera-recommended setting. For the Thai dancer shot, I set the available light exposure four stops under the camera-recommended setting, and as a result the background went black. In both shots the subject is well exposed by the flash.

As you may have surmised, by using daylight fill-in flash, you can control the brightness of the subject *and* the background independently. Very cool!

TECH INFO: Canon EOS 1D Mark II, Canon 28–105mm lens @ 105mm, ISO 400, 1/125th sec. @ f/8

TECH INFO: Canon EOS 1D Mark II, Canon Speedlite 550EX, Canon 28–105mm lens @ 105mm, ISO 400, 1/200th sec. @ f/8

Shutter Speed Control

When photographing fast-paced outdoor action with a flash, you need to pay attention to both the f-stop and the shutter speed. A slow shutter speed could result in a blurry photograph. For action shots, I recommend a speed of at least 1/200th of a second, the speed I selected to photograph my son, Marco, at a local skate park. The picture on the left is a natural light shot; the one on the right is a flash photograph.

But be careful! Make sure that your flash sync speed can match your shutter speed, otherwise the shutter will not open long enough to allow activation of the full flash. As a result, part of the frame will not be illuminated by the flash.

Macro Photos

Speaking of outdoor flash photography, you also use daylight fill-in flash when taking close-up photographs using a macro lens for magnification, which is how I took this picture of two butterflies mating at Butterfly World in Coconut Creek, Florida. Again, the goal is not to have the picture look like a flash picture. For even lighting of an exposure taken with a macro lens, you'll need a ringlight, a flash accessory that fits around the end of your lens.

Before we move on to indoor flash photography, keep in mind that you can use a fill-flash indoors too—again so your pictures don't look like flash pictures.

TECH INFO: Canon EOS 1D Mark II, Canon 50mm macro Lens, Canon Ring Lite MR-14EX, ISO 100, 1/60th sec. @ f/11

TECH INFO: Canon EOS 1D Mark II, Canon 17–40mm lens @ 17mm, ISO 400, 1/125th sec. @ f/5.6

Indoor Flash Photography

Professional studio photographers spend thousands of dollars on lighting equipment. Many times their goal is to get portraits with shadowless lighting, as illustrated in these pictures of model Caroline McCallister in a professional studio.

But as illustrated at the start of this lesson, we can also get pictures with shadowless lighting, without spending thousands. Read on!

TECH INFO: Canon EOS 1D Mark II, Canon 28–105mm lens @ 35mm, ISO 100, 1/125th sec. @ f/8

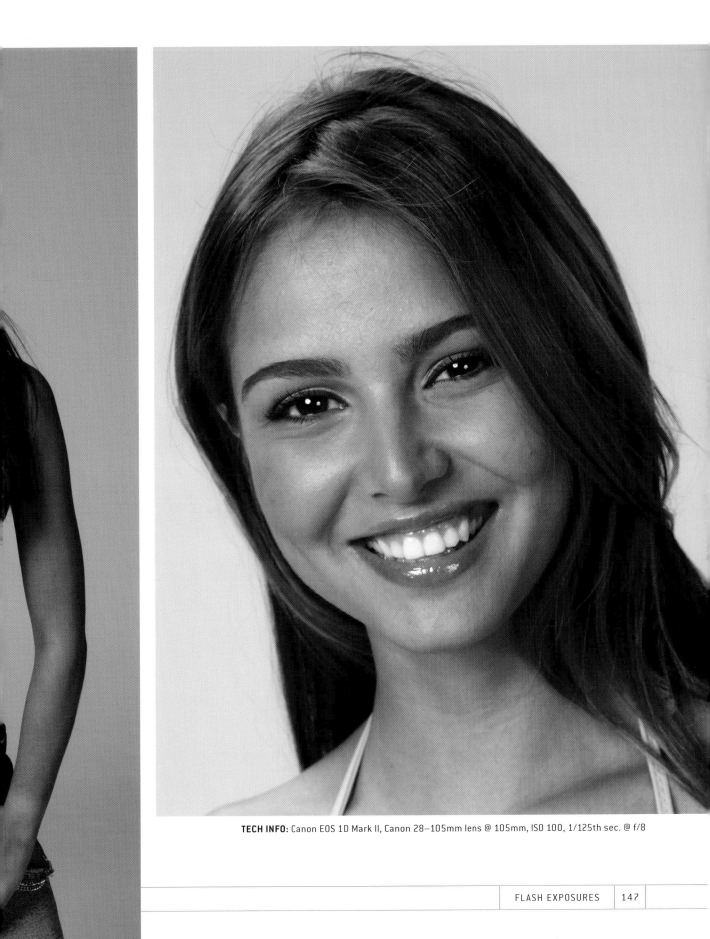

TECH INFO: Canon EOS 1D Mark II, Canon 28–105mm lens @ 105mm, ISO 100, 1/125th sec. @ f/8

TECH INFO: Canon EOS 1D Mark II, Canon Speedlite 580EX,
Canon 28–105mm lens @ 105mm, ISO 400, 1/125th sec. @ f/8

TECH INFO: Canon EOS 1D Mark II, Canon Speedlite 580EX Canon 28–105mm lens
@ 105mm, ISO 400, 1/125th sec. @ f/8

Only the Shadow Knows

In this pair of pictures of my son, Marco, the harsh shadow in the first shot ruins, for me, the natural feeling of the photograph. My ISO setting for this low-light picture was set at 400. As I mentioned, in low light, you'll need to boost the ISO to record the available light at a hand-held shutter speed.

In the photo of Marco wearing a hat, I balanced the light from the flash to the available light using the technique I suggested that you use outdoors (see page 142). Look closely, and you'll see the catch light that the flash produced in Marco's eyes.

Hold Your Flash Carefully

How you hold your camera affects one of the most important elements in indoor flash photography: the shadow produced by the flash.

The accompanying pictures illustrate how the position of the flash, as well as the flash head, affects the shadow. For each photo of Marco and his camera I held my camera and flash in the same position as Marco is shown holding his gear. I'll skip the tech info for these photos, because it's not necessary.

The flash unit shown features a swivel head for expanded creative control. A swivel head is a must for serious shooters.

Holding the camera vertically with the flash above the lens produces harsh shadows behind the subject.

Holding the camera horizontally with the flash off to the side produces a harsh shadow on the side of the subject opposite the flash.

Ahhh! Look what happens when you turn the swivel head upward to bounce the light off the ceiling while holding the camera both horizontally and vertically. The shadows are greatly reduced as the lighting becomes soft and pleasing. In the shot below, I bounced the flash straight up, so that the light would diffuse off the ceiling in all directions. In the bottom-right shot, I bounced it forward at a 45-degree angle, which produced more direct light on my subject. Note that the color of the ceiling will affect the color of your subject. If the ceiling is white, the color of your subject should be correct (if you set your white balance to Flash, or at least to Automatic White Balance).

When there is no ceiling around for bounce flash photography, you can reduce the shadow or hide it behind the subject by adding a flash bracket and a coil cord. Flash brackets have swivel arms, so you can take both horizontal and vertical pictures with the flash positioned directly above the lens. A flash bracket increases the distance between your lens and flash. Hence, it can push a flash shadow further away behind or below your subject. For this exposure I didn't position my flash to mirror Marco's set-up; can you tell I bounced the flash off the ceiling by the light shadow that the bracket makes on Marco's wrist?

For even softer light, add a flash diffuser. That's the white opaque cover you see over my flash in this photograph of a wax likeness of Annie Leibowitz, taken at the Madame Tussauds wax museum in New York City.

TECH INFO: Canon EOS 1D Mark II, Canon Speedlite 580EX, Canon 28–105mm lens @ 35mm, ISO 400, 1/60th sec. @ f/8

Family Shots

When taking indoor pictures, such as a family photograph, try to position the subject or subjects away from a wall. The closer the subject or subjects are to a wall, the greater chance you have of capturing a shadow. Here you see no shadow, because the subjects took a few steps away from the background. Plus, I bounced the light from the flash off the ceiling.

TECH INFO: Canon EOS 1D Mark II, Canon Speedlite 580EX, Canon 70–200mm lens @200mm, ISO 400, 1/125th sec. @ f/8.

Blur the Background

As with all exposures, the f-stop you select when taking flash pictures indoors is important. To blur the background, use a wide aperture, f/4.5 or f/5.6, as I did for this portrait of a house cat. For a more in-focus foreground, I used a smaller aperture, f/8 or f/11, with a long 200mm lens setting.

TECH INFO: Canon EOS 1D Mark II, Canon Speedlite 580EX, Canon 70–200mm IS lens, @ 100mm, ISO 400, 1/125th sec. @ f/8

Flash Exposure Compensation

In Lesson 8, "Challenging Exposure Situations," I talked about how a white subject can fool a camera's exposure meter into thinking that a scene is brighter than it actually is, resulting in an underexposed picture. The same thing can happen in flash photography. The dark picture here of a masked Filipino performer was taken with the flash's exposure compensation (EV) set to 0. Notice the man's neck and collar are too dark. The lighter, correctly exposed image shows what happens when the flash EV is set to +1. The higher EV setting compensates for the large amount of white in the scene and avoids overexposing the darker areas of the frame.

Some cameras feature a built-in flash EV compensation setting. Use one or the other. Each gets you to the same place.

Watch the Background

Throughout this book I talk about the importance of seeing the light. In indoor flash photography, we need to see the light on the subject *and* the light on the background. We also need to see if the background is reflective, as was the case when I was photographing this performer in Bangkok.

The direct light from the flash caused a harsh reflection on the wall behind the subject. By moving slightly to the side of the subject, I was able to eliminate the harsh reflection.

TECH INFO: Canon EOS 1D Mark II, Canon Speedlite 580EX, Canon 100–400mm lens @ 100mm, ISO 400, 1/60th sec. @ f/5.6

TECH INFO: Canon EOS 1D Mark II, two Canon Speedlite 420X flash units, Canon Wireless Transmitter, Canon 28–105mm lens @ 50mm, ISO 200, 1/60th sec. @ f/8

Adding Flash Units

Want to have more fun with indoor flash photographs? Try using two slave flash units (circled at the right and left of this photo), which can be fired remotely by a wireless transmitter (on the camera in the center of the photo). That's how I got even lighting in this self-portrait studio shot.

By adding a second flash unit, you'll get more light, and you'll be able to shoot at a smaller f-stop—for more depth of field— without reducing your shutter speed or ISO settings.

Create a Studio

Need a professional studio fast? Take a look! I leaned a background against a bookshelf in my office, mounted the two flash units on either side of my camera, which was mounted on a tripod, set the self-timer, and then jumped into the scene. Good fun!

TECH INFO: Canon EOS 1D Mark II, Canon Speedlite 580EX, Canon 17–40mm lens, ISO 800, 1/30th sec. @ f/5.6

Sometimes, No Flash is Best

TECH INFO: Canon EOS 1D Mark II, Canon 24–105mm lens
@ 105mm, ISO 1000, 1/60th sec. @ f/4.5

TECH INFO: Canon EOS 1D Mark II, Canon 24–105mm lens
@ 105mm, ISO 1000, 1/60th sec. @ f/5.6

Now you know how, when, and why to use a flash. Don't get so caught up in the excitement of all these flash techniques, however, that you use them all the time. Sometimes, not using a flash is the best idea. These two pictures of my friend Chandler, one taken indoors in low light and one outdoors in low light, are two such examples. In both situations, I boosted the ISO up to 1000 for natural light photographs. I reduced the noise in Adobe Camera RAW by moving the Luminance and Color sliders (under the Detail tab) to just under 30 percent.

We often use a flash to illuminate a subject. That, however, is not the only way to artificially light a subject. We can use a flashlight for a technique known as painting with light. By using a flashlight as we would a paintbrush, we can illuminate a subject and light it beautifully and creatively in our own unique manner—controlling shadow and highlight areas with an artistic wave of our "light brush."

Check out these two pictures of a piranha. The top one is a behind-the-scenes shot. The much more dramatic image below it is the result of using a small flashlight to "paint" the subject with light during a 20-second exposure. I was careful not to spill any "paint" on the background. The result, after taking five not-so-great exposures, looks like museum-quality lighting, created with a $3.99 flashlight.

Painting with light is not only fun, but it can be very creative. Here are some tips for the best results.

TECH INFO: Canon EOS 1D Mark II, Canon 24–105mm lens @ 105mm, ISO 100, 20 seconds at f/11

TECH INFO: Canon EOS 1D Mark II, Canon 24–105mm lens @ 105mm, ISO 400, 1/30th sec. @ f/5.6

Experiment with flashlights of different beam sizes and different light intensities. Here we see the effect of using a medium-size yellow beam from a small flashlight (the same one I used for the piranha photograph) compared to the red beam from a smaller flashlight with a built-in laser pointer.

Set your ISO to 400 and aperture to f/11 or higher for good depth of field.

Work in a dark area, so the light from the flashlight becomes the main light source. That said, you could even paint with light outdoors. In theory, you could paint a tree with a large flashlight just after sunset, when there is just a hint of light in the sky.

Set your camera to the Manual mode and work with long exposures, long enough to paint your subject, maybe as long as a minute. Of course, you'll need a tripod to steady your camera.

Be prepared to take a lot of exposures, because you will move the light at different speeds over a subject, causing bright and dark areas that you may or may not like.

TECH INFO: Canon EOS 1D Mark II, Canon 24–105mm lens @105mm, ISO 400, 20 seconds at f/11

TECH INFO: Canon EOS 1D Mark II, Canon 24–105mm lens @105mm, ISO 400, 20 seconds at f/11

LESSON 10

Explore Color Modes and Parameters

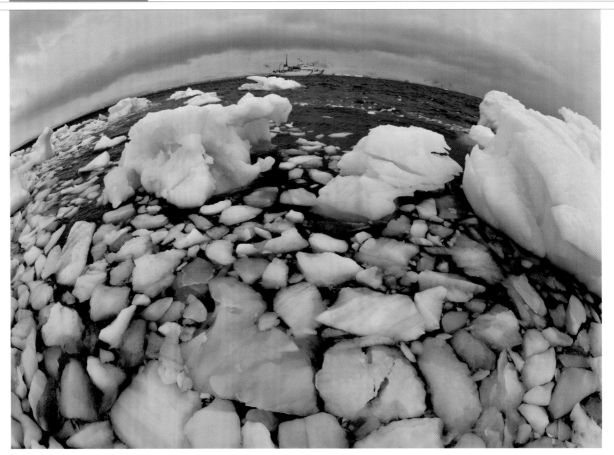

TECH INFO: Canon EOS 1Ds Mark II, Canon 15mm lens, ISO 100, 1/125th sec. @ f/8

One of the cool things (besides the temperature) about being in Antarctica, where I took this picture, is that you can actually see the curvature of the earth. Only kidding! I used a 15mm full-frame fisheye lens on my full-frame image sensor camera to get this dramatic image.

I like the black-and-white effect, just one of several color modes you'll find that digital SLR cameras offer in what's sometimes referred to as parameters.

This black-and-white image, however, started out as a color file. I converted it black-and-white in Photoshop to illustrate the effect of choosing the black-and-white color mode.

I shoot all my pictures in color, and then experiment with color options (as well as exposure changes) in Photoshop. I shoot color files because I need color pictures for my books and magazine articles. However, it is fun to experiment with in-camera color modes, because it allows us to see different versions of a scene on-site on the camera's LCD monitor.

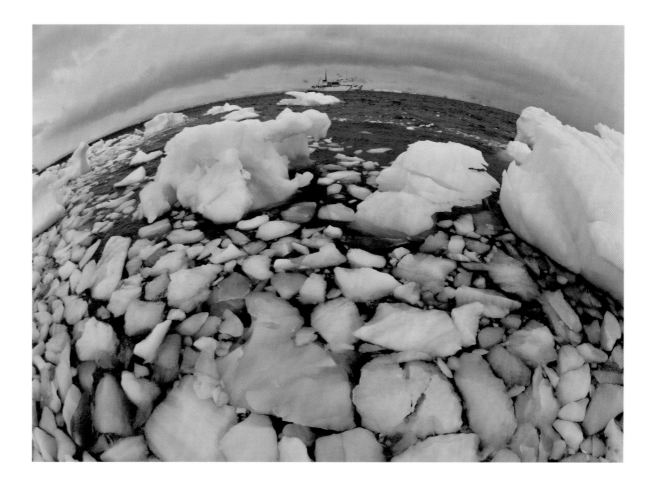

Color modes can also be creative, because when you see a scene with a different color tint or tone, you may make changes in exposure compensation accordingly, perhaps increasing or decreasing the exposure slightly. So for the novice, color modes can be a good teaching tool, too.

Each camera model handles parameters or color modes a little differently. Check your owner's manual for available options and how to use them. Experiment! Have fun!

Using some before and after examples, let's explore some of these color options, as well as other in-camera enhancements (simulated here in Photoshop) that can be applied to a file while in-camera.

But first, here's a look at the original Antarctica color file. It's one of my favorite pictures from the bottom of the world.

TECH INFO: Canon EOS 1D Mark II, Canon 28–105mm lens @ 105mm, ISO 400, 1/125th sec. @ f/8

Sepia Tone Image

I photographed this schoolgirl in Bhutan in a setting with soft light. Here you see how the image would look if we selected Sepia as the color mode. By removing the natural color in the scene, some of the reality is removed. In this case, her pink shirt becomes less bold and the tone of her face more closely matches that of the pillar beside her.

Increase Saturation

Ever since supersaturated films were introduced some time ago, photographers have gravitated toward color-saturated pictures. Here is an example of how increasing the Saturation option can enhance a picture. The colors pop in this seascape that I photographed in Corsica, with blues becoming more blue and greens greener. Of course, we can desaturate an image for a more subtle effect.

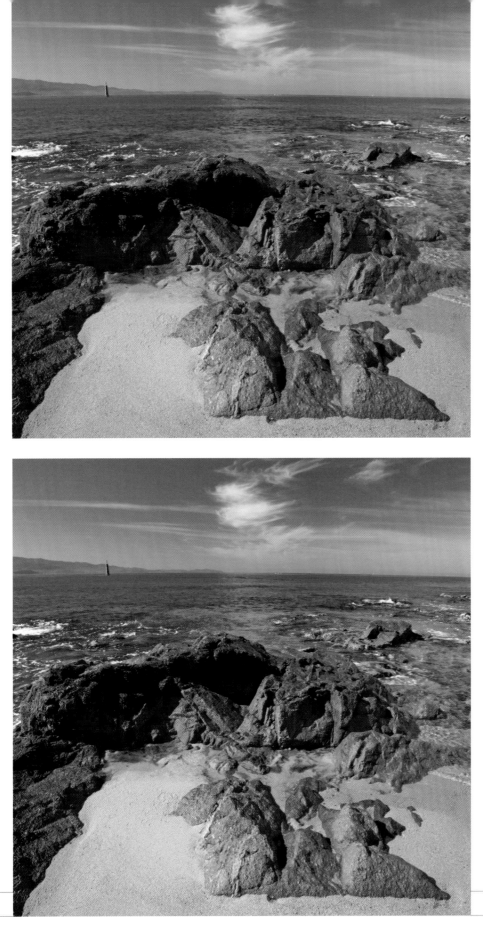

TECH INFO: Canon EOS 1D Mark II, Canon 17–40mm lens @ 40mm, ISO 200, 1/125th sec. @ f/5.6

TECH INFO: Canon EOS D60 (converted to infrared-only), Canon 17–40mm lens @ 17mm, ISO 400, 1/60th sec. @ f/22

Black-and-White Infrared Images

Some digital SLR cameras offer a black-and-white infrared (IR) mode. When set to the IR mode, digital pictures have the dreamy, grainy look of infrared film. Leaves turn white and the sky turns black. The pictures seem to glow.

Some digital SLR cameras from Canon and Nikon can be converted, permanently, to infrared-only cameras by companies such as the IR Guy (www.irdigital.net) and by Life Pixel (www.lifepixel.com). These IR-only cameras produce the best infrared effects I have seen. I took these two IR pictures, one of a tree in my backyard and one of a roadside building in Utah, with my IR-only camera.

Combining Black-and-White and Color IR Images

Here is something that I think is very cool: a black-and-white and color image. I took the roadside shot on the opposite page in Utah with my converted IR-only Canon. Here's how I got the blue sky.

First, I set my camera on Custom White Balance. Then, while looking through the viewfinder, I filled the frame with green grass and set the white balance for the grass. That made the grass appear white in my pictures rather than gray. (Normally, with color photography, you fill the frame with a white subject and set the white balance for white, which should give you accurate color of all the other objects in a scene.)

When I opened the picture in Photoshop, I created a new Hue/Saturation Adjustment Layer and set the

TECH INFO: Canon EOS D60 (converted to infrared-only), Canon 17–40mm lens @ 17mm, ISO 400, 1/60th sec. @ f/22

mode to Color. Then, in the Hue/Saturation dialogue box, I reduced the Hue completely. That turned the image, except the sky, into a black-and-white photograph. The blue is the result of setting the white balance for green grass.

Increase Contrast

Although not a color option, one of the parameter choices many cameras offer increases the contrast of a file. Increasing the contrast makes a picture look sharper. If you increase the contrast too much, however, you may lose detail in the brightest highlight areas, as you can see in the bottom image of a palace I photographed in India. So, choose the Contrast setting—from a little to a lot—very carefully, or shoot the same scene with several different Contrast settings.

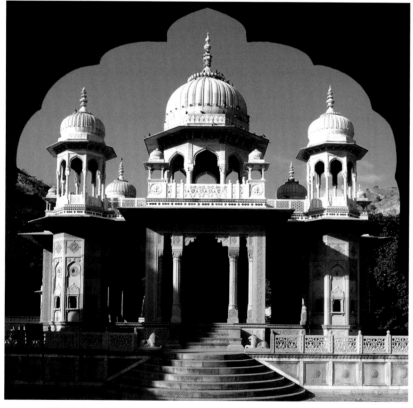

TECH INFO: Canon EOS A2E, Canon 16–35mm lens @ 20mm, ISO 200, 1/125th sec. @ f/11

Sharpen Up Your Files

Increasing the sharpness of an image is also a parameter option in many cameras. As with the Contrast setting, you need to be careful when increasing in-camera sharpness. If you oversharpen, it will be virtually impossible to get rid of the resulting pixilation. The bottom image of Dochla Pass in Bhutan illustrates oversharpening—in-camera and then in Photoshop. Yuck!

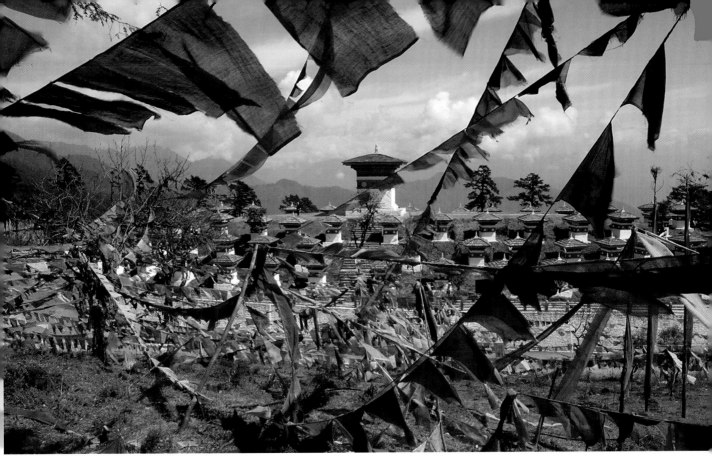

TECH INFO: Canon EOS 1Ds Mark II, Canon 17—40mm lens @ 17mm, Canon Speedlite 580EX, ISO 100, 1/125th sec. @ f/11

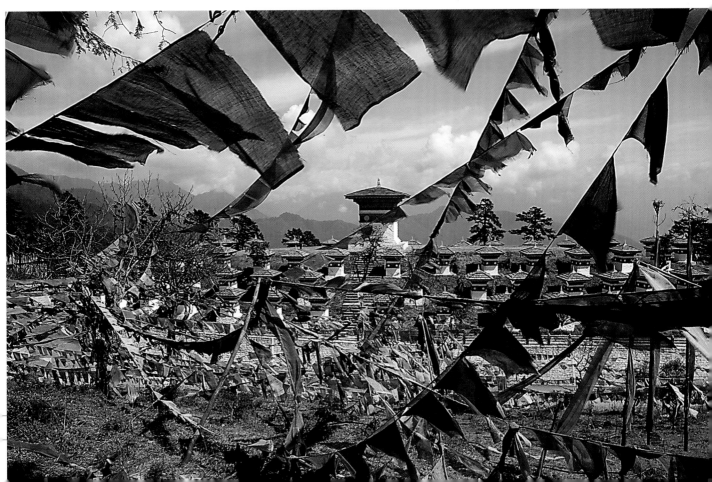

Do It in Photoshop

As I mentioned, I simulated the aforementioned effects in Photoshop, and so can you!
I thought I'd take a moment and show you where to find the enhancements I used.

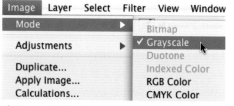

1) Black-and-white: Image > Mode > Grayscale

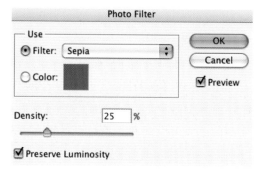

2) Sepia: Image > Adjustments > Photo Filter > Sepia

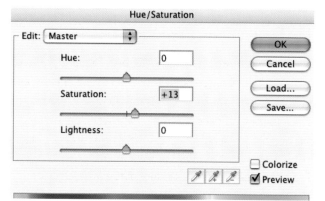

3) Increase saturation: Image > Mode > Hue/Saturation

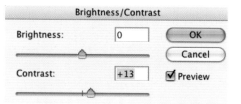

4) Increase contrast: Image > Mode > Brightness/Contrast

All the features and image enhancements, both in-camera and in Photoshop, are wonderful. However, I advise my students to be very careful not to overdo any of them.

5) Increase sharpness: Filter > Sharpen > Smart Sharpen

LESSON 11 Control Natural Light

Throughout this book I've talked about the importance of seeing the light. In this lesson, I am going to talk about how you can control the light in your surroundings to get better in-camera exposures.

Let's begin with the easiest way to control natural light: naturally, without using any accessories.

I like the exposure of this picture of a Kuna woman at the San Blas Hotel in Kuna Yala, Panama, because both the subject and the surrounding area are correctly exposed. I also like the way the woman is framed against the dark, open doorway. But this photograph did not happen by accident. I worked to get a good exposure. Read on.

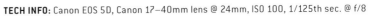

TECH INFO: Canon EOS 5D, Canon 17–40mm lens @ 24mm, ISO 100, 1/125th sec. @ f/8

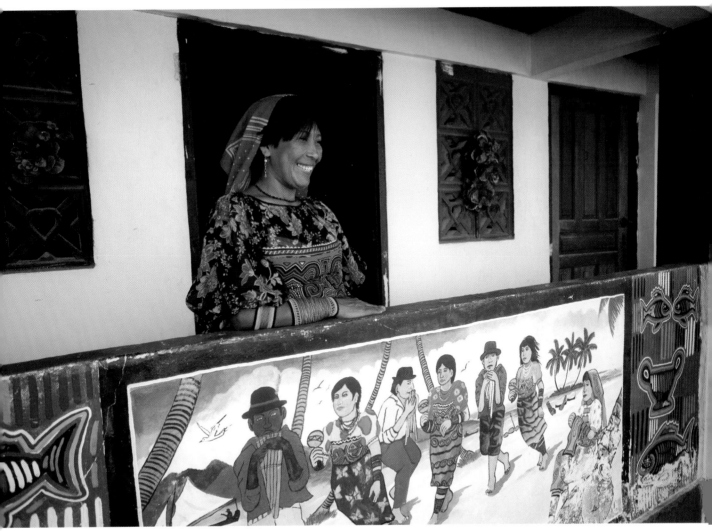

TECH INFO: Canon EOS 5D, Canon 17–40mm lens @ 40mm, ISO 400, 1/125th sec. @ f/11

Here's the first picture I took of the Kuna woman. I shot it from a different position, head-on. What's wrong with this picture? The washed-out look is caused by lens flare, light falling on the front element of the lens (even though I was using a lens hood). I had to find a way to increase my control of the natural light in the scene. I moved a few feet closer to the woman and shot her at an angle to get the exposure that opens this lesson, which is one of my favorite pictures from my Kuna Yala trip.

TECH INFO: Canon EOS 5D, Canon 17–40mm lens @ 24mm, ISO 400, 1/125th sec. @ f/8

When I want a nice portrait of a subject, I often select the background first. I take a shot and adjust my camera for the proper exposure, which is what I did here. That way, I have an idea of a good exposure ahead of time, which saves time when the subject steps into the scene.

Now let's take a look at how we can control light using a few accessories.

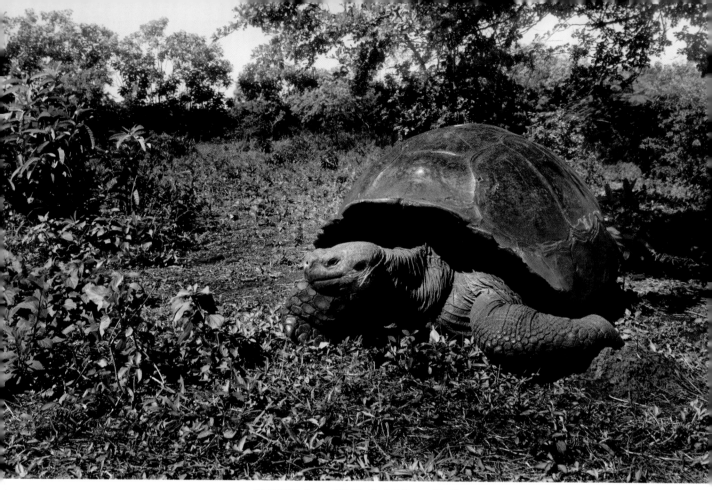

TECH INFO: Canon EOS 1Ds Mark II, Canon 17–40mm lens @ 20mm, ISO 200, 1/125th sec. @ f/8

Graduated Filter

I took these pictures in the Galapagos Islands. Above is my original image. While composing the scene in my viewfinder, I liked how the light fell on the giant tortoise, but the brighter sky in the background was overexposed and distracting. To reduce the difference in the two areas' brightness levels and to add a touch of blue to the sky, I used a graduated blue filter over my lens. This filter is blue on the top and gradually lightens to clear on the bottom—unless you hold it upside down, in which case it does the opposite. Graduated filters come in different colors (including gray, which does not affect the colors in the scene, but does moderate the amount of light recorded), densities (for a stronger or less noticeable effect) and even different gradations—from soft (as I used here) to strong (best used when there is a strong line between the dark and light areas of a picture, such as the horizon line in a seascape).

As you can see by comparing this filtered picture to the opening image, the filter not only darkened and added color to the sky, it also improved the overall exposure by reducing the contrast range.

TECH INFO: Canon EOS 1Ds Mark II, Canon 17–40mm lens @ 20mm, ISO 200, 1/125th sec. @ f/11

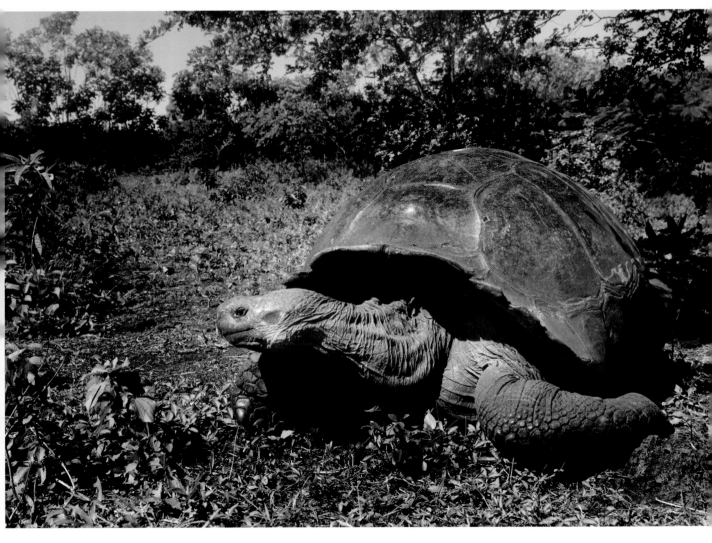

Polarizing Filter

Another useful accessory for controlling the light outdoors is a polarizing filter. You place the filter over the lens, and dial in the effect by rotating the filter: darken a blue sky, whiten white clouds, and reduce reflections on water and glass. In addition, a polarizing filter can make your pictures look sharper by reducing reflections from atmospheric haze. A polarizing filter is only effective, however, when the sun is off to your left or right side—technically, at a 90-degree angle to the direction in which you are facing. If the sun is directly in front of you or behind you, a polarizing filter will have no effect.

The unfiltered picture below of Sullivan Bay on Bartolome Island in the Galapagos looks washed out due to the glare on the water. A polarizing filter reduces the light level entering your camera by about one f-stop, but as in all the Auto modes, the camera compensates for the light loss.

Below is the same scene shot with a polarizing filter. Notice the effectiveness of the filter compared to the unfiltered shot.

TECH INFO: Canon EOS 1Ds Mark II, Canon 17–40mm lens @20mm, ISO 200, 1/125th sec. @ f/8

TECH INFO: Canon EOS 1Ds Mark II, Canon 17–40mm lens @ 17mm, ISO 400, 1/125th sec. @ f/8

TECH INFO: Canon EOS 1D Mark II, Canon 16–35mm lens @ 16mm, ISO 100, 1/125th sec. @ f/11

Don't overdo it. A polarizing filter is perhaps the most useful outdoor filter on sunny days, but it's important to use it wisely. If you dial in the effect too much, the center area of the picture can become darker than the surrounding area (and therefore unnatural), as illustrated in this picture I took of a hot air balloon at the Albuquerque International Balloon Fiesta in New Mexico. To avoid this problem, which is hard to see in your camera's viewfinder and on its LCD monitor, shoot an exposure. Dial the filter back a bit and shoot another exposure. Dial in the maximum effect, and then dial the filter back just a bit.

TECH INFO: Canon EOS 1D Mark II, Canon 16–35mm lens @35mm, ISO 100, 1/125th sec. @ f/8

Use a Diffuser for a Soft Touch

Here's a behind-the-scenes look at one of my portrait sessions. My son, Marco, is holding a diffuser between the sun and the subject, my nephew, William, to soften the harsh sunlight. For outdoor portraits on sunny days, a diffuser is a wonderful accessory. It reproduces the soft and pleasing natural lighting you'd get on an overcast day.

TECH INFO: Canon EOS 1D Mark II, Canon 28–105mm lens @100mm, ISO 200, 1/125th sec. @ f/8

Compare these two images. As you can see, using a diffuser dramatically softened the lighting in the picture by removing the harsh shadows on William's face. The f-stop is wider for this picture to compensate for light loss caused by the diffuser.

TECH INFO: Canon EOS 1D Mark II, Canon 28–105mm lens @ 100mm, ISO 200, 1/125th sec. @ f/5.6

TECH INFO: Canon EOS 1D
Mark II, Canon 16–35mm
lens @ 16mm, ISO 200,
1/125th sec. @ f/8

TECH INFO: Canon EOS 1D Mark II, Canon
28–135mm IS lens @ 135mm, ISO 100,
1/125th sec. @ f/8

Use a Reflector to Brighten the Subject

Here is another behind-the-scenes
look at one of my photo shoots.
This time, my friend, Michelle
Cast, is holding a gold-colored
reflector to bounce direct sunlight
onto the face of a cowgirl, who is
standing in the shade.

TECH INFO: Canon EOS 1D
Mark II, Canon 28–135mm IS
lens @ 135mm, ISO 100,
1/125th sec. @ f/11

Now compare these two images. As you can see, using a reflector dramatically
brightened the picture by adding soft, reflected light.

TECH INFO: Canon EOS 1D Mark II, Canon 16–35mm lens @16mm, ISO 400, 1/125th sec. @ f/5.6

Use a Reflector Indoors to Reduce Shadows

In this behind-the-scenes view, one of my students is holding a silver-colored reflector to bounce window light onto the shadow side of the subject's face.

TECH INFO: Canon EOS 1Ds Mark II, Canon 28–135mm IS lens @ 100mm, ISO 400, 1/125th sec. @ f/8

TECH INFO: Canon EOS 1Ds Mark II, Canon 28-135mm IS lens @ 100mm, ISO 400, 1/125th sec. @ f/5.6

Compare these two images. As you can see, the reflector filled in some of the shadows on the subject's face.

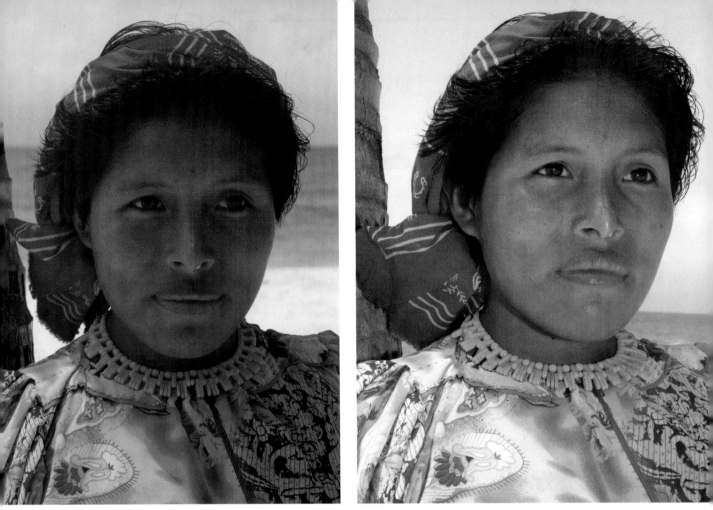

TECH INFO: Canon EOS 1Ds Mark II, Canon Speedlite 580EX, Canon 28–135mm IS lens @ 135mm, ISO 100, 1/125th sec. @ f/8

Daylight Fill-in Flash

We can also use a flash to fill in darker areas in daylight settings. At first, I photographed this young woman in Kuna Yala, Panama in natural light. Then, using a flash, flash bracket, and coil cord, I took the second picture in which her face is brighter. Notice how the light from the flash is balanced to the daylight. See Lesson 9, "Flash Exposures" for more information.

I'll close this lesson with another pair of pictures that shows how using daylight fill-in flash can make dull lighting dramatic.

So, before you leave home to take pictures, keep in mind that you can easily control outdoor light with filters, a reflector, a diffuser, or a flash.

Take control!

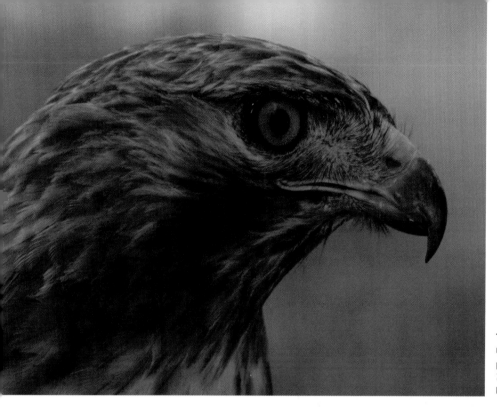

TECH INFO: Canon EOS 1Ds Mark II, Canon Speedlite 580EX (bottom photograph only), Canon 70–200mm IS lens at 200mm, ISO 400, 1/125th sec. @ f/5.6

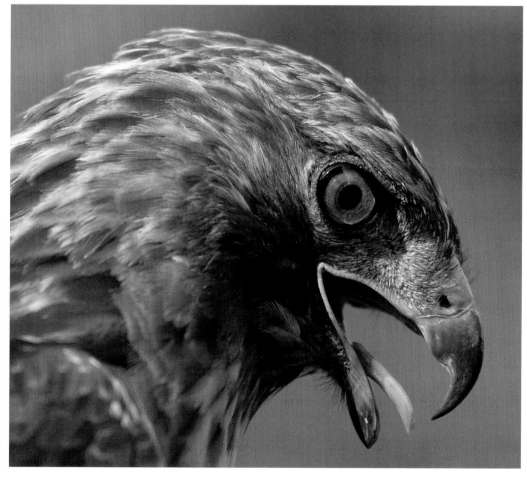

Check Your Exposures

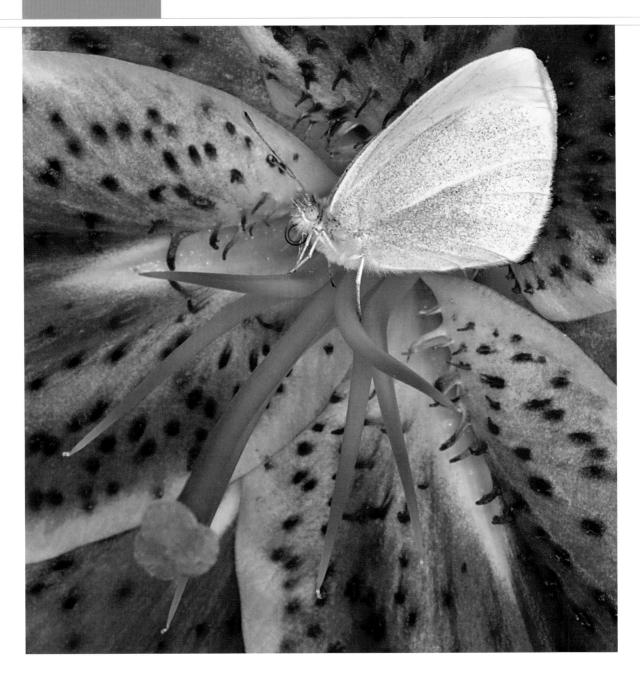

Digital cameras are wonderful recorders of memories. They are
also great teachers, showing us on the LCD monitor what we did
right or wrong seconds after taking a picture.

Novice photographers often use the LCD monitor to check composition and facial expressions. As they get more and more into the art and craft of picture taking, they take fuller advantage of the LCD display, checking it to fine-tune the exposure. That's what I did for this picture of a cabbage white butterfly resting on a flower in my backyard. In the first exposure I took, the butterfly's wings were overexposed. Seeing the problem on the LCD monitor, I underexposed the second image, shown here, by 1/2 f-stop.

In this lesson I'll begin with a discussion on the camera's LCD monitor. Then I'll move on to another wonderful teaching device: Adobe Camera RAW, which you use on your computer. I have not included technical info for each photo because I'd like you to concentrate on simply checking exposures.

LCD Monitor Primer

The first thing you need to know about your camera's LCD monitor is that it does not provide a 100 percent accurate rendition of your picture. How could it, when that job requires a high-resolution, desktop-size monitor that may cost more than $1,000? Still, the LCD monitor does help you check exposure. The image you see on the LCD monitor is for a JPEG file—whether you shoot in JPEG or RAW file format. That's important to know, because even if the LCD monitor tells you that a RAW picture is slightly over- or underexposed (again, we'll get to that soon), you may be able to rescue the highlight or shadow areas in Adobe Camera RAW and in Photoshop. A JPEG file has a smaller exposure latitude than a RAW file, and the data in a JPEG file in areas of over- and underexposure may be lost forever!

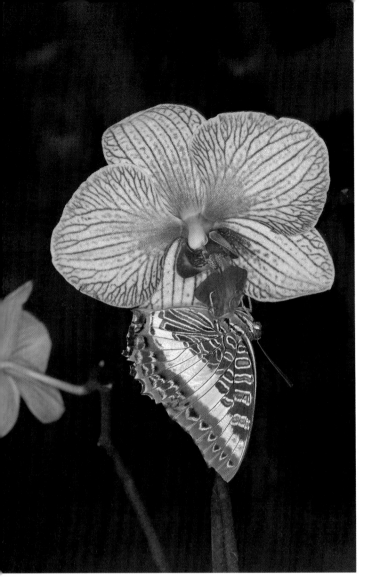

Don't Always Believe Your Eyes

Compare these two flash pictures of a butterfly resting on an orchid that I took indoors at the American Museum of Natural History. On my camera's LCD monitor, the background looked pretty much the same in both pictures—very dark. Knowing the limitation of the LCD monitor, however, I suspected that the lighted background might be visible in the picture, which indeed was true when I viewed the image on the monitor in my digital darkroom.

To be on the safe side, I reduced my exposure (setting a faster shutter speed and a smaller f-stop) to reduce the amount of natural light entering the camera. The picture with the digital frame, added in PhotoFrame Pro 3 from onOne Software, shows the effect I had in mind: the beautiful orchid and butterfly framed against a jet black background.

The moral of the story: Don't always trust what your eyes see on the LCD monitor.

Set the Brightness Level

Here's another thing you need to know about your camera's LCD monitor: You should set it at the highest brightness level and then leave it alone. That way, you'll have one less variable with which to deal. If you set the brightness level too low, your pictures will look too dark, and you may make decisions that will actually cause your pictures to be overexposed.

Overexposure Warning

A really useful feature of the LCD monitor is the overexposure warning, especially when you are photographing a high-contrast scene or a scene with bright areas, such as the sky in this picture of me crawling on the ice in the subarctic.

You can choose to have the warning active or inactive. When activated, potentially overexposed areas of a scene flash on and off rapidly (simulated with the overexposed sky area matted in pink and outlined in red). When you see the warning, reduce the exposure. Or, in a case like this, use a flash or reflector to brighten the subject, or use a neutral density graduated filter to darken the sky.

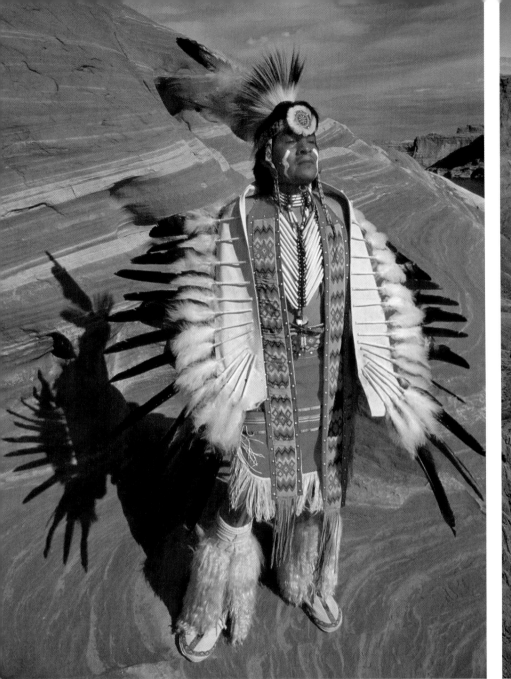

Invaluable Warning

In the previous picture of me freezing on the ice, it's easy to realize that the sky is much brighter than the shivering subject (it was –35°F). In my picture of this Native American performer photographed near Lake Powell, Arizona, potentially overexposed areas, such as the white features on the man's outfit, may be harder to identify. In these situations, the overexposure warning is invaluable. To prevent the white feathers from being washed out, I set my exposure compensation to –1/2.

The same goes for the reflection on the river in this photograph of Horseshoe Bend near Page, Arizona. Take advantage of your camera's overexposure warning feature. It can save the day—and your exposure.

Histogram

All digital SLR cameras and some compact digital cameras have a histogram display. The histogram, which looks like a mountain range, is a graph that shows the distribution of the brightness levels in the picture, with the light areas indicated on the right and the dark areas indicated on the left. Some cameras display only a monotone histogram (for all the tones in a picture), while others feature a much more accurate, three-color histogram that shows the distribution of the brightness levels in the red, green, and blue channels.

There is more information on the histogram in the next lesson, but for now, here's the concept: Generally speaking, you don't want a spike at either end of the histogram. If you have a spike on the right, some highlights will be washed out, and you'll need to decrease your exposure. If you have a spike on the left, some shadows will be blocked up, and you'll need to increase your exposure.

The histogram for the mother and child image that I took at a market in Bhutan shows that I have a good exposure for the scene—no spike at either end of the histograms.

The following three examples show how a histogram will look for a properly exposed image, an underexposed image, and an overexposed image. In Photoshop, I simulated the over- and underexposed images of a picture of Horseshoe Bend near Page, Arizona.

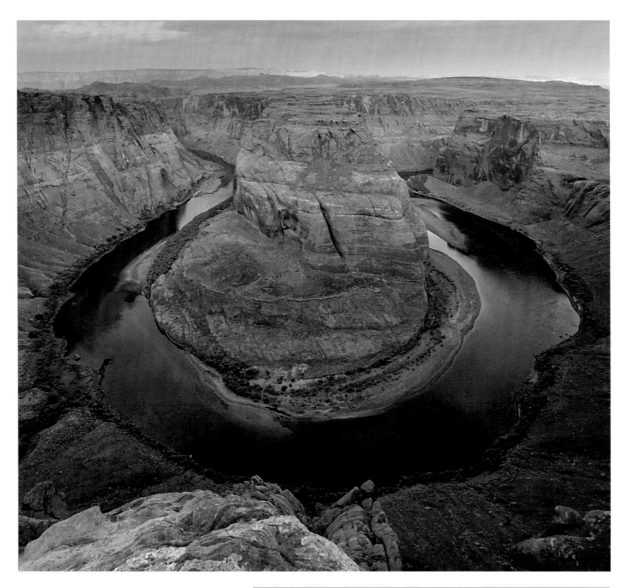

Good Exposure

When an image is properly exposed, the mountain range representing the brightness levels extends nicely across the display. Even a well-exposed image may show some spikes. For example, the histogram for this properly exposed picture of Horseshoe Bend shows a spike at each end of the histogram window.

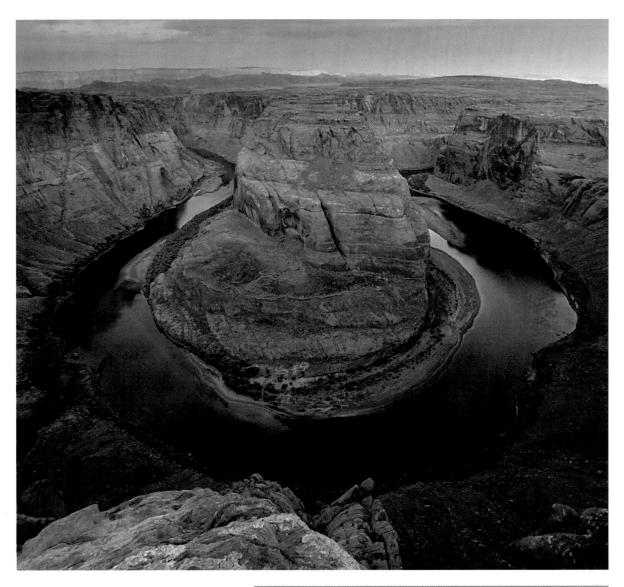

An Underexposed Image

The histogram is weighted toward the left side of the display which indicates a dark image. An increase in exposure is necessary to keep the details in the shadow areas from being lost and to accurately depict the highlight areas.

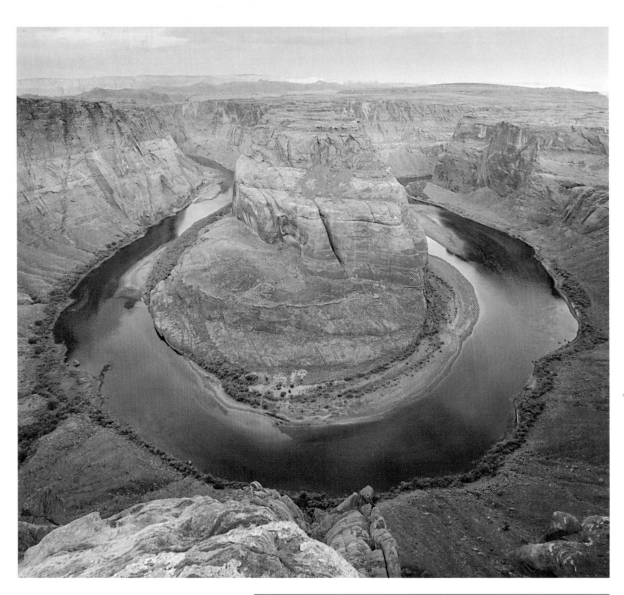

An Overexposed Image

The histogram shows a spike in the highlights at the right side of the display, which indicates a washed-out image. A decrease in exposure is necessary to keep the highlights from being overexposed.

No Such Thing as a Perfect Histogram

There is no right or wrong histogram. How you use the histogram information depends on the brightness levels in a scene and how you want to record it.

I took this nighttime photograph through the front window of a Tundra Buggy; I was on a trip to Cape Churchill in Canada to photograph polar bears. The histogram for this image is all over the place, because the large dark areas contrasted with some dominant midtones. To me, the picture is still properly exposed.

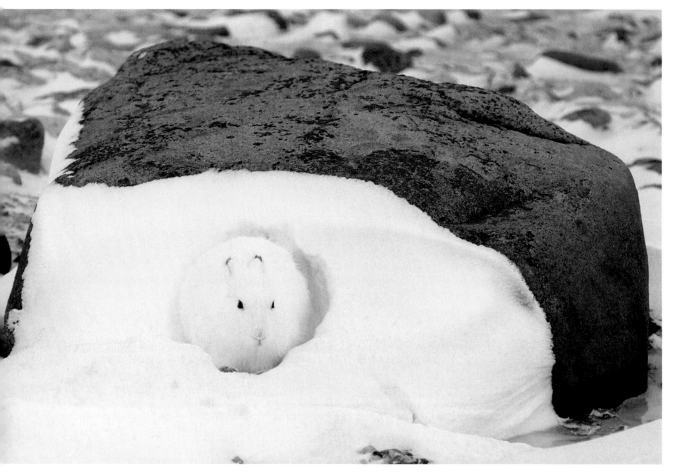

I took this photograph of an arctic hare on the same trip to the subarctic. As you might expect, the snow causes the histogram to be weighted to the right, the highlight areas. Again, I think it's a good exposure.

So use your histogram, but use your common sense and your creativity, too!

Enter Camera RAW

Let's take a quick look at how Adobe Camera RAW can help us learn about exposures back in the digital darkroom.

Here is a photograph I took of Niagara Falls at night. I set my camera to RAW capture because I wanted the extra exposure latitude that RAW file processing offers—at least one f-stop more than a JPEG file.

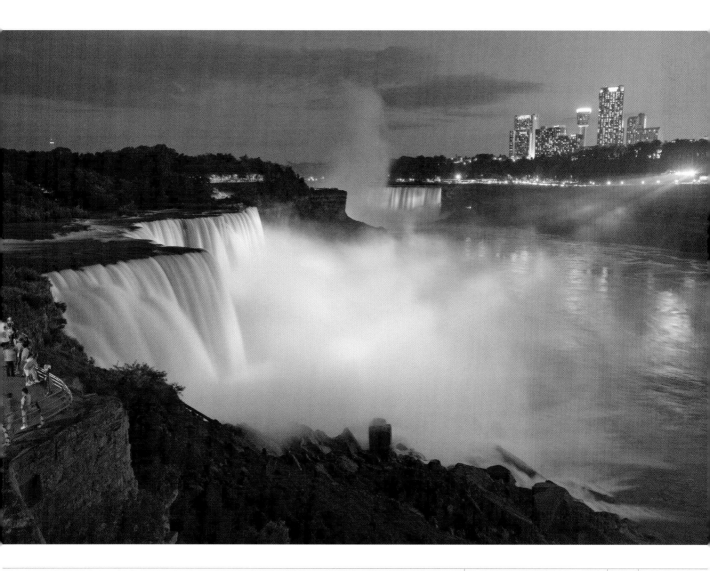

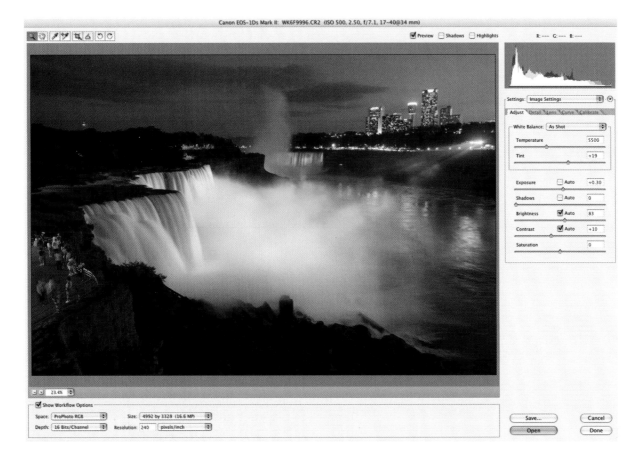

Camera RAW is a very powerful tool. Most pros do as much image enhancement in Camera RAW as possible before editing in Photoshop. When you import an image shot in RAW format into Adobe Photoshop, this main window in which you take control of your image will open first. Among other features, you can control exposure, shadows, brightness, contrast, and saturation.

So how do you learn about photography in Camera RAW? That's easy. Click on the Camera Data Tab (Exif or Exposure Information) and scroll down to see a list of all your camera settings. If you have a blurry picture, check the shutter speed—maybe it was too slow. If your depth of field is limited, check the f-stop to see if you used a small aperture. You can also check the ISO setting if you think your picture has too much digital noise, and the focal length of the lens if you like the scene's perspective. There is plenty to learn here, if you take the time and compare the data to your picture.

As I mentioned, the LCD monitor on your camera offers an overexposure warning. Camera RAW offers an over- and underexposure warning—if you check the Preview, Shadows, and Highlights boxes at the top of the window. Here I have simulated the warnings in Photoshop. The red and blue warnings are the actual colors you see on the LCD monitor: red for overexposed areas of the scene and blue for underexposed areas.

When you are out taking pictures, check the displays on your LCD monitor regularly. Then when you are home, use Camera RAW to learn more about your exposures—good and bad.

An additional note: I have also used Adobe Photoshop Lightroom and Apple's Aperture to process my RAW files, as well as Canon's Digital Photo Professional. I am sure some of you use these programs, too. I stuck to discussing Adobe Camera RAW (and Photoshop) enhancements because I think it's probably the most popular RAW processing program—but that may change as features in the other programs are expanded.

Change, Improve, and Rescue Exposures in Photoshop

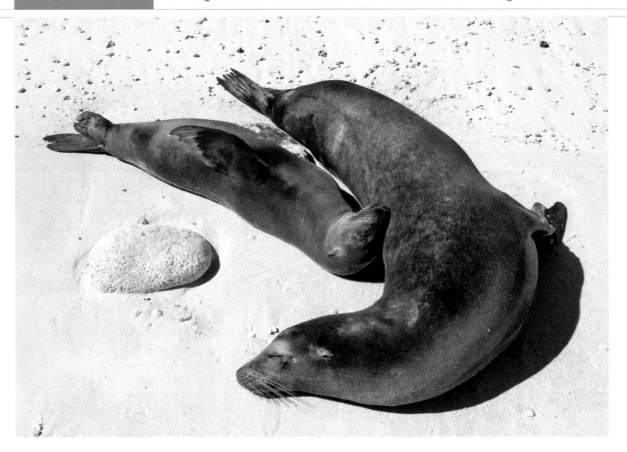

Adobe Photoshop and other image-editing programs offer many options for enhancing or fixing your photos, and even for creating works of art.

In this lesson I'll show you several basic Adobe Photoshop image adjustments that can improve your images quickly and easily. I'll also briefly talk a bit more about Adobe's Camera RAW—the ultimate digital exposure control program. Many of these enhancements are also achievable in Adobe Photoshop Elements, a less-expensive version of the professional program.

To illustrate the enhancements, I'll use some digital files that I took in the Galapagos Islands in August 2006.

In this lesson, I have not included tech info because I'd like to focus on the post-exposure, computer-based enhancements, rather than the settings at which the photographs were taken.

Levels (Image > Adjustments > Levels)

Levels is one of the most basic and important enhancements you can apply to your pictures. That's what I used to enhance the opening picture for this lesson—a picture of a mother sea lion nursing her pup.

In the Levels dialogue box you see the image's histogram, which shows the distribution of the brightness levels in the picture. The light areas are on the right, the dark areas on the left. The size of the "mountain" indicates the extent of the light and dark areas in the image. The basic idea is to move the Highlight triangle inside the right side of the mountain range, and then move the Shadow triangle inside the left side of the mountain range. The result is that the Levels of the image are spread out. If you were to open the Levels dialogue box after making those adjustments, you'd see the mountain range extending to the right and left side of the histogram.

In a few seconds, I've improved the color, contrast, brightness, and saturation of the scene using only Levels. My original, darker image is shown below.

You can also use the Eyedropper tools in the Levels to set the white point (right Eyedropper), the black point (left Eyedropper), and the gray point (middle Eyedropper). Simply click on the appropriate Eyedropper and then click on the area of the picture that you feel is white, black, or gray, and the points are set automatically, producing an improved image—if you select the points correctly.

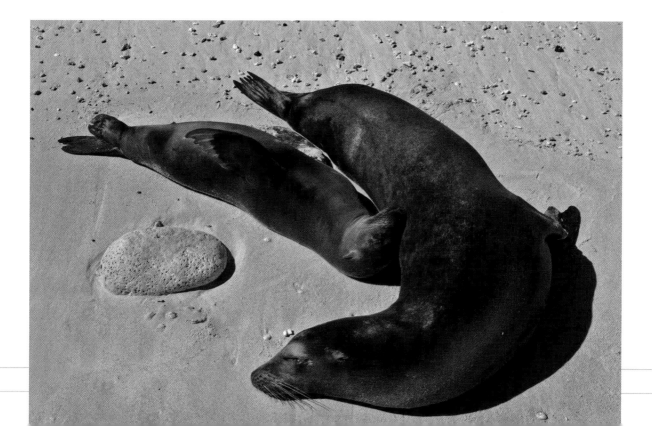

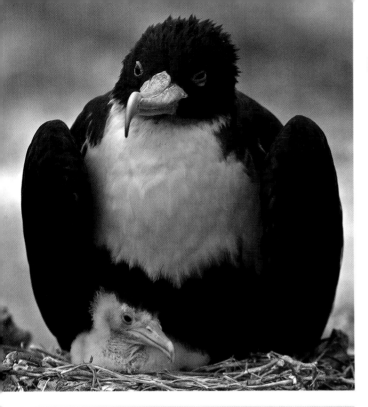

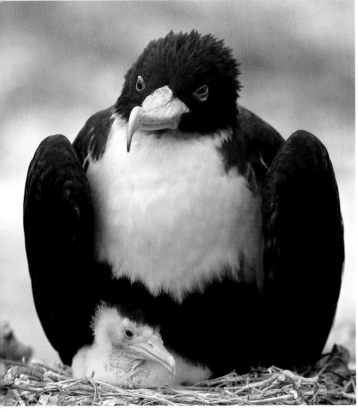

Curves (Image > Adjustment > Curves)

Professional Photoshop users rely on Curves more than Levels. Although Curves offers more control over the color, contrast, and brightness range of the scene, it basically gets you to the same place as Levels. I use Curves to make selected color values in a picture darker or lighter, while maintaining good contrast (which is not possible with the Brightness control in Brightness/Contrast, because increasing or decreasing the Brightness applies to all the color values in a picture and tends to make the image look flat). For this picture of a frigate bird and her chick, I simply pulled down the diagonal curve line from the center point toward the bottom right hand corner—my basic technique for darkening an image. If I had wanted to make the picture lighter, I would have pulled the curve line from the center point up toward the top left corner.

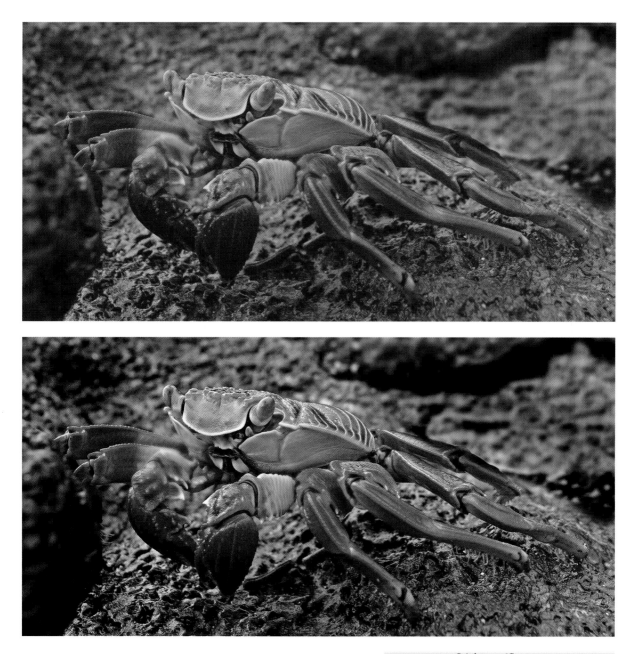

Contrast (Image > Adjustment > Brightness/ Contrast)

When a picture can be improved by increasing the contrast, I often use the Contrast control in Brightness/Contrast. That's what I did to this picture of a Sally lightfoot crab, which I photographed in the low-contrast lighting of an overcast morning.

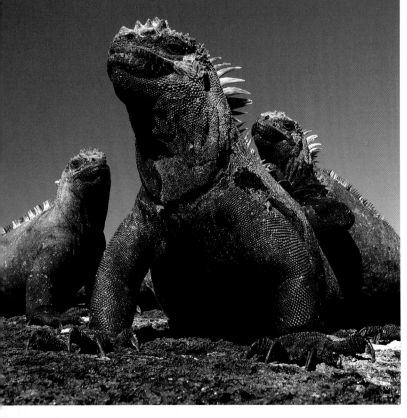

Shadows/Highlights
Shadows
Amount: `19` %
Highlights
Amount: `1` %
☑ Preview
☐ Show More Options

OK
Cancel
Load...
Save...

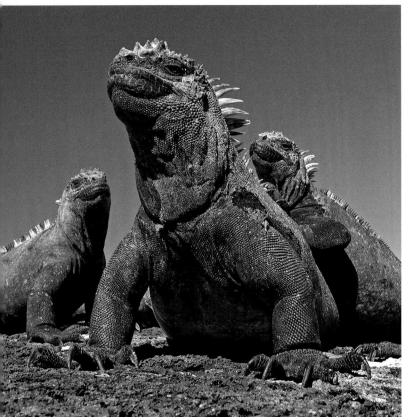

Shadows/Highlights (Image > Adjustment > Shadows/Highlights)

Shadows/Highlights lets you control the shadow and highlight areas of a picture by moving the appropriate sliders. When this feature was introduced in Photoshop, I wasn't sure how I might use it. After using it on some pictures that contained noticeable shadow and highlight areas, however, I became a convert. In fact, it's my preferred enhancement when I quickly and easily want to see into shadows and tone down highlights, as was the case in this picture of a trio of marine iguanas.

Saturation (Image > Adjustment > Hue/Saturation)

In Photoshop, you can simulate the effect of using supersaturated slide film by moving the Saturation slider to the right in the Hue/Saturation dialogue box. Of course, you can desaturate an image (which will give you an image with little or no color) by moving the slider to the left. The blue-footed booby is a favorite animal in the Galapagos. To draw attention to the bird's feet, I boosted the saturation slightly in the photo on the right.

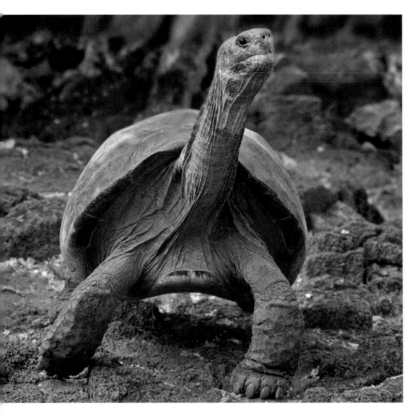

Exposure		
Exposure:	-0.64	OK
		Cancel
Offset:	0.0000	Load...
		Save...
Gamma Correction:	1.00	
		Preview

Exposure (Image > Adjustment > Exposure)

Photoshop offers Exposure as another way to darken or lighten your pictures. In the Exposure dialogue box, you can control the Exposure (brightness of the picture), the Offset (which lets us darken the shadows and midtones while only slightly affecting the highlights), and the Gamma (which shows you how dark or light a picture looks on your monitor). You can also use the Eyedropper tools as you do in Levels (see page 197). Here I used the Exposure slider to darken my photograph of a giant tortoise that I took at the Charles Darwin Research Station.

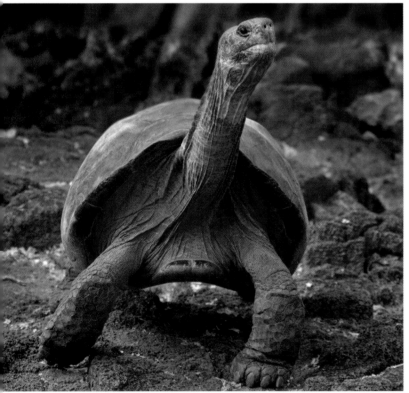

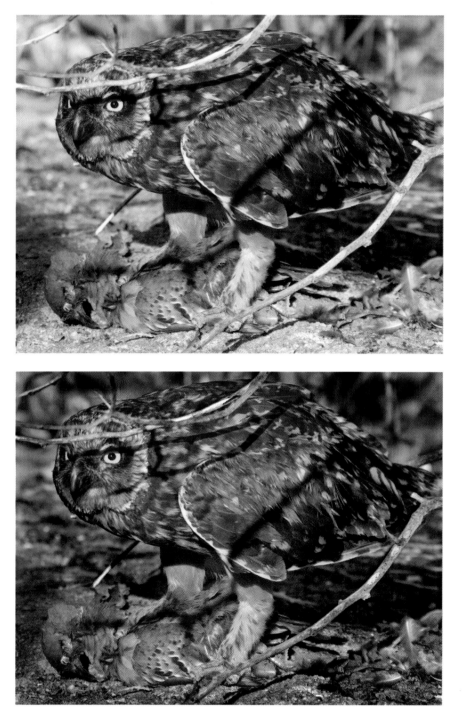

Burn and Dodge Tools (Toolbar)

The Burn tool lets us darken individual areas of a picture, and the Dodge tool lets us lighten individual areas of a picture. I used both to enhance my picture of a short-eared owl taken moments after it killed a small dove. Compare the light and dark areas of the first picture to the second. In the second picture, the branches are darker and less distracting.

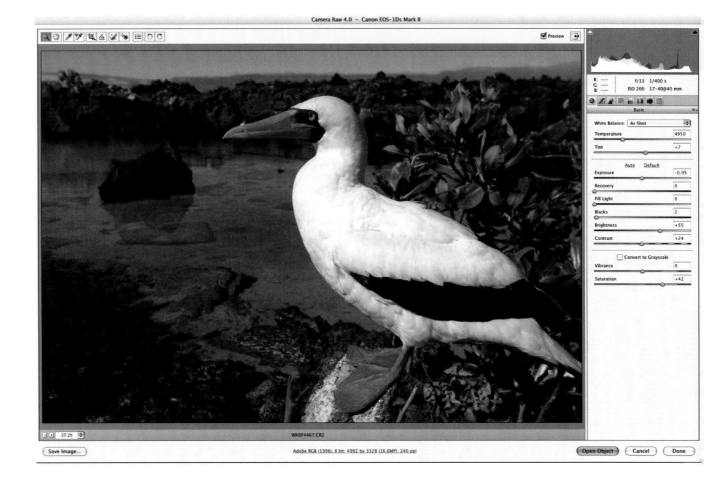

Camera RAW

Camera RAW is part of Adobe Photoshop CS3 and Adobe Elements 6. When you shoot a RAW file, it opens in Camera RAW. I shoot RAW files exclusively, because Camera RAW offers the ultimate in exposure and image control. If you are serious about your photography, shoot RAW files and process them in Camera RAW. After that, you'll open them in Photoshop, where you can make additional enhancements. Here I used Camera RAW to maintain detail in the bright areas of the picture (the masked booby's white feathers) and the shadow areas (the background).

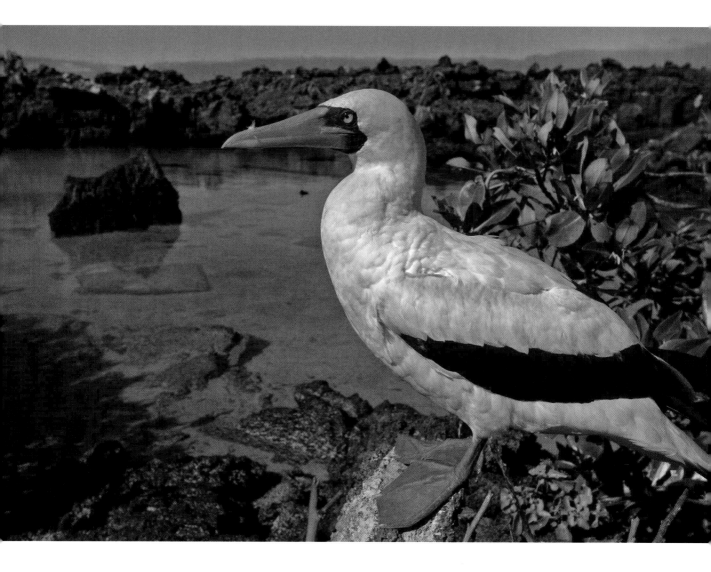

Adobe Photoshop CS3 Changes the Exposure Rules

Adobe Photoshop CS3, which includes a new version of Camera RAW and Adobe Bridge, offers many new features that help enhance good exposures and save, to some extent, the imperfect ones.

From an exposure standpoint, two of the most amazing features included in Photoshop CS3 are High Dynamic Range and Photomerge, both greatly improved from previous versions—so much so that I want to share with you some of their capabilities.

Let's take a look.

High Dynamic Range

High Dynamic Range (HDR) can automatically combine several exposures of the same scene, taken at different exposure settings, into one good exposure. The resulting image looks like the scene when viewed with our eyes, recording the 11-stop dynamic range that our superior, built-in light detectors can see. HDR reveals all the shadow details and maintains all the highlights that are lost in an

ordinary single exposure. In fact, an HDR image can look better than the actual scene, because the different levels of brightness are all accurately recorded.

For this HDR image of my kitchen and backyard, I combined seven exposures. After exposures are combined into one image, you can tweak it while in HDR and then again in Photoshop, using traditional enhancements such as Levels and Curves.

A stand-alone program, Photomatix Pro 2.3.3, offers HDR imaging, too. You can check it out at www.photomatix.com.

The greater the dynamic range of the scene, the greater number of pictures you'll need to take. My kitchen composition had a lot of contrast, from the bright scene outside to the shadow areas indoors, which is why I needed to take seven exposures—one for each of the different brightness levels.

Here are three of the seven images used for my HDR image, each of which was taken with a separate emphasis. As you can see, the exposure for the outside scene (top) prevents us from seeing the details in the kitchen. The exposure for the kitchen (bottom) totally blows out the outside details. And an average exposure, in the center, shows the outside scene overexposed and the kitchen underexposed.

Scenes with an obviously broad dynamic range, such as my kitchen scene, are not the only times you may want to consider using HDR. I used it for these images of the Ice Hotel, located about thirty minutes outside Quebec City.

For the daytime image, I wanted both the dark blue sky and bright white ice to hold detail in my final image. For the nighttime image, I wanted to capture the glow of the hotel without totally overexposing the flame from the torch in the foreground. Without HDR, the entire flame would have been pure white.

For both images, I took four exposures and combined them in HDR.

In Photoshop, go to **File > Automatic > High Dynamic Range** to open the HDR dialogue box. The rest is quite simple. You browse your computer and select the files you want to combine. Then press OK and you should be good to go. It's actually that easy.

For best HDR results, mount your camera on a tripod, use a cable release or the camera's self-timer to help prevent camera shake, shoot at a low ISO setting, reduce noise (in-camera, in Camera RAW, or in some other noise-reduction program), take more exposures at different settings than you think you'll need (at least three), keep the aperture constant and adjust the exposure via the shutter speed, and choose a static subject (although moving water may look nice).

You'll also need some patience and some time. Combining and adjusting the seven RAW images for my HDR kitchen shot took about ten minutes. Then I played with the image for another ten minutes in Photoshop (you will probably find that your combined HDR image needs some additional enhancements, maybe sharpening, or color or contrast adjustments).

With HDR we can virtually eliminate all shadow areas of a scene. But that's not always a good thing. Shadows add a sense of depth and dimension to a photograph, and that is usually good. Use HDR wisely. Imagine how flat this beach scene in Kuna Yala, Panama, would look without the beautiful shadows on the sand.

Merge to HDR

Source Files

Choose two or more files from a set of exposures to merge and create a High Dynamic Range image.

Use: Files

08-32.tif
08-33.tif
08-34.tif
08-35.tif
08-36.tif
08-37.tif
08-38.tif

Browse...
Remove
Add Open Files

OK
Cancel

☑ Attempt to Automatically Align Source Images

Photomerge

Photoshop's Photomerge, like HDR, works like magic!

Check out the above image of my house, which looks like a photograph taken with an expensive panoramic camera. In actuality, the image is a combination of four exposures taken with my full-frame digital SLR camera.

What's truly amazing is that I did not use a tripod, did not accurately or evenly overlap the photographs, and did not keep the exposure constant for the four images—techniques that used to be required in previous versions of Photomerge and in most other panorama stitching programs. Basically, I shot in the Program mode and took four pictures in an arch, knowing that Photomerge would magically stitch them together—seamlessly!

Speaking of seamlessly, in the past, a stitched panorama of a landscape or seascape would have been easier to create than a scene like this one, with its many vertical lines that could fool a stitching program and create noticeable joint points. As you can see, it's impossible to tell where the images are joined. Amazing!

Here are the four point-and-shoot images that I took initially. I knew that Photomerge would work perfectly, which is why I didn't work too hard on aligning the images.

You can find Photomerge by going to **File > Automatic > Photomerge**. Once there, simply browse your computer for the images you want to stitch together, select the preferred layout, and click OK. In a matter of seconds, you have a beautiful panorama—almost.

When your photographs are stitched together, you'll get an image that looks something like the one immediately below. There are several ways to eliminate those unwanted areas in the background layer. The easiest way is to use the Crop tool and crop them out. Another technique is to select the entire image (**Select > All**) and then use the Transform/Warp feature (**Edit > Transform > Warp**) to adjust the anchor points until you are pleased with your crop. You can also use the Warp feature to correct some distortion, which can happen, as it did in my panorama, when using a very wide-angle lens (in this case, 17mm).

As I mentioned in the HDR discussion, after your panorama is completed you'll probably want to play around with some of the standard Photoshop enhancements to fine-tune your image. But don't stop there! Experiment with different filters and actions. Here I used Blizzard Action to enhance my snow scene.

When you are photographing a high-contrast scene and when you want to take a panoramic photograph, envision how Photoshop, HDR, and Photomerge can help you achieve your goal quickly and easily.

From Snapshot to Art Shot in Photoshop

This book is not about Adobe Photoshop. However, digital image editing is such an integral part of photography I thought I'd include a Photoshop lesson on how to transform a good exposure into a more artistic image.

This lesson was inspired by a self-portrait my friend, Karen Ippolito, sent me via e-mail. In the subject line, Karen typed: Having Fun!

Karen is a good photographer and a talented artist. She has taken many creative photographs with her Canon 5D and professional lenses. But this shot, a good exposure, was taken with a tiny point-and-shoot digital camera that she uses for less formal photos.

The e-mail arrived while I was working on this book. I took a break and looked at the self-portrait, which, although I thought it captured Karen's artful side, lacked the touch of her artful eye. With her permission, I started to play with the photo. Could I transform it into a picture that better represented the artful side of the artist? Certainly! This is something we can all do—create artistic images from our straight shots.

I'll share with you how I edited the photograph first. Then we'll also look at how to enhance a landscape and a seascape.

Let's go!

The Creative Portrait

Here is Karen's original photograph.

The first step was to crop out most of the dead space. That was easy, but the new image size, 2.437 x 2.573 inches with a resolution of 300 pixels per inch, was now too small to make a print, or to be used as an illustration in a book or magazine.

I had to upsize the image. To do that I went to **Image > Image Size**, which opened the Image Size dialogue box. After choosing Bicubic Smoother (rather than simply the default, Bicubic), I upsized the image to 6 x 6.33 inches with a resolution of 300 ppi. Whenever you upsize an image, use Bicubic Smoother. (When you downsize, use Bicubic Sharper.)

The next step was to convert the color file to a grayscale image by going to **Image > Mode > Grayscale**. (Photoshop experts: I know this is not the absolute best way to get a black-and-white image, but for now, it serves the purpose.)

Converting a color file to a grayscale image tends to make the picture look flat. I boosted the contrast by going to **Image > Adjustment > Brightness/Contrast** and increasing the contrast just a bit.

My image was starting to take shape; here is the result of my efforts. Already, I felt the picture looked a bit more creative. But there was more work to be done—and fun to be had!

I like infrared photography. To simulate that effect, I went to **Filter > Distort > Diffused Glow** and played around with the sliders until I was pleased with the pseudo-IR effect. When you use this filter, don't settle for your first settings choice. Experiment and take control of this fun filter. Also, make sure your Background Color is white.

Now my picture (I mean Karen's picture with my Photoshop touches) looks kind of like an infrared photo. But wait. In Photoshop, you are really never finished with a photograph.

Talk about exposure! One of the coolest filters in Photoshop is Render Lighting Effects (**Filter > Render > Lighting Effects**). Choose that filter, and you get a dialogue box that gives you a tremendous amount of control over the "lighting" in an image. For this image, I chose Spotlight as the Light Type and experimented with the exposure, intensity, and placement until I liked the effect. (If you try Render Lighting Effects and the filter is not available, it's because you need to work on an RGB file. Before working with the filter, I went to **Image > Mode > RGB** to convert the image back to an RGB file.)

Okay! Now the picture looks a bit like a studio shot taken with a professional lighting system.

To add an artful frame to the image, I used a Camera filter in onOne Software's PhotoFrame Pro 3. The frame I created is just one of a million or so possibilities—if you use all the controls in this fun plug-in.

As a final touch, I added a black border around the edges of the picture. First, I used the Rectangular Marquee Tool to select an area of about 1/8 inch inside the frame. Next I went to **Select > Inverse**, which selected the 1/8-inch border. Then I went to **Edit > Fill** and filled the selected area with black.

Look closely and you'll see one more enhancement. Check out the whites of Karen's eyes. I used the Dodge tool to lighten them—and draw more attention to them.

As you can probably tell, I had a lot of fun working on Karen's fun shot!

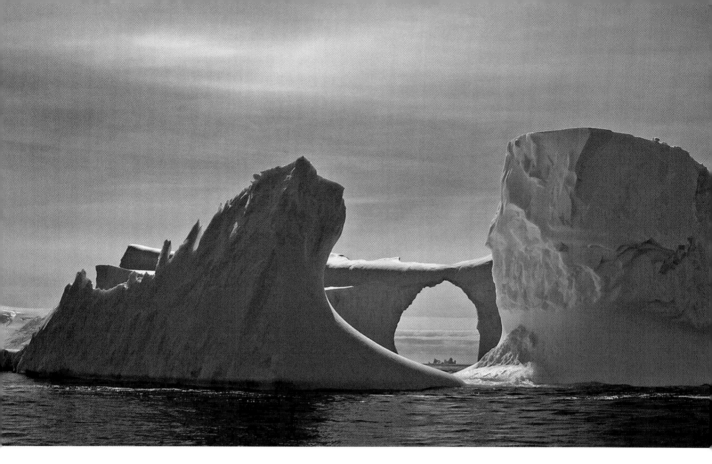

Landscape and Seascape Enhancements

Naturally, you can also transform a scenery shot—a landscape or a seascape—into an art shot, too. Let's take a look.

Here's one of my favorite photographs, a good exposure no less, from my 2005 Antarctica expedition. It's cropped to the HD (high definition) format from a full-frame image.

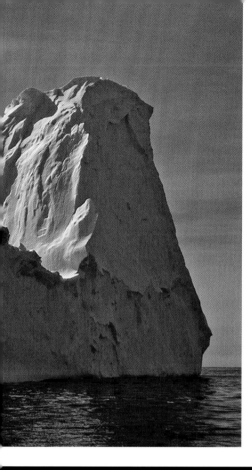

For a more artistic look, I converted the color file to black-5and-white (**Image > Mode > Grayscale**). Next, I applied the Diffuse Glow filter (**Filter > Distort > Diffuse Glow**). Finally, I added a digital Camera frame from onOne Software's PhotoFrame Pro 3.0, a Photoshop plug-in.

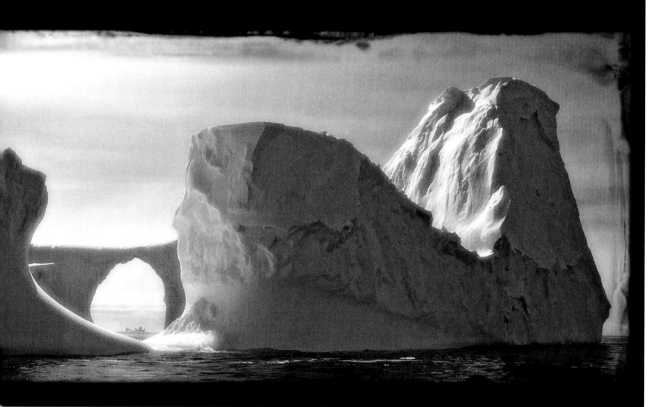

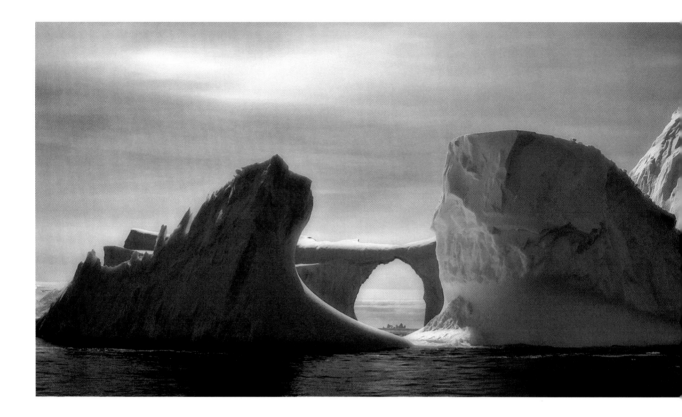

Here's a shot I took of Double Arch in Arches National Park, Utah. I used a setting of about 50mm on my 28–105mm zoom lens.

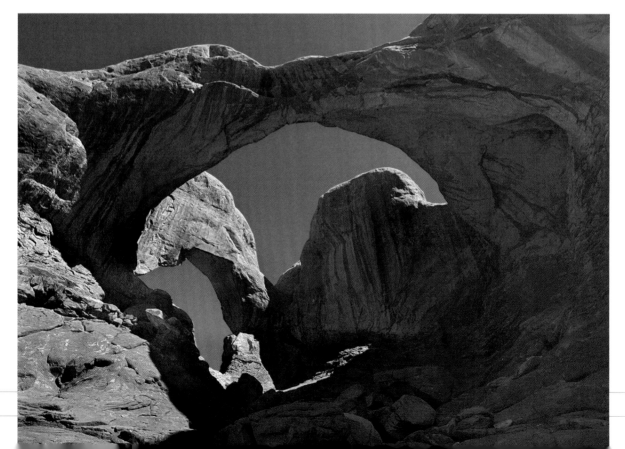

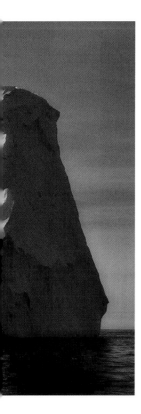

Here I applied the Midnight Blue filter in Nik Software's Color Efex Pro 2.0, another Photoshop plug-in.

In Photoshop, I stretched the image (**Image > Canvas Size > Unchecked Constrain Proportions**) to make it look as if I were standing closer to the arch and using a 17mm lens. The image was now longer but not wider. Next I applied the Duplex Monochrome filter in Nik Software's Color Efex Pro 2.0. With a few clicks of a mouse, the image takes on a more creative look.

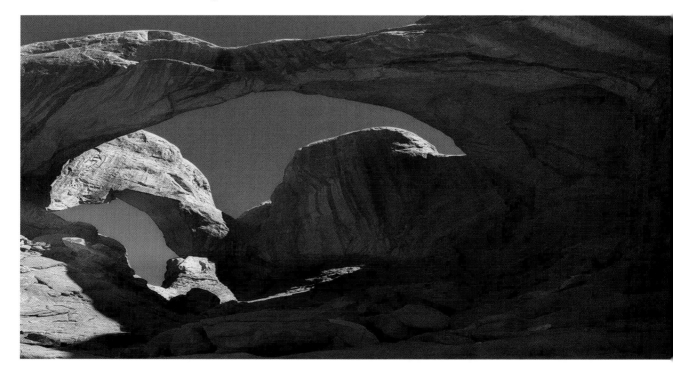

Here's a stretched version of the sunset scene from page 75. Below is the same shot reflected in an imaginary lake, a trick that's actually quite easy to do in Photoshop. First, select the image (**Select > All**). Second, copy the image (**Edit > Copy**). Then create a new document (**File > New Blank Document**) and paste (**Edit > Paste**) the copied image into it. The new document will be the exact same size as the copied image, because that's how Photoshop works. Next, flip the duplicated image (**Image > Rotate Canvas > Flip Horizontally**). Now, double the canvas size of your original file (**Image > Canvas Size**), adding an empty area below your original image. Finally, drag the upside-down image into the expanded original file and align the mirrored image to the original.

As you can see, you can have a ton of fun in Photoshop. Please keep in mind, however, that it all starts with an in-camera image. Get that right the first time, and then have fun playing and working in Photoshop!

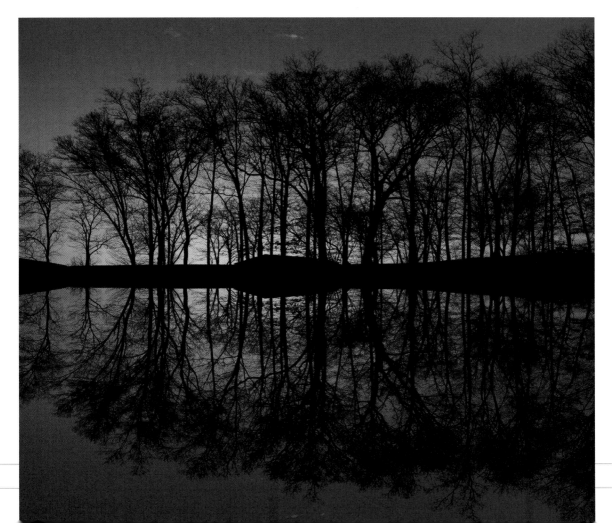

Epilogue

Final Exposures

After reading and digesting all the technical talk and Photoshop techniques on the preceding pages, I thought a nice way to end a book on exposure would be to share some favorites from a 2006 trip to Kenya, the magical and enthralling home of the Masai and the land of the lion king.

To get these exposures, I followed the techniques covered in this book. These techniques need to become second nature, so that when you are looking through your viewfinder, all you have to do is concentrate on focus and composition.

In sharing these pictures, I'll suggest a tip from preceding lessons that applies to each picture. So you could look at this epilogue as a minireview. Enjoy!

Sunrise, Amboseli National Park. *Slightly underexpose a scene for more dramatic colors.*

Sunset, Masai Mara. *Crop creatively.*

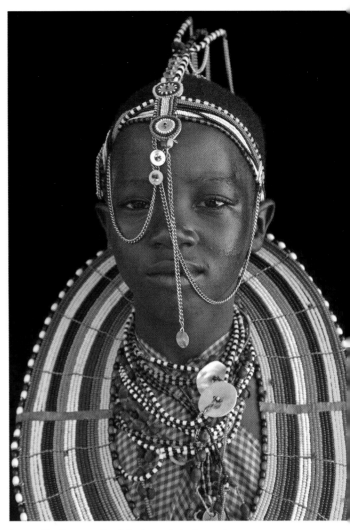

A young Masai woman singing during a village's welcome dance. *Select a wide aperture to blur the background.*

A young Masai woman. *Carefully choose the background.*

Profile of a young Masai woman. *Make a picture; don't just take a picture.*

An intricate Masai earring. *Expose for the highlights.*

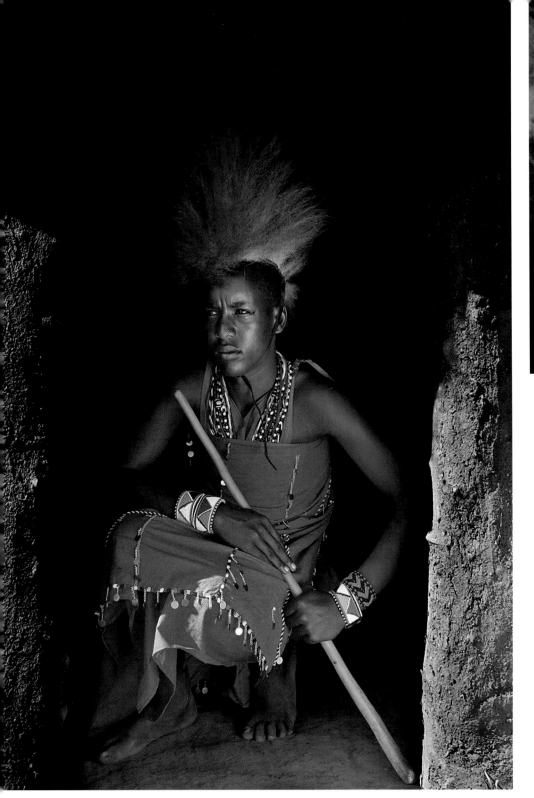

A Masai boy wearing the mane of the lion he killed. *Use a reflector when a subject is in the shade.*

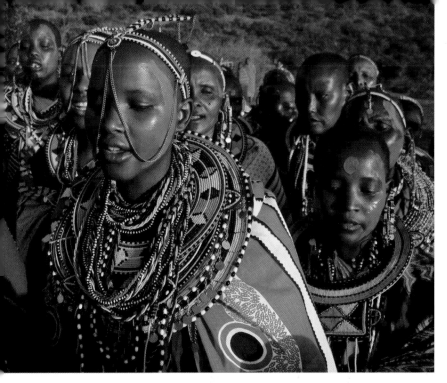

A welcome dance and song of the Masai women.
Catch the beautiful light of early morning.

Masai men in a jumping event.
Capture the peak of action.

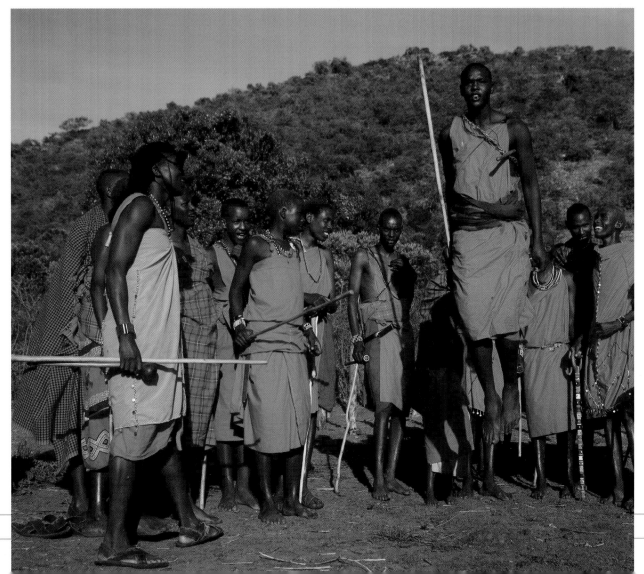

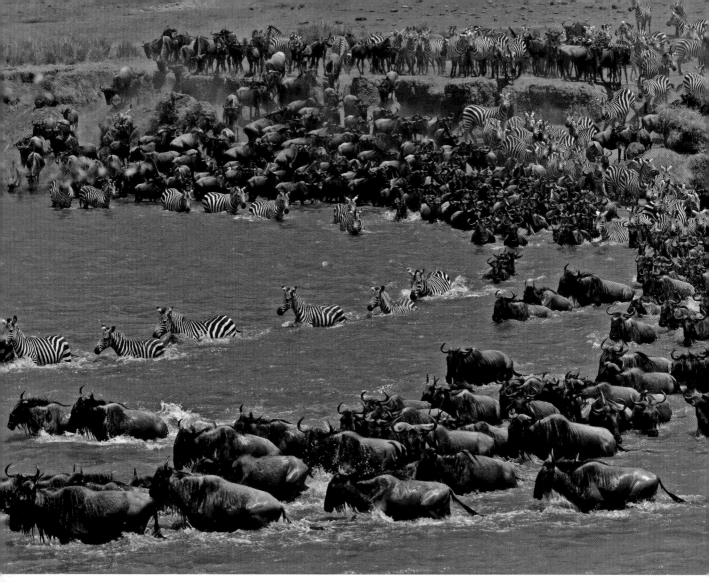

Wildebeest and zebra herds at a river crossing. *The name of the game is to fill the frame.*

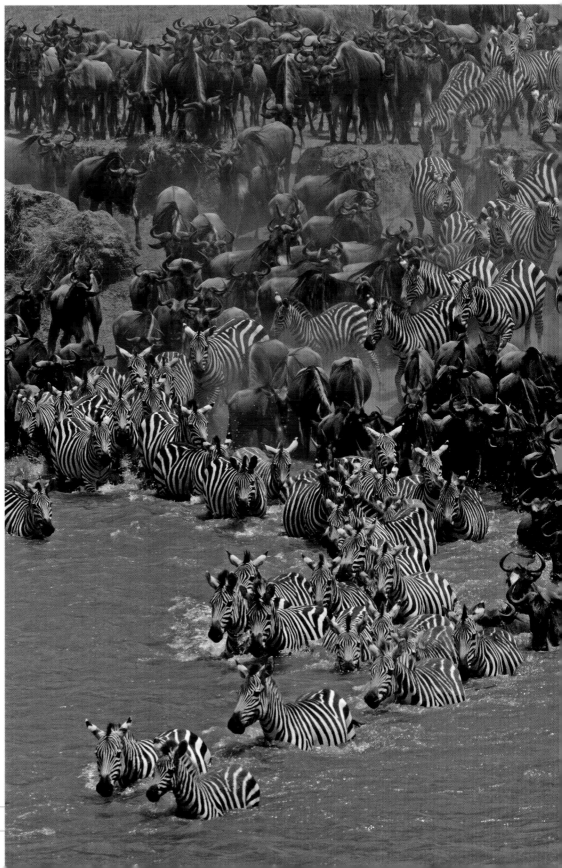

Wildebeest and zebra
herds at a river crossing.
*Use a small f-stop for
good depth of field.*

Wildebeest swimming during the river crossing. *Freeze action with a fast shutter speed.*

A lone wildebeest at sunrise. *Remember that the dead center is deadly when it comes to composition.*

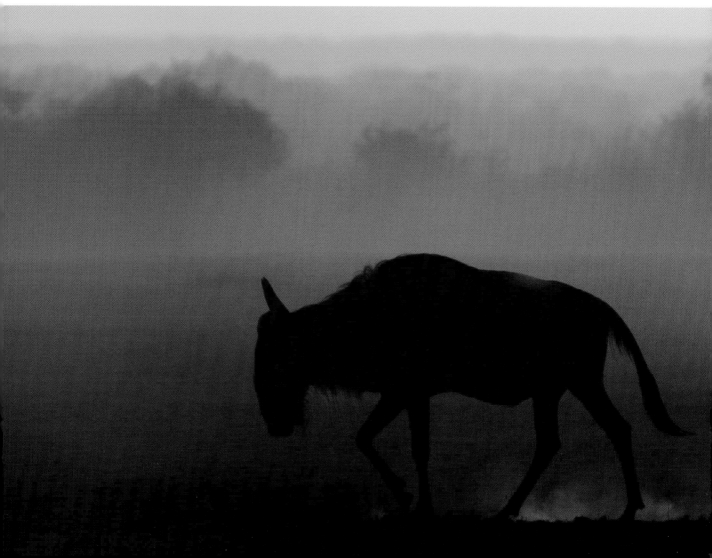

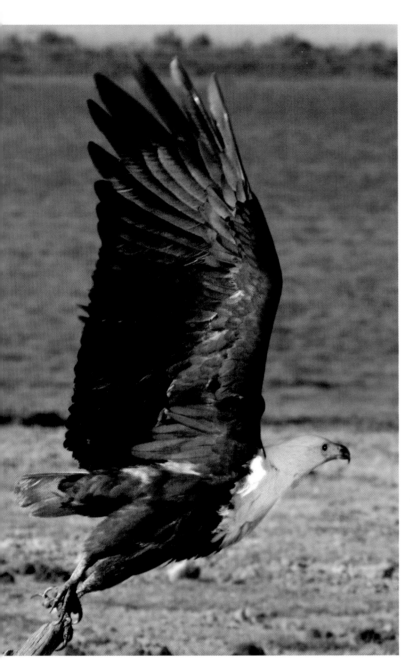

An African fish eagle taking flight. *Shoot RAW files to capture all the details.*

Male and female elephants. *See the light and expose for the brightest part of the scene.*

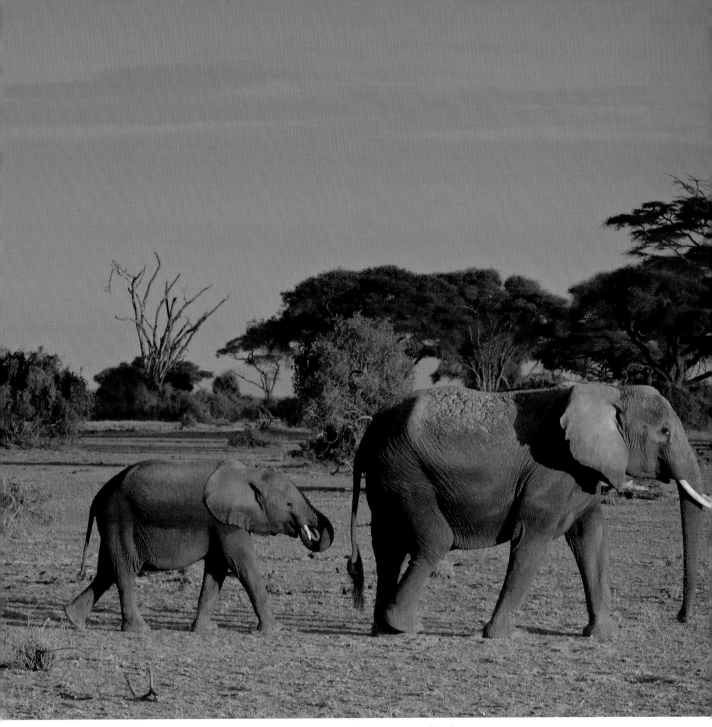

A female elephant with her young calf. *Use the lowest possible ISO setting for the clearest possible picture.*

Adult elephants protecting their young from predators. *Use a graduated filter to darken the sky.*

Giraffes in the late afternoon.
Keep a keen eye on the horizon line.

A cheetah looks for a meal. *Focus on the eyes.*

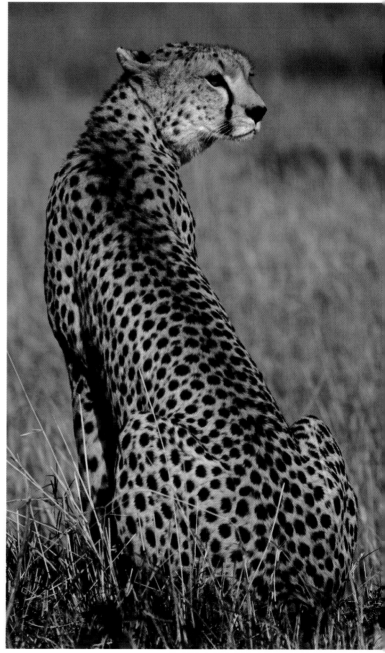

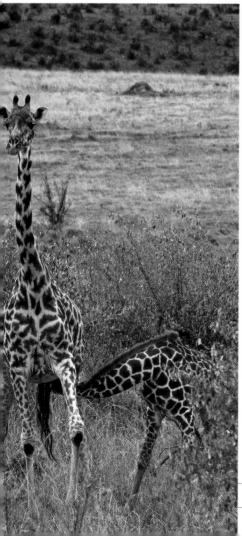

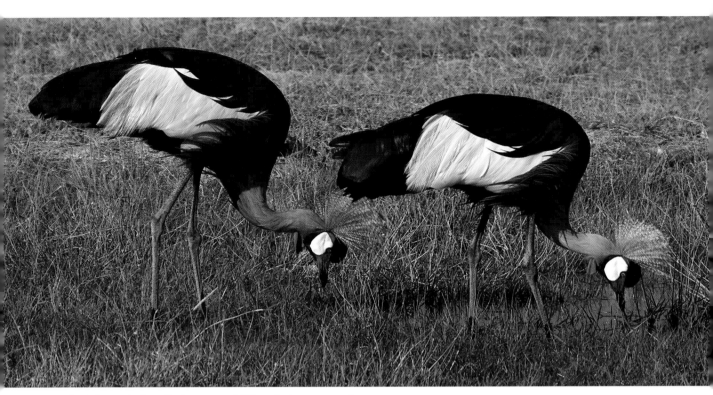

Crested cranes feeding. *Check your camera's LCD monitor to ensure a good exposure.*

The rough road from Nairobi to the Masai Mara. *Have fun!*

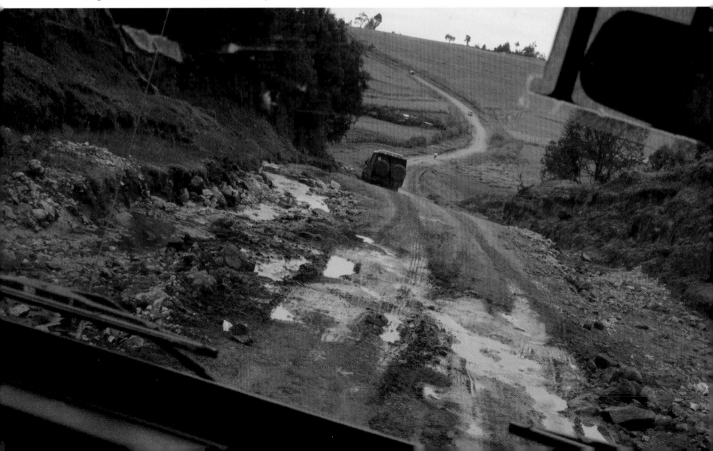

Acknowledgments

Flash back to 1959. Early morning. I'm nine years old. It had started snowing heavily the night before.

On the tube radio in my parents' room, the announcer included my school in the list of closings for the day. "Great, a snow holiday," I said to myself. "Maybe my dad and I can set up my model trains today."

About an hour later I stood at the living room window and watched my dad trudge through the deep snow and what looked like a blizzard on his way to the train station. "He was going to work for an important meeting," my mother told me. I set up my trains in my basement by myself and actually came up with a pretty good layout.

That night, when my dad came home, I showed him what I had done. He congratulated me on

the layout and we played with the trains for a while before he tucked me into bed.

Flash forward to today. As I was thinking of whom to thank in these acknowledgments, my dad came first to mind. Why? Because it was the strong work ethic of this totally self-made man that I fortunately inherited, which is one reason why I have produced so many books, television shows, articles, DVDs, workshops, and seminars. Sure, at nine years old I did not understand how important a single meeting could be, but I sure do now.

Forty-seven winters later, my dad is still a tremendous influence in my life. He helps me with all my books and articles. He gets the first pass on all my material, and even with macular degeneration, finds mistakes and makes good suggestions.

So thanks, Dad!

What's interesting is that my seventeen-year-old son, Marco (named after Marco Polo because we take him around the world with us), also has a strong work ethic, in his case, when it comes to doing his homework, sports, and music. He's an A+ student, plays five instruments, is a star runner, and is a great model and photo assistant. Plus, he keeps me young!

Other Sammons have helped me with my projects. My wife, Susan, is a wonderful photo assistant, and editor, too. And my late mother, a hard home worker, helped me develop black-and-white prints in our basement—and helped me learn about the art and craft of photography.

At W. W. Norton, Leo Weigman, my main contact and editor, has been a godsend, helping me develop my ideas into books (this is our fourth) that are informative and entertaining. Other helpful folks at Norton include Jennifer Cantelmi, Carole Desnoes, Ingsu Liu, Nancy Palmquist, Lisa Rand, Don Rifkin, Bill Rusin, Nomi Victor, Rubina Yeh, and Devon Zahn.

Julieanne Kost, Adobe Evangelist, gets a big thank you for inspiring me to get into Photoshop in 1999.

Addy Roff at Adobe also gets my thanks; she's given me the opportunity to share my Photoshop techniques at trade shows around the country.

Other friends in the digital imaging industry that have helped in one way or another include David Leveen of MacSimply and Rickspixelmagic.com, Mike Wong and Craig Keudell of onOne Software, Wes Pitts of *Outdoor Photographer* and *PCPhoto*, Ed Sanchez and Mike Slater of Nik Software, George Schaub of *Shutterbug*, Scott Kelby of *Photoshop User*, Chris Main of *Layers*, and Susanne Caballero of Lowepro.

At Mpix.com, my on-line digital imaging lab, I'd like to thank Joe Dellasega, John Rank, Dick Coleman, and Richard Miller.

Rick Booth, Steve Inglima, Peter Tvarkunas, Chuck Westfall, Rudy Winston, and all the members of Canon's Professional Services have been ardent supporters of my work, as well as my photography seminars. So my hat is off to these friends, big time! The Canon digital SLR cameras, lenses, and accessories that I use have helped me capture the finest possible pictures for this book.

Jeff Cable of Lexar hooked me up with memory cards (4GB and 8GB because I shoot RAW files) and card readers, helping me bring back great images from my trips.

My photo workshop students were, and always are, a tremendous inspiration for me. Many showed me new digital darkroom techniques, some of which I used in this book. During my workshops, I found an old Zen saying to be true: "The teacher learns from the student."

So thank you one and all. I could not have done it without you!

Index

About the Author

Rick Sammon has published twenty-eight books, including *Rick Sammon's Travel and Nature Photography*, *Rick Sammon's Complete Guide to Digital Photography 2.0*, *Rick Sammon's Digital Imaging Workshop*, and *Flying Flowers: The Beauty of the Butterfly*. He also writes for *PCPhoto*, *Outdoor Photographer*, and *Layers* magazines.

Rick has produced *3-Minute Digital Makeover*, an interactive DVD for Photoshop Elements users. He has also produced DVDs for Photoshop CS and CS2 users—*Rick's Roundup of Photoshop Enhancements*, *Photoshop for the Wedding and Portrait Photographer*, *Photoshop for the Outdoor and Nature Photographer*, *Awaken the Artist Within*, and *Close Encounters with Camera RAW*—as well as *Rick Sammon Live!* a DVD version of the presentation he gives around the country and around the world.

Rick travels the world and gives more than a dozen photography workshops and presentations each year. He teaches for VSP Workshops (www.vspworkshops.com), Palm Beach Photographic Centre (www.workshop.org), International Expeditions (www.ietravel.com), and Maine Media Workshops (www.theworkshops.com). In addition, Rick gives private workshops around the world. He also presents at Photoshop World, which he says is a "blast."

Rick is the host of the *Canon Digital Rebel Personal Training Photo Workshop* DVD and book. He is the author of the Canon Digital Rebel XT lessons on the Canon Digital Learning Center, and he is also a Canon Explorer of Light.

Photograph by Susan Sammon

Rick also hosts classes on www.xtrain.com and www.kelbytraining.com.

When asked about his specialty, Rick says, "My specialty is not specializing."

See www.ricksammon.com and www.rickspixelmagic.com for more information.